# The Hoosier Group

## Five American Painters

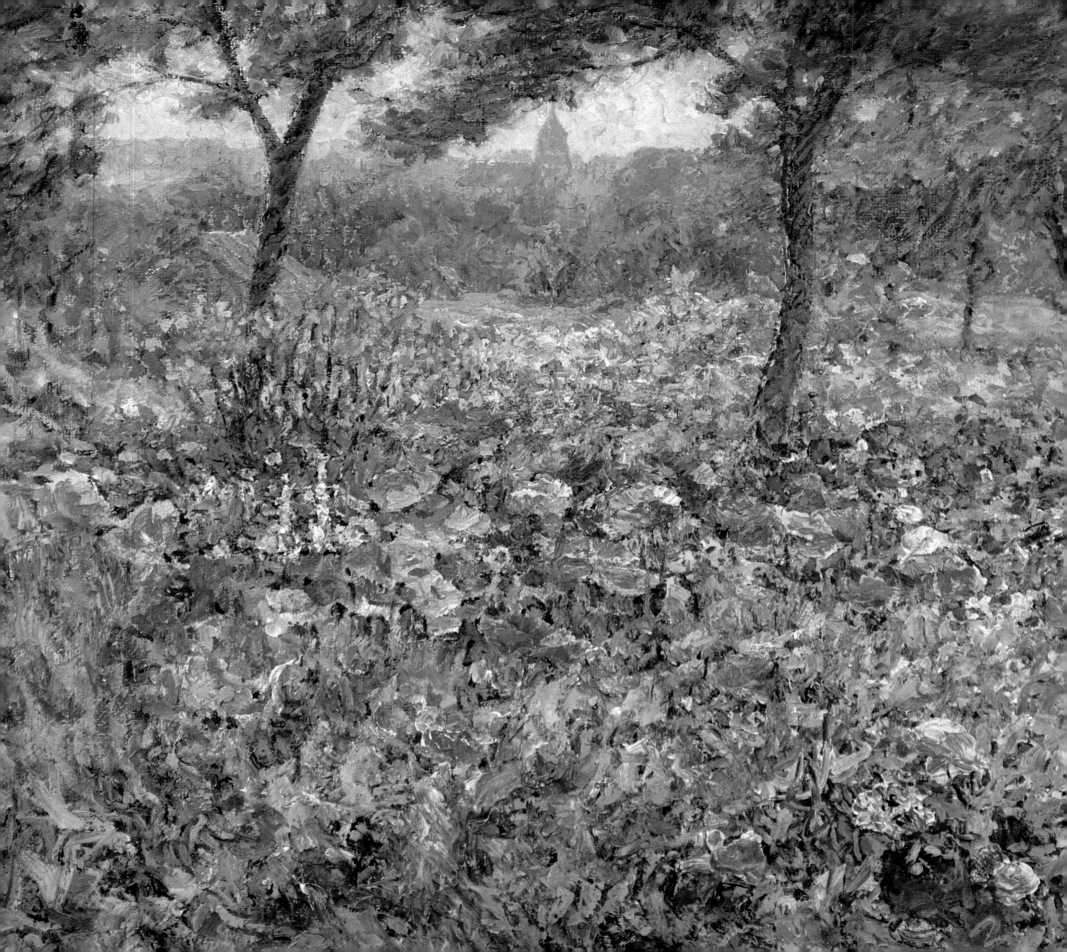

# The Hoosier Group

## Five American Painters

**Introductory Essay by William H. Gerdts**

**Biographical Essays by Judith Vale Newton**

**Works Selected by Jane and Henry Eckert**

**Eckert Publications**
**Indianapolis, Indiana**

Published in 1985 by Eckert Publications,
Indianapolis. All rights reserved. No part of the
contents of this book may be reproduced without
the written permission of the publishers.

Second printing 1991

Library of Congress Catalog Card Number: 85-80653

ISBN: 0-9614992-0-6

Designed by Douglas Wadden

Edited by Marjorie V. Wilson

Front jacket (detail) p.2 (detail)
**J. Ottis Adams**
*Poppyfields*
Oil on canvas
22 x 29 inches
Private Collection

Type set in Century by Thomas & Kennedy,
Seattle.

Color separations, printing and binding by Nissha
Printing Co., Ltd., Kyoto, Japan.

Back jacket
**Theodore C. Steele**
*Summer Days at Vernon*
Oil on canvas
22 x 40 inches
Private Collection, Zionsville, Indiana

# Foreword

In 1973, we purchased our first piece of Indiana art. It was a small watercolor by William Forsyth which he had painted in 1903 as a Christmas greeting to a friend. Our finances, at that time, were rather meager, and when someone expressed an interest in buying the holiday card, we reluctantly let it go. Looking back on it now, that was the beginning of a whole new life for us as art dealers. Little did we know what lay ahead of us and that, in twelve years, we would be publishing a book, *The Hoosier Group: Five American Painters*.

Long after we had sold that little watercolor, we thought often about Forsyth and the times in which he had painted. There were few books, however, available on Indiana art dealing with that period, with the notable exceptions of *Pioneer Painters of Indiana* by Wilbur Peat, *Art and Artists of Indiana* by Mary Burnet, and *The House of the Singing Winds* by Theodore L. Steele, Selma Steele, and Wilbur Peat. They were helpful, but we wanted to learn more about the personal side of our Hoosier artists. We sought out the descendants and friends of these painters and listened for hours to their reminiscences. Soon we felt that we knew these men, and their paintings began to have even more meaning for us. Although we appreciated other periods of art in our state's history, it became clear to us that there had been a "Golden Age" of painting which had centered around the Hoosier Group: Theodore C. Steele, William Forsyth, Otto Stark, John Ottis Adams, and Richard Buckner Gruelle. Despite the lure of the East Coast, these Hoosier artists had remained loyal to their state and had developed a distinctive style of painting which had left a mark upon the development of American art.

About three years ago, we started going through stacks of notes and photographs of paintings which we had accumulated on Indiana art. We wanted to put a book together on the Hoosier Group and set out to find a professional writer who would give us a first-rate account of these artists. We turned to Judy Newton who holds degrees in both law and journalism. Because of her legal research abilities, experience as a working journalist, and love of Indiana art, our choice was easy. Over three years of her life have been dedicated to this project. She has traveled to Europe to uncover new information on the learning years of Steele, Stark, Forsyth, and Adams. She has also interviewed relatives of these artists from all over the country and has retrieved personal papers and old photographs from their attics and cellars. We thank her for making our dream a reality.

We had long admired the books written by art historian William H. Gerdts and knew that, because of his strong interest in regional art, he was eminently qualified to comment upon the role of the Hoosier Group in the development of American art. Not only had Bill focused upon our Indiana artists in prior publications, but he was enthusiastic about their work and did not hesitate to accept our invitation to write an essay for *The Hoosier Group: Five American Painters*. His participation has been an invaluable addition, and we will always be grateful to him for having confidence in this project.

Hoping to illustrate our book with some of the best works of the Hoosier Group, we have spent months visiting museums, schools, libraries, offices, and private homes to find these special paintings. Everyone was eager to share their pieces, and it made our task an enjoyable one. The only hard part was narrowing down all of the fine paintings which we saw and making our final selections. We are particularly pleased that many of the works in this book are being published for the first time.

Although a number of the heirs of the Hoosier Group artists have helped in this book, there are a few we would especially like to acknowledge. Long before work on *The Hoosier Group* began, we became friends with Ted Steele, one of the artist's grandsons. The stories Ted told us about his grandfather had such warmth and such interest that we have never forgotten them. Also, during the early years of our business, we were fortunate enough to have met "The Girls," our affectionate nickname for Constance Forsyth and Evelyn Forsyth Selby, daughters of the painter. It has been our good fortune to know them, and we will always cherish their delightful tales. Thank you Ted, Connie, and Evie for helping us get started and for sharing your memories.

When our business began, there was only a handful of collectors who followed Indiana art. As our interest in this area grew, people "came out of the woodwork." Our gallery began to bustle with collectors who were sharing thoughts on artists and excitedly looking for new pieces. It was as if we were all rediscovering the work of these turn-of-the-century artists which had been buried by two world wars and a depression. We are proud to share this book with the collectors of Indiana art and especially with the supportive friends in the Hoosier Group, Inc.

Among those devoted people who have helped make this book possible, we would like to thank Ken Armour for his superb photography, designer Doug Wadden for creating the kind of book we had envisioned, and our employees, Dianne Wright, Steve Redman, Jack Gummer, and Ann Houston, for pitching in and working extra hours. And lastly, we wish to thank Jane's parents, June and Troy Coats, for helping us get started in a business which brings us so much happiness.

**Jane and Henry Eckert**

# Acknowledgments

I often wonder, while looking at a painting, about the artist "hidden" in the picture. Why did he choose that particular scene? What was happening in his world at the time he was painting? Where did he find his inspiration? Was he happy? The journalist in me, I must admit, is many times more intrigued by what a painting seems to be saying about its creator than by what techniques were used in its execution. More often than not, I am especially curious to learn about the artist as a person rather than about the artist as a professional.

From this perspective, the writing of *The Hoosier Group: Five American Painters* began as an art collector's attempt to find the man behind each of the artists in the Hoosier Group. And the book ended, I hope, with the emergence upon its pages of the five distinctly different personalities which made up this distinguished group of Indiana painters. It has been a rare privilege for me to have "met" them while sifting through their century-old letters, reading from their ink-splotched diaries, and listening to their descendants talk of family stories. These artists have become my friends.

It is with great appreciation that I thank Henry and Jane Eckert for their willingness to bring the story of the Hoosier Group to the attention of the reading public and William H. Gerdts, Executive Officer of the Ph.D. Program in Art History of the City University of New York, for his guidance and encouragement. His definitive essay on the work of the Hoosier Group artists adds immeasurably to this book. I thank him for his discerning analysis.

Without the cooperation and whole-hearted enthusiasm of the families of the Hoosier Group artists, this book could never have been written. These special people have spent long hours answering my questions, days searching for documents, and, through it all, they have continued to ask: "How else can I help you?" With deepest gratitude, I thank them: Theodore L. Steele, Robert B. Neubacher, Lewis L. Neubacher, Brandt F. Steele, M.D., and Brandt N. Steele; Constance Forsyth, Evelyn Forsyth Selby, and Robert Selby; Worth Gruelle, Peggy Y. Slone, Joni Gruelle Keating, R. J. Butterfield, and Harry R. Gruelle; Rosemary Ball Bracken, Caroline Brady, Marion Adams Stockwell, Alexander M. Bracken, and Lucy Ball Owsley; Mary Stark Oakes, Margaret Stark, Michael Lewis, and Barbara Lewis.

To those students and neighbors of the Hoosier Group artists, I thank you for sharing your memories: Jean Brown Wagoner, Isabelle Layman Troyer, Beulah Hazelrigg Brown, Evelynne Mess Daily, Orpha McLaughlin Pangborn, Dorothy Canfield Blue, Mildred Stilz Haskens, Ruth Bozell, William Harris Forsyth, and Mary Elizabeth Lupton Wood.

The research for this project during the last three years has been all-consuming at times, and the transformation of scattered bits and pieces of information into a book has been an exciting challenge. During both the research and the writing of *The Hoosier Group*, I have been exceptionally fortunate in working with people who have generously shared their talent and their insight with me. Inadequate though my thanks may be, I would like to express my gratitude to a few of those who have helped: Martin Krause, Jr., Associate Curator of Prints and Drawing, Daphne Miller, formerly Print Room Manager, and Martha Blocker, Librarian, Indianapolis Museum of Art; Alina Entralgo, Curator of Fine Arts, Ron Newlin, Historian, and Janine Beckley, formerly Assistant Curator, Indiana State Museum; Alain Joyaux, Director of the Ball State University Art Gallery; Jeannette M. Matthew, Archivist, and John Straw, Archives Senior Assistant, Indiana University-Purdue University at Indianapolis Archives; Julie J. Young, Senior Archives Assistant, DePauw University Archives; I. Valentin, Ltd. Regierungsdirektorin, Akademie Der Bildenden Künste; Katherine Baird, Librarian, St. Martin's School of Art; Joan Walden, Assistant Librarian, Royal College of Art; Dr. Christian Lenz, Bayerische Staatsgemäldesammlungen; and Anne Roquebert, Conservatrice, Établissement Public du Musée d'Orsay.

I am also indebted to a number of kind and caring friends, collectors, and scholars who have unselfishly given their time to helping me in the creation of *The Hoosier Group:* Leland Howard, Talitha Peat, Ernestine Bradford Rose, Diana Hawes, Robert Boykin, Helen Connor, Beth Wood, Parker Lanier, Robert Wilson, Susan Hanafee, Steve Schmidt, Rita Rose, Corinne Worzalla, Marina Ashanin, Professor William A. Kerr, and Jon Lockhart. Heartfelt thanks go as well to Suzanne Newland, Maria Reed, Mike Etten, and Heike Schmid for their skillful translation work; Patti Bendinger for her invaluable assistance in the preparation of this manuscript, and editor Marjorie Wilson for her perceptive comments.

Most of all, I am grateful to my husband and two children who gave me their loving understanding. Thank you.

**J. V. Newton**

Indianapolis, April 1985

# Table of Contents

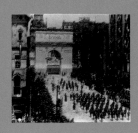
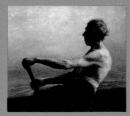
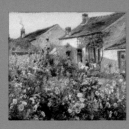

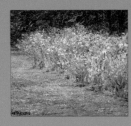

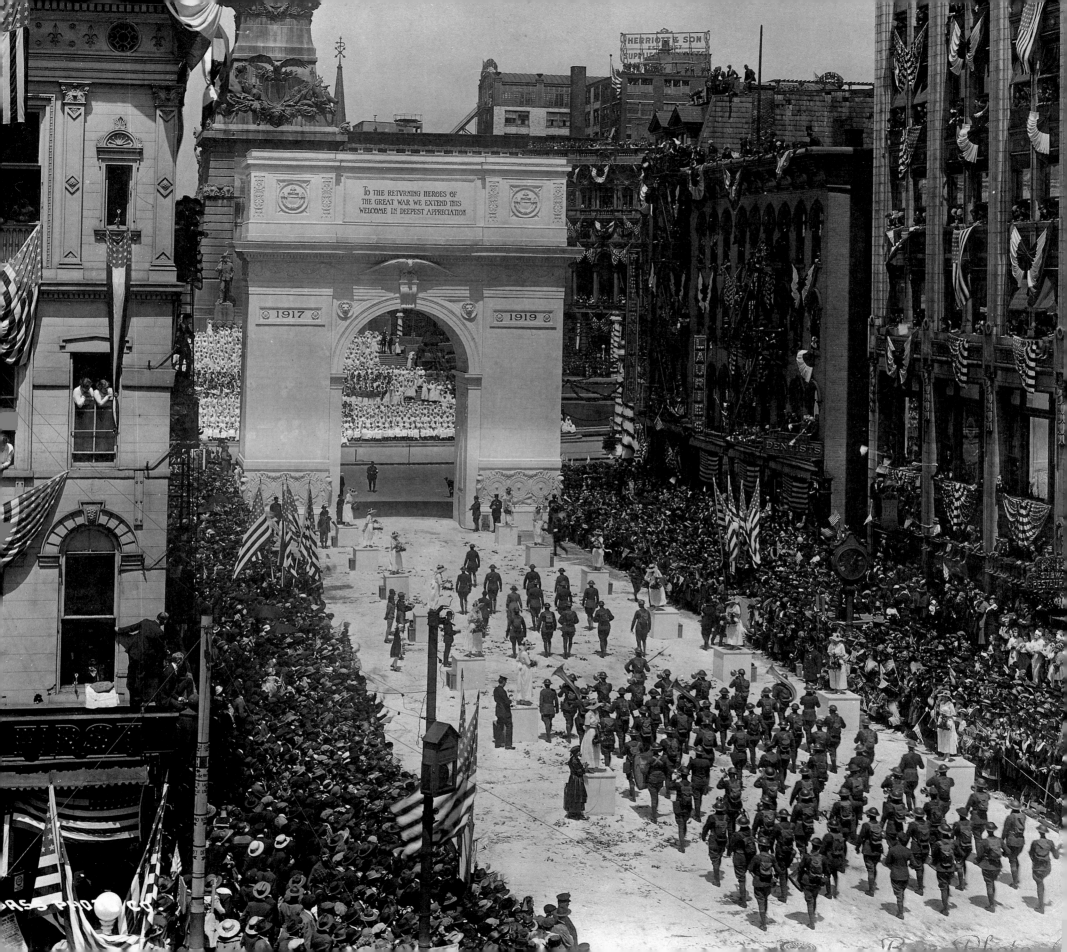

# The Hoosier Group Artists   A Look at Their World

**Judith V. Newton**

Leaving Munich of the 1880s (above), the Hoosier artists returned to Indianapolis to find their city in the midst of change. Newly built office buildings and magnificent hotels dominated the city's Monument Circle where, in 1919, an arch was built to celebrate the triumphant return of Indiana's veterans from World War I. Bass Photo Archives.

The notes for this text begin on page 13.

The world of the 1850s into which the Hoosier Group artists—Otto Stark, Theodore C. Steele, J. Ottis Adams, William Forsyth, and Richard B. Gruelle—were born was a quiescent one, yet to be shattered by the sacrifice and sorrow of the Civil War a decade later. Raised in small midwestern towns, these talented men spent their boyhoods attending school, doing chores, and, when time and circumstances allowed, learning what they could about art. Each of them, in his own fashion, was irresistibly drawn to art, and each of them, in his own manner, followed that destiny which ultimately called him to be an artist.

Life was often a struggle for those who lived in the more than two hundred villages, towns, and cities which dotted the wooded flatlands of northern Indiana and the rugged hills of the state's southern region. Conditions in these mid-century Hoosier[1] towns, where an open square was typically ringed by a local blacksmith shop, tavern, livery stable, hotel, and general store, were frequently dirty and unsanitary. Residents depended upon wells for their water supply, outhouses for sanitation, and rutted dirt roads for their link to neighboring towns.

Following the fighting of the Civil War, the character of Indiana's economic life changed significantly. A Hoosier population which had been two-thirds agricultural on the eve of the conflict saw its state become, by the war's conclusion in 1865, a manufacturing force. The wartime economy had spurred the development of big business. And manufacturing, no longer dependent upon the ill-fated canal network of the 1830s, had utilized Indiana's burgeoning rail system to shift its economic base from the Ohio River basin into virtually every part of the state.

Indianapolis emerged from the tumult of the Civil War a city in the midst of change. The Hoosier capital's streets, muddy and neglected, were being paved and illuminated by gaslight, and trolley cars, drawn by mules, were creaking down tracks which were embedded in the city's main thoroughfares. Downtown Washington Street property sold for eight hundred dollars per foot, community baseball had begun, and more than half of the residents were relatively new to the rapidly growing town. With understandable pride, the city applauded its publicly-supported Indianapolis City Hospital, its school system of nearly forty-eight-hundred pupils, and its several independent libraries around town from which readers could borrow books. City dwellers enthusiastically supported local music, art, and theater. The town's twenty-five-hundred-seat Academy of Music theater had opened, attracting sellout crowds for touring minstrels, variety shows, and stock melodramas. Prominent Indianapolis families patronized local portrait artists; guest musicians appeared with some frequency, and musical societies vied with one another to present concerts, operas, and cantatas.

The postwar prosperity in Indianapolis and the Hoosier state crumbled in September of 1873[2] with the news of the collapse of a New York banking house. In a country overextended in speculative railroading, manufacturing, and grain farming, the bank failure set off a nationwide chain reaction of financial catastrophes. Indianapolis, as a developing industrial power, felt the impact of the Panic of 1873 almost immediately. Banks closed their doors, businesses became insolvent, payrolls were slashed, and unemployed men looking for work walked the deserted city streets.

Of the Hoosier Group artists, J. Ottis Adams, who was studying at the South Kensington School of Art in London, was the least affected by this economic depression. Steele and Gruelle, who were trying to establish themselves as portraitists in the Midwest, took on a variety of odd jobs to help support their families.

Steele teamed up with poet James Whitcomb Riley to decorate signboards in Indianapolis, and Gruelle, at various times, painted landscape scenes on steel office safes. Stark, still a teenager during the financial crisis, continued to work at his family's Indianapolis Cabinet Makers' Union, and Forsyth, wanting to supplement his parents' income, dropped out of high school to paint houses on the southside of Indianapolis with his brother.

The artists and their families survived the Panic of 1873 along with the residents of the Hoosier capital who ushered in the "city's springtime"[3] during the late eighties, nineties, and early years of the twentieth century. Once again, new industry brought prosperity to the city. Indianapolis was centrally located, labor was cheap, railroads were efficient, and the town's population was increasing each day. The Hoosier capital had become the place to live. There were the elegant hotels, the fine restaurants, and the stylish ladies and gentlemen riding around the city Circle[4] in hansom carriages. There were the magnificient buildings constructed with little regard for cost, the exciting theaters, and the lively bustle of thriving urban life.

Indianapolis had grown. From a log cabin settlement carved out of the wilderness[5] in 1820, the state capital had become a metropolis, by 1890, of some twenty square miles and one hundred five thousand inhabitants. Sixteen railroad lines crisscrossed the city, and seven newspapers, two of which were printed in German for the area's large immigrant population, were published daily.

There was always a variety of leisure activities in this town which enthusiastically embraced the introduction of the safety bicycle and the debut of golf during the 1890s. Cheering on Butler University's rugby team, attempting the newly introduced game of tennis, playing

Académie Julian student publication, Paris.

Forsyth surrounded by student easels during his teaching days at the John Herron Art Institute. Indiana University-Purdue University at Indianapolis Archives.

croquet, and watching the city's professional baseball team occupied the time and interest of sports-minded Indianapolis residents. More sedentary Hoosiers joined one of the many clubs which were in vogue at the turn of the century. Among the best known were the Indianapolis Literary Club, the Portfolio Club, the Indianapolis Woman's Club, the Fortnightly Club, the Matinee Musicale, and the Dramatic Club which presented one-act plays written by its members.

At the heart of the city's cultural life during these vibrant times were the five Hoosier Group artists who found themselves attracted to the artistic challenges presented by their state. Instead of locating in the East upon the completion of their foreign work, Steele, in 1885; Forsyth, in 1888, and eventually Stark, in 1893, settled in Indianapolis. Adams began teaching classes in nearby Muncie, Indiana,[6] in 1887, and Gruelle, who was largely self-taught, had begun working in Indianapolis in 1882.

During these "Golden Years"[7] in Indianapolis, Steele established his reputation as one of the premier portraitists in the state, painting many of its best-known men and women. Gruelle's critically-acclaimed *Notes: Critical & Biographical* was published in 1895, and Stark, with his appointment as the Supervisor of Art at Manual Training High School, changed the course of art instruction in the Indianapolis public schools. Both Adams and Forsyth took their turn as principal instructor of drawing and painting at the city's John Herron Art Institute, officially opened on March 4, 1902, by the far-sighted Art Association of Indianapolis.[8] Adams served on the Institute's faculty until his retirement in June of 1906 when he was replaced by Forsyth who, during his twenty-seven-year tenure at the school, was to become one of its leading professors.

The residents of Indianapolis were not alone in acknowledging the importance of art in their community; public-minded citizens throughout the state joined to celebrate this world of beauty. In 1888, the Fort Wayne Art Association was organized; in 1892, the Muncie Art Students' League; in 1895, the Progress Club of South Bend; and, in 1898, the Lafayette Art Club. One of the more prominent groups of the era was the Art Association of Richmond. Founded in 1897 and widely admired for its exhibitions, the Association annuals drew work from Indiana painters as well as from such national artists as William Merritt Chase, Frank Duveneck, Childe Hassam, Edward Henry Potthast, George Inness, and Frank Benson.

The tranquil pace of early twentieth-century Hoosier life was scarcely disturbed by the outbreak of war in Europe in 1914. With President Wilson's declaration of war in 1917, however, Hoosiers put aside their political differences to unite in support of their country. Ninety thousand men from the state were drafted for military service, and forty thousand more volunteered. Although too old to be involved in combat, the Hoosier Group artists who were still living in Indianapolis patriotically devoted their time and talents to the war effort. The fifty-eight-year-old Stark teamed up with the sixty-three-year-old Forsyth to design posters for the war bond campaigns as well as to paint a massive signboard for an American Red Cross fund-raising drive.

Soon after welcoming home the state's war-weary veterans, Indianapolis celebrated its one-hundredth birthday in June of 1920 with nearly a week of pageants, speeches, church services, and music. From the serenity of retirement, Steele, Stark, and Adams watched the opening years of the Roaring Twenties with bemused detachment. Forsyth, however, who was still teaching at the Art Institute, was caught up in the dizzying social changes of the decade marked by Hoosier Hoagy Carmichael's jazz, bootleg whiskey, Prohibition scandals, and the silver-toned voice of radio.

J. Ottis Adams relaxing in his studio in Muncie, Indiana. Caroline Brady Papers.

Of the members of the Hoosier Group, only Forsyth was alive to feel the crushing weight of the Great Depression. As the effects of the 1929 stock market crash swept across the nation, banks failed, factories closed, jobs became scarce, and wages were cut. Forsyth himself was not immune to the ravages of the economic breakdown; he was relieved of his position at the Art Institute at the close of the 1933 spring term. The Depression years were harsh ones, bringing hardship and suffering to a great many Indiana families. The Hoosiers survived, nevertheless, and with a unique blend of traditional log-cabin individualism and determined community spirit, they worked together to move their state into the economic recovery of the next decade.

Along with Indiana's growth as a state had come, on the part of its citizenry, a deep appreciation and a willingness to nourish the literary and artistic work being created within its boundaries. A number of the authors publishing during Indiana's "Golden Years"—Theodore Dreiser, Booth Tarkington, Lew Wallace, Gene Stratton Porter, Charles Major, Edward Eggleston, Maurice Thompson, George Ade, Meredith Nicholson—wrote for readers drawn by the virtues of pioneer existence, the stability of middle class values, the lure of historical adventure, and the simple pleasures of rural living. Indiana's poet laureate James Whitcomb Riley appealed to many of these same people with his unerring ability to weave images of homespun good cheer and a common man's cares in colloquial verse.

The poetry and novels of Indiana were, for the most part, rustic, romantic, and often full of nostalgia. They offered memories of things past in a world in which the unhurried pace of the farm and small town was being exchanged all too quickly for the busier life of the city.

Hoosier artists, working alongside their literary brethren during the first years of the twentieth century, mirrored, in their paintings, the writers' fascination with Indiana. Choosing to remain in the state after returning from art study abroad, Steele, Stark, Adams, and Forsyth joined Gruelle in dedicating themselves to picturing the pastoral landscapes of Indiana. What the writers achieved with words, these painters accomplished with oil and watercolor as they sought to immortalize the common scenes, the everyday experiences, and the quiet beauty of their state. Encouraged by a supportive public and by generous patrons who helped further their training, the Hoosier Group members worked steadfastly to bring artistic recognition to themselves and to their native land.

## Notes

1. The origin of the word "Hoosier" as describing a resident of Indiana is unknown. One popular explanation holds that Indiana was nicknamed the Hoosier state for the strong-armed pioneering "hushers" who could effectively "hush" an opponent in a wrestling match at one of the early territorial logrolling contests. Another theory maintains that visitors, upon hailing a frontier cabin in the area, were usually greeted by a "Who's yere," with Indiana becoming known as the "Who's yere?" or Hoosier state. Yet another legend focuses upon a contractor named Hoosier who was employed on the construction of the Louisville canal. Hoosier apparently preferred to hire workers from Indiana; thus, his employees became known as "Hoosier's men" and then simply as Hoosiers. After noting that the word "Hoosier" was used in many parts of the nineteenth-century south to describe rough hill men, Jacob Piatt Dunn, secretary of the Indiana Historical Society for a number of years, traced the word to "hoozer" from a dialect in England's Cumberland district. Dunn theorized that the descendants of the English immigrants had brought the name with them when they had settled the southern Indiana hills.

2. The financial ruin triggered by the New York bank failure quickly became known as the Panic of 1873. From 1873 to 1876, nearly one thousand Indiana businesses went bankrupt.

3. To Hoosier author and political leader Claude Bowers, this period was the "city's springtime" when "men found time in the evening 'to read the *News* and to stroll across the velvety lawns to their neighbors' to exchange views of what they read.'" Edward A. Leary, *Indianapolis: The Story of A City* (Indianapolis: The Bobbs-Merrill Co., Inc., 1971), 135.

4. Governor's Circle was the site of a poorly designed, never-occupied governor's residence which had been built in 1827 pursuant to Alexander Ralston's city plan. The house was used for public meetings and as office space for the state Supreme Court justices until it was demolished in 1857. For several years after the house had been razed, the Circle was a dirty, treeless expanse where cows were left to graze. Finally, in 1867, the City Council tired of the unsightly property and ordered the Circle to be graded, fenced, and encircled with a sidewalk. The grassy, well-kept area was used as a downtown park until the construction of the Indiana State Soldiers' and Sailors' Monument. The gray oolitic limestone monument, one of the first memorials in the nation to pay tribute to the common soldier and sailor, was dedicated on May 15, 1902. For a definitive discussion of Monument Circle, see Ernestine Bradford Rose, *The Circle: The Center of Indianapolis* (Indianapolis: Crippin Printing Corp., 1971), 6-12, 43-58.

5. At the conclusion of the War of 1812, Indian uprisings occurred only occasionally in Indiana for twenty more years. Slowly the Indians were driven out of the state, which had been admitted to the Union in 1816, by a series of federal treaties with the Indians between 1818 and the late 1830s.

6. Muncie, in 1887, was one of several mid-state farm towns whose fortune was dramatically changed with the discovery of a natural gas field in the area in 1886. Industries relying heavily upon heat in their manufacturing processes—tinplate, glass, and strawboard—flocked to east-central Indiana where investors rushed to buy up land, housing became scarce, and farm lads thronged to the prospering cities, hoping for a job in one of the new factories. Among those companies to locate in Muncie was Ball Brothers, an enormously successful family enterprise which moved its glassworking operations from Buffalo, New York, to Muncie in 1887. Today, Ball Corporation is one of the nation's top manufacturers of high-quality commercial glass containers and a leader in the fields of high technology and aerospace.

7. Leary, *Indianapolis*, 135.

8. Beginning with the opening of the John Herron Art Institute in March of 1902, the Art Association of Indianapolis has shepherded the art museum and school through the construction of a new facility in 1906, the building of an addition in 1928, and, under the distinguished directorship of Wilbur Peat, a permanent move to the Lilly estate north of 38th Street. In 1968, the museum officially separated from the art school and changed its name to the Indianapolis Museum of Art. The former building at 16th and Pennsylvania Streets remains the Herron School of Art which is now associated with Indiana University-Purdue University at Indianapolis.

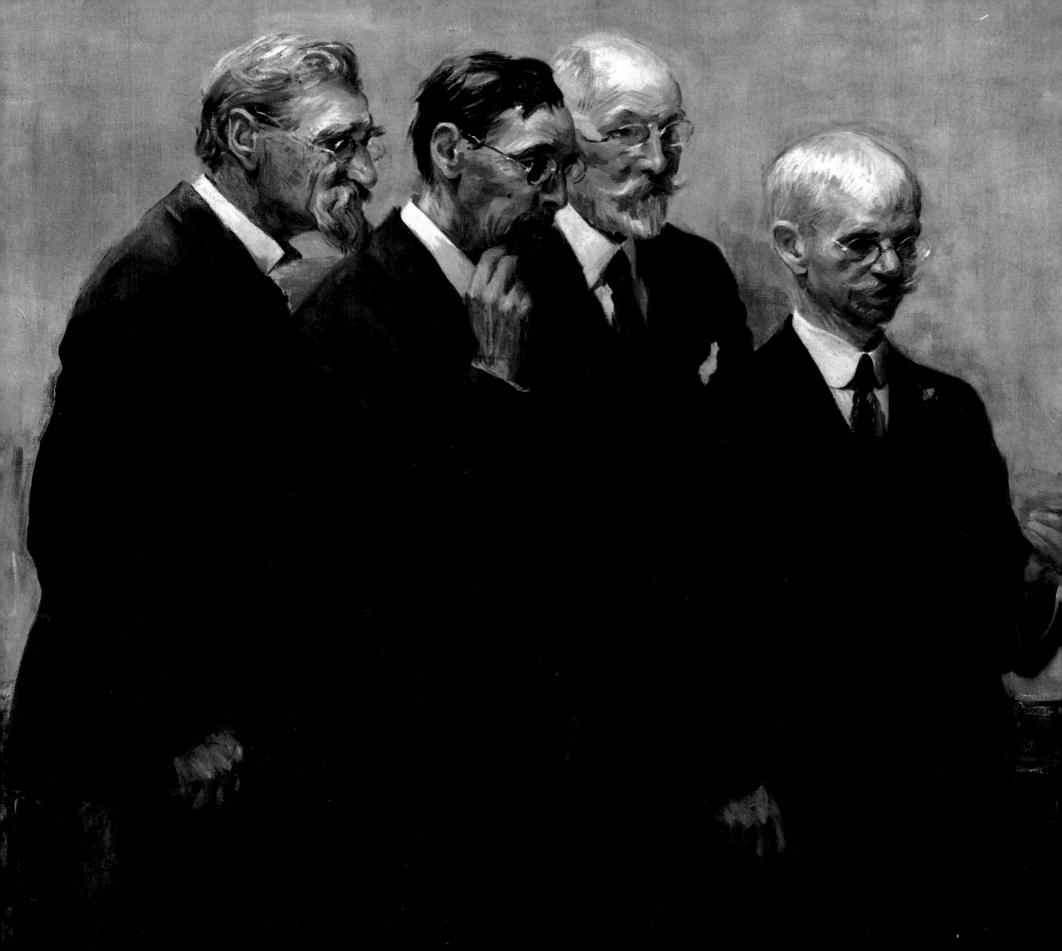

(detail)
**Wayman Adams**
*The Art Jury.*
Oil on canvas
82 x 54 inches
Indianapolis Museum of Art,
Popular Subscription

# The Hoosier Group Artists   Their Art in Their Time

**William H. Gerdts**
Professor of Art History
Graduate School of the City University
of New York

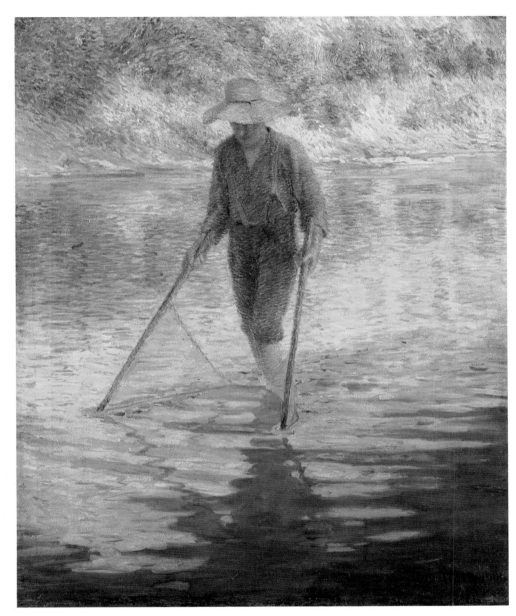

*The Art Jury*, a portrait study of Theodore C. Steele, J. Ottis Adams, Otto Stark, and William Forsyth, was painted from life by Wayman Adams during the winter of 1921. According to one of Richard B. Gruelle's sons: "Wayman always expressed his regret to me that R.B.G. (who had died in 1914) was not included."

The notes for the Introductory Essay begin on page 32.

**Otto Stark**
*The Seiner.* 1900
Oil on canvas
27 x 22 inches
Mr. and Mrs. Clarence Long

It is important for the understanding of the contribution made by the five painters of the Hoosier Group to comprehend the state of the art world in the late nineteenth century—in their own region of Indiana, in the nation at large, and, indeed, in the Western world. Works of art had been both imported into and created in the New World as early as the seventeenth century and even earlier, if one also considers the pictorial reports of explorer-artists of the previous century. By the time of the Civil War, the new nation of the United States had created a relatively mature, albeit provincial, expression in almost all the art forms. Yet that expression *was* provincial, a relative insularity which was occasionally exposed both by the reports of perceptive commentators travelling abroad and viewing such shows as the annual Salon exhibitions in Paris and those at London's Royal Academy and by the appearance, in the few commercial art galleries and elsewhere, particularly in New York City, of fully realized examples of academic art by painters of the French School such as Horace Vernet, Paul Delaroche, and Ary Scheffer. Mid-century American aesthetic attitudes were also shaped by an aggressive and perhaps excessive nationalism which often vaunted the best of our own provincial artists as superior or at least equal to their European contemporaries. This nationalism decreed that the art produced by and reflective of our democratic processes and/or inspired by the virgin, untrammelled wilderness handed down by the deity as a bountiful second Eden could not help but surpass the hackneyed forms and ideas of European art.

All this changed after the Civil War, although the seeds of change were occasionally sown earlier. The role of the great conflict in stimulating the transformation of our cultural attitudes and expression, however, is beyond the scope of this essay. The Civil War may or may not have created some degree of disillusionment with nationalistic ideals which had previously held sway, but it certainly helped to bring about new bases for wealth and a shift in economic patterns. These in turn were both based upon and also stimulated greater efficiency in transportation, communication, and a greater integration of the whole skein of the American way of life with that of the Western world at large. All of these changes could not help but be reflected in the artistic concerns and ambitions of our painters and sculptors, and certainly also in the attitudes of American art patrons.[1]

The primary characteristic of post-Civil War American art is its conscious cosmopolitanism. Our artists had travelled abroad to see the sights, the landscape, and the Old Masters of Europe earlier, and some, although relatively few, had studied there, entering European academies or occasionally working individually under a recognized European master. But immediately following the end of the war—Thomas Eakins, who went off to Paris in 1866, was one of the first—our young artists and art students began a veritable migration to Europe, particularly to the art schools of Paris and Munich. There they sought the degree of professional training that had been unavailable for them at home even in the academies in New York and Philadelphia, but that had been the heritage of their foreign peers for generations. Many of these young Americans, men and women alike, succeeded; they were able to create major exhibition pieces which were hung in the Salon exhibitions, awarded prizes, noticed and discussed by the critics, and reproduced in the publications devoted to the Salon. Some few works were even acquired by the French state, and others were either bought up abroad, particularly by wealthy Americans, or sent back to the major exhibitions held in New York, Philadelphia, and occasionally elsewhere in this country where the success and fame they had previously

garnered served them in good stead in regard to both notoriety and patronage.

Moreover, this was the central core in the development of a highly complex system of artistic professionalism which attempted and, by and large, succeeded in reproducing the sense of an "art establishment" already in force abroad. The few commercial American art galleries of the earlier years of the century multiplied many times over, often introduced as branches of well-known European concerns. Newspapers increased their coverage of artistic matters as did the general magazines, while there arose a tremendous proliferation of specialized art periodicals, heretofore almost unknown in the United States. Concomitant with that was the institutionalization of the profession of the art critic, no longer an amateur or the magazine editor taking on an occasional critical role, but rather men and women who were seriously devoted to the arts and to writing about them as a full-time vocation.[2]

Indeed, the arts became institutionalized beginning in the late 1860s. The first major art magazine of the period was the *Aldine*, which was published for a decade after 1869, and it was followed by the *Art Interchange* in 1878 and *Art Amateur* the next year, both much longer lived. That same decade witnessed the birth of the American museum movement with the founding of the Museum of Fine Arts in Boston and the Metropolitan Museum of Art in New York City, both in 1870. New societal institutions of professional artists, which were more conducive to the new cosmopolitan artistic currents, were founded to challenge the traditional supremacy of the National Academy in New York and the Pennsylvania Academy in Philadelphia. Organizations such as the Society of American Artists in New York, founded in 1877, and its counterpart, the Philadephia Society of Artists, which began to have annual exhibitions in 1879, flourished. Specialized institutions appeared too, such as the American Society of Painters in Water Colors, founded at the end of 1866, the New York

Etching Club, founded in the winter of 1877-78, and other organizations dedicated to promoting the art work of women, such as the Ladies' Art Association in New York, founded in 1867, and the Society of Decorative Art, organized in 1877.

These last were all centered in New York City, but soon their counterparts could be found in many other metropolitan areas. The same was true for the proliferation of professional art schools. The old academies previously mentioned, the National and the Pennsylvania, were institutions providing artistic instruction as well as annual exhibitions. But as our younger artists returned with the fruits of their expert training at the Royal Academy in Munich or at the École des Beaux-Arts or the various academies such as Julian's in Paris, they organized new schools modeled upon these foreign counterparts. These new schools, such as the Art Students' League in New York, founded in 1875, became places where professional methodologies could be propagated, and, at the same time, the young, trained American could be provided with a supportive income. Indeed, the success of these schools was sufficiently great that the need for actual European training appears to have substantially diminished by the end of the century, although the lure of Europe itself always remained.

All these changing conditions in the fabric of the American art world in the decade and a half after the close of the Civil War inevitably related to the patterns of art patronage. A new, incredibly wealthy class rose up, short on establishment and tradition, but long on social ambitions and the means to achieve them. One of the signs and hallmarks of that achievement was the amassing of a large collection of fashionable paintings and sculptures with which to adorn their newly created chateaux on the great metropolitan avenues. These new collectors cared little for the traditional,

nationalistic American art or for its creators—a few painters such as William Trost Richards somehow maintained their favoritism—and, indeed, preferred contemporary French painting above all, choosing the academic artists such as Jean Léon Gérôme and William Bouguereau, and, depending upon individual taste, the Barbizon landscape masters. The American painters were not necessarily neglected, however, as long as they had undertaken professional foreign training and had proven their mastery of it with critical exhibition success abroad.

On the basis of their foreign training, the thematic concerns of American artists changed radically beginning in the 1870s. They shifted away from the predominant portraiture, native landscape tradition, and nationalistic, anecdotal genre to an emulation of those subjects emphasized by their European confreres. American artists undertook ambitious, multi-figured historical paintings, although only occasionally, and related figural religious pictures were not uncommon. Genre subjects—scenes of everyday life—continued to be standard in the pictorial repertory, but they were now life-size and often with historical overtones since the category of "historical genre" had become a popular one. Particularly prevalent were peasant subjects, which proliferated in France and Germany after the mid-century introduction of rural genre by the French painters Millet and Courbet, although the Americans related more to the second-generation French specialists such as Jules Breton and Jules Bastien-Lepage, creating images at once more individual and occasionally sentimental.[3]

Many writers opined at mid-century that the predominant artistic form in American art was landscape. Landscape continued

to be an important concern for our artists in the last three decades of the century, although figure painting, on the basis of academic training, may have superceded landscape in popularity. In any case, the tight, meticulous approach to rendering the American landscape in great detail was superceded by a more introspective, mood-producing interpretation of Nature for her own sake, with forms more generalized and with an absence of earlier anthropomorphizing. This approach to landscape was inspired by the French Barbizon artists such as Camille Corot and Theodore Rousseau. By the end of the century, there had developed an even more rarified approach to the interpretation of Nature, known as Tonalism, with a poetic emphasis upon minimal forms, often evening and autumnal settings, and with a concentration on a single, dominant, harmonious hue, often of grays, russets, or blues. Tonalism may be a more indigenous art form than most that developed in America, but it too had its ultimate antecedents in French Barbizon art and also in both the nocturnal art of Whistler and the silver-gray settings of the peasant genre pictures of artists such as Bastien-Lepage.

However, in America, both Barbizon and Tonalist landscape gave way to the astounding and quite sudden impact of Impressionism, the bright colors and sparkling light of which first became well-known in this country in 1886 when the French dealer, Paul Durand-Ruel, brought over a collection of some three hundred French Impressionist paintings and showed them in New York. This was followed by the return of increasing numbers of American painters who had gone to Europe to study in the academic ateliers, but who were seduced away from traditional forms by the lure of Modernism in the form of Impressionism. Artists such as Childe Hassam and Theodore Robinson exhibited their Impressionist pictures in New York, Boston, and elsewhere beginning in the late '80s, and while they met

**Otto Stark**
*Qui Vient?* 1886
Oil on canvas
31 x 22¾ inches
In collection of Mrs. Leland Howard

with some critical opposition, by the time of the Columbian Exposition in Chicago in 1893, Impressionism had all but triumphed in America.[4]

These developments, outlined above, may have first impacted in the major eastern cities of Boston, Philadelphia, and New York, but, by the late nineteenth century, they were quickly reflected throughout the nation. The great Columbian Exposition, after all, took place in the American heartland. Before 1870, however, professional artists tended to concentrate in only a few large eastern metropolitan centers. Some cities, such as Charleston, South Carolina, and Annapolis, Maryland, gradually even lost some of their cultural commitment to attract artists, while other such as Baltimore supplanted them. Beyond the Atlantic seaboard, New Orleans was an isolated enclave of predominantly French-inspired culture with some first-rate portrait painters in residence and the beginnings of a local landscape school originated by the finest of them all, Richard Clague. And when San Francisco suddenly became the center for wealth and commercial activity, following the discovery of gold in California in 1848, numbers of painters flocked to the region, some drawn by the twin lures of potential patronage and the gold fields.

The Midwest was not without economic and cultural centers, and, therefore, it was not without its artists. Cincinnati was known as the "Athens of the West" from the 1820s, and hosts of young painters and, surprisingly, even more sculptors rose up to local prominence there, although nearly all of them subsequently pursued their careers in the East or in Europe. St. Louis, further west at the confluence of the Mississippi and Missouri Rivers, was the other thriving center in this large region, and it was the home of artists as well. The prominence of her great master, George Caleb Bingham, the first interpreter of what was then "western" life, has blinded us to the richness of other artistic endeavors there—able portraitists such as Sarah Miriam Peale and Manuel De

Franca; still life painters such as Hannah Skeele; the Indian subject specialist, Carl Wimar; and other genre artists such as James F. Wilkins and William Brickey, the latter a sometime-follower of Bingham[5]

Outside of these larger urban centers, however, art was carried out in this country on a haphazard basis before 1870. It consisted, for the most part, of portraiture, often practiced by itinerants who traveled door-to-door or who, in somewhat larger communities, set up a temporary shop in a hotel room and advertised for customers in the local newspapers. Occasionally, some of these artists found business sufficiently lucrative to remain for a couple of years, and, in any case, they often established a "home base" from which they conducted their travels. Such, for the most part, was the pattern in Indiana where the great majority of pre-Civil War painting consisted of portraiture, with only a rare, occasional foray into the recording of the local landscape. The artists of these portraits and landscapes were often anonymous, and, if they were identified, they were usually untrained, self-trained or minimally-trained painters, at best semi-professional or semi-primitive, depending upon one's point of view. Horace Rockwell, working in Fort Wayne, was one of the best and most appealing of these.

Only a few Indiana painters appear to have aspired to greater esteem, wider creative range, and professional recognition. The earliest of these was English-born George Winter who spent the third quarter of the nineteenth century, until his death in 1876, in Lafayette where his portraits are overshadowed today by his landscapes and Indian paintings. Even Winter, although he was a professional and trained in his native land and then at the National Academy of Design schools in New York, was still a provincial, though able artist, most significant to us for the pictorial records he left of the life and appearance of early Indiana.[6]

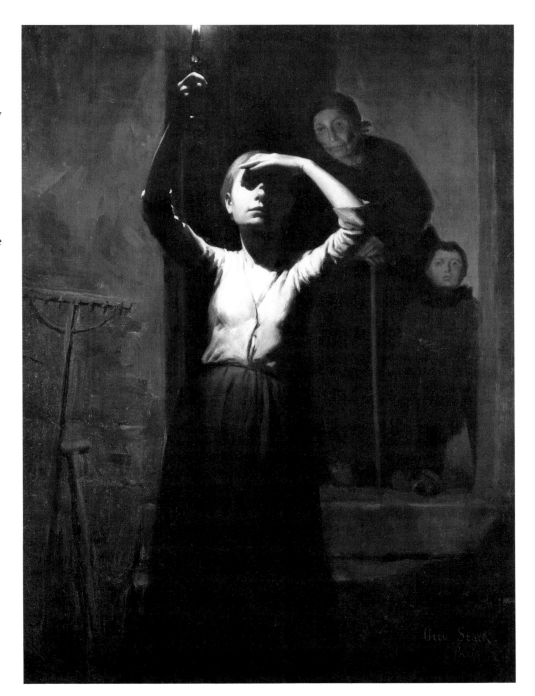

**J. Ottis Adams**
*Clock Apprentice.* **1884**
Oil on canvas
22½ x 17 inches
Private Collection

Indianapolis was made the state capitol in 1820, and the amenities of life grew rapidly along with the city's population. At first, again, there were the itinerant portraitists, the most able of whom was John Insco Williams, a Cincinnati artist who occasionally painted across the state border beginning in 1835. Jacob Cox arrived from the East earlier, in 1833, and he made Indianapolis his home, developing into the city's first professional resident artist, although he was self-taught. Cox was an able portraitist and an occasional landscape and still life painter, but his lack of technical training was a limitation which prevents his often charming work from rising above the category of the provincial. A more proficient artist, and a more influential one, was Barton S. Hays, an Ohio-born painter who came to Indiana about 1850 and settled in Indianapolis in 1858, remaining there, for the most part, until 1883. Hays too was self-taught and, like the others, was primarily a portraitist, but he worked in a more assured, if not necessarily inspired, technique. He was also, surprisingly, a first-rate still life painter; thus his greatest fame in the annals of American art today is as the first teacher of William Merritt Chase who himself started out working at still life. Hays was a younger artist than Cox and could better provide an initial role model for some of the younger Indiana artistic aspirants such as William Forsyth who visited his studio early on. Still, even Cox and Hays could ultimately represent only the narrow provincialism against which the young men of the Hoosier Group would react and whose limitations they would hope to surmount.

A major means of transcending those limitations was to be found in professional training. Only Richard Gruelle, among the members of the Hoosier Group, was, like Cox and Hays, self-taught. All four of the other members of the group had not only professional but foreign training; this must, in fact, be an important reason for Gruelle's lesser impact upon Indiana art than that of Stark, Forsyth, Adams, or,

especially, of Steele. Of these four, all but the first sought their most significant training in Munich, Germany.[7]

It is difficult to estimate how talented the Hoosier painters were before they went abroad. Their initial training was strikingly dissimilar: Steele had local lessons and further study in Chicago; Forsyth's was the most Indiana-based with John Love at the Indiana School of Art; Adams studied at the South Kensington schools in England; and Stark had the most complete training— about as thorough as one could have found in this country around 1880—working at the School of Design of the University of Cincinnati and then becoming a pupil of the Art Students' League in New York City in the early years of that progressive institution. Certainly, all four of these men must have learned the rudimentary factors of art in these beginning years and, probably, a good deal more. Undoubtedly, certain impulses and influences were already formed in these years in regard to stylistic and thematic preferences. Too little work of their pre-European days is available, however, to estimate their initial directions, and, in any case, the impact of Europe was to be crucial upon all of them.

What may, at first, seem most surprising is that, given the literally thousands of Americans who went to Paris to study at the end of the century, three out of four of the European-trained Hoosiers went instead to Munich. Yet this was not at all unusual at the time, and it was a meaningful factor in the artistic development of the Midwest. In the post-Civil War years, Munich was second only to Paris as a magnet for American artistic aspirants, but it was, indeed, second. But, while this probably held true even when analysis is focused more narrowly on artists from the Midwest—from, let us say, Pittsburgh to

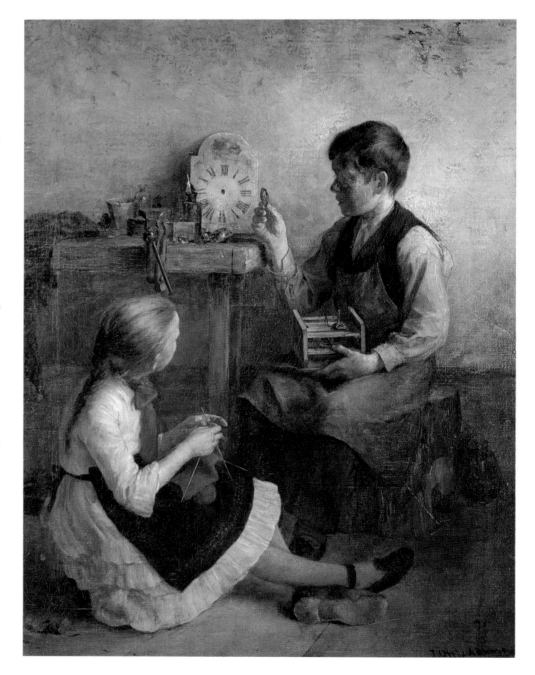

St. Louis—the proportions almost surely narrow. While many midwestern artists sought their training in Paris, and while some young art students from the East Coast and also from San Francisco studied in Munich, the Royal Academy there drew especially upon the Midwest for its American enrollment.[8]

While no single factor may be introduced to account for each determination to study in Munich, the most important consideration was the large Germanic enclaves which were found among the population of numerous midwestern communities. Families of Germanic heritage most often urged their children and grandchildren to seek training in their homeland, and often, although not always, the younger generations had at least a smattering of the native language to assist them in such relocation. Sometimes, too, distant members of the larger family still resided in the native land to offer some initial welcome. Furthermore, families who were not openly hostile toward the artistic profession in the first place—and many were—would find greater comfort and offer greater encouragement for artistic pursuit in a land reputed for a combination of industriousness and moral probity. They would choose Munich rather than a city such as Paris whose reputation for temptation and licentiousness matched the general critical estimation of French art as technically proficient, but devoted to the combination of explicit brutality and unabashed eroticism.

Furthermore, the tradition of a midwestern migration to the Royal Academy in Munich had begun even in the 1860s, with Frederick Freer of Chicago matriculating there in 1867 and Charles Reinhart of Pittsburgh, in 1868. But most important as role models for the Indiana painters was the success of Frank Duveneck of Cincinnati, who left for Munich late in 1869, and Indiana's own William Merritt Chase who began his studies there in 1872.

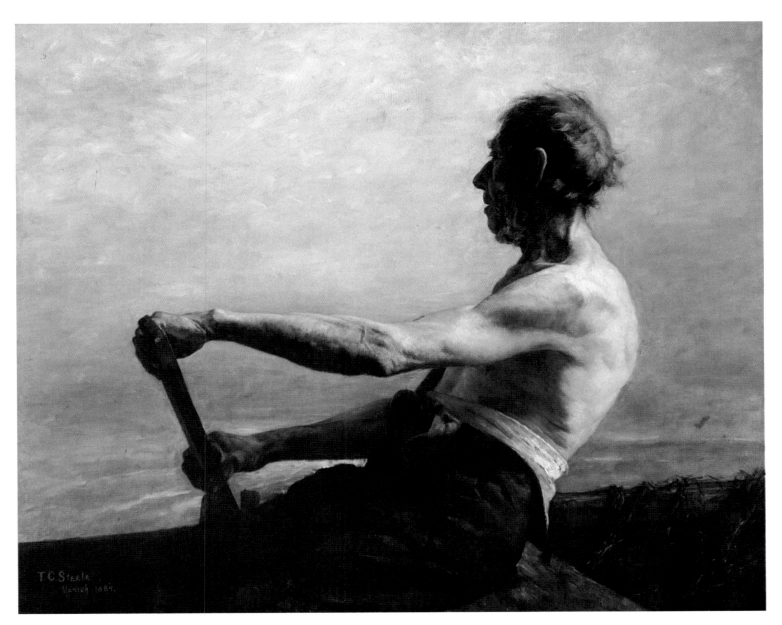

By 1880, when Steele and Adams left for Germany, along with Samuel Richards and several other Indiana artists, Duveneck had not only been recognized back home as a successful practitioner of a distinctly Munich proficiency, but had, in turn, attracted a large group of primarily midwestern followers back in the Bavarian capital. And the success of Chase, particularly, in the first exhibitions of the newly-founded progressive Society of American Artists in New York, had led that organization of European-trained painters and sculptors, however incorrectly, to be judged as dominated by the practitioners of "the Munich style."

It is important, however, to realize of what Munich art consisted because considerable confusion has arisen in regard to its characteristics. Just as Americans went to Paris to become proficient in academic artistic processes, however much they might be lured away from the traditional paths by the modernistic attractions of Impressionism, so our young artists went to Munich to become adept primarily in figure drawing, construction, and composition, taught by such masters at the Royal Academy as Wilhelm von Kaulbach and Karl von Piloty, artists renowned for their multi-figured historical compositions. David Neal, who went from California to Munich as early as 1861, was probably the first American attracted to Munich teaching, and, like many, he remained faithful to its academic procedures and subject matter. But some of those Americans, such as Duveneck and Chase who entered the Academy at the beginning of the '70s, took the requisite classes and learned the requisite techniques, only to be additionally stimulated by the dissident group of German art students who surrounded the young radical painter, Wilhelm Leibl. Leibl himself had been recently inspired toward an emphatic Realism based upon lower-class subject matter by contact with Gustave Courbet and his works. Duveneck became part of the "Leibl-Kreis" or "Leibl-Circle," and, in turn, Chase, Walter

Shirlaw, J. Frank Currier, and others followed suit. Their work, like that of Leibl and other young German artists in the early and mid-'70s, was effected in a bravura technique of dashing brushstrokes, dramatic tonal contrasts of strong chiaroscuro and minimum color, and a vibrant spontaneity devoted primarily to figural subject matter and occasionally to landscape and still life. The technical forebears for this art lay not in a Germanic tradition, but immediately in the art of Courbet and Manet and ultimately in Dutch seventeenth-century precedence, the painting of Frans Hals and Rembrandt.

This aspect of the "Munich Style," however, was never espoused by the Academy or taught there. While this bravura approach to so-called "finished" paintings contributed to the controversy over the espousal of the sketch and "sketchiness" in the on-going critical debate in the late nineteenth century, even Leibl himself abandoned this spontaneous, painterly approach after about 1876, referring his art back to the native tradition of Hans Holbein, although he remained devoted, for the most part, to peasant subject matter. The Americans too, such as Duveneck and Chase, gradually ameliorated the extremes of the Munich-derived Leibl style.

By the time the Hoosiers arrived in Munich in 1880, Duveneck and Chase were, indeed, gone. Duveneck, with some of his American followers, was working in Italy in Florence and Venice, and Chase was back in New York. In any case, when Adams and Steele arrived in Munich in 1880, and Forsyth, early in 1882, they had come to learn their profession at the great Munich art school, not to apprentice with their fellow countrymen. They began by entering a basic class in drawing, which was the beginning of the academic process, however well they may have drawn previously. Interestingly, however,

their instructors were not Germans. Gyula Benczur, who taught Steele, Forsyth, and Adams, was one of the leading Hungarian artists of his time. He was "Germanic," if you will, by virtue of his Austro-Hungarian nationality, but not German. When, in fact, Benczur returned to Budapest to head the local academy in Budapest, his place at the Royal Academy was taken by another "foreign" artist in Munich, Nikolaus Gysis, the most significant Greek artist of the century. Nor was this connection fortuitous, for the Bavarian royal family had initially provided the head of state for the modern Greek kingdom in 1832, and ties between the two nations had remained strong, politically and culturally, throughout the century.

Both Benczur and Gysis were teachers of drawing, and one might question the impact of their own painting upon the mature art of the Hoosiers. There might well have been an empathetic response, subconsciously at least, for both the Indiana men and their first teachers were foreign to the Bavaria where they worked. While Benczur specialized in historical tableaux which seem never to have attracted the Hoosiers, Gysis represented the dominant direction of Munich art of the later 1870s and '80s: precisely rendered figural genre, sometimes of peasant subject matter, inspired by the "Little Masters" of the Dutch seventeenth century. This same approach to painting dominated the art of Wilhelm von Diez, the leading painting teacher in Munich during the years the Hoosiers were there. Diez, himself, appears to have had little interest in the radical experimentation of the Leibl-Kreis, but while his own art was primarily devoted to historical genre in a crisply precise manner, he appears to have given his students great leeway in their painterly approaches. A protracted illness in the late '70s, however, led him to restrict his own teaching and to turn his classes over to his former pupil, Ludwig von Loefftz.

Loefftz, as a former fellow classmate and good friend of Duveneck, thus became a link between the Munich-Americans of the early '70s and those of the '80s, including the Hoosiers who studied under him—Steele in 1881 and Adams and Forsyth in 1883. His best-known painting, *The Lamentation of Christ*, painted in the latter year, suggests an artist drawn to dramatic chiaroscuro derived from the study of baroque models and rendered in a broader, more painterly manner than Diez's work, although Loefftz's paintings are little-known today.[9]

Still, while the young Hoosier artists in Munich were not yet up to the rendering of strong emotive themes such as Loefftz's *Lamentation* and may well not have been interested in such traditional subject matter in any case, works such as Forsyth's *Old Man*, Steele's *Study of Negro*, and his famous *Boatman*, the last two both of 1884, suggest the Munich manner and Loefftz's influence in particular. There is a conscious avoidance of ideality of form and type, although all three figures are rendered with great dignity. Forsyth stresses the sagging flesh of his elderly model in a manner not unrelated to baroque types of the Spanish artist, José de Ribera, and Steele's gaunt boatman displays a profile deliberately unclassical. These would be Munich, as opposed to Parisian, characteristics, as would be the emphasis upon all three heads as "character studies," a concern more for individuality than ideality. Formally, the espousal of strong light-dark contrasts, the elimination of seductive color, and the breadth of painterly treatment is again Munich and probably Loefftz. However, Steele, unlike Forsyth, in both of these Munich figure paintings and in others as well, favors a back-lit illumination, emphasizing a strong profile and a silver current of light along the facial edge with the rest of it plunged into shadow. This is strikingly dramatic and suggests a degree of formal experimentation which already marks him as the most innovative and perhaps forward-looking of the three Indiana men.

**William Forsyth**
*Old Man.*
Oil on canvas
28 x 23¼ inches
Private Collection, Zionsville, Indiana

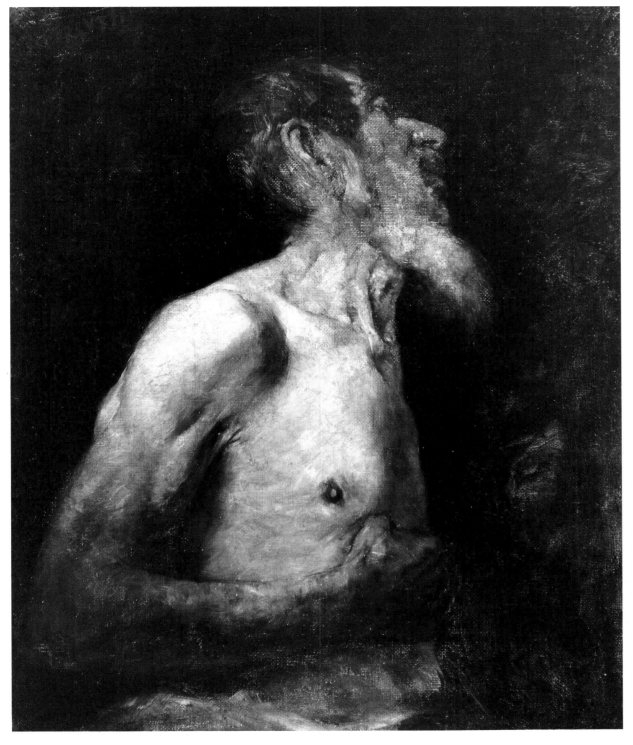

This approach to figural lighting and strong profiling, however, is primarily Germanic in origin. Numerous German genre paintings of the period feature a back wall plane punctured by glare-lit window panes through which light passes to silhouette the figures in the interiors, and similar effects hold force even when the light source is not distinguished. Steele's *Study of Negro* is rendered and lit in a manner which resembles the more picturesque *Ave Maria* of the German, Paul Hocker, a Diez student of the '70s.

Of course, the mastery of figural construction and composition was not an end in itself, but it was to be directed toward thematic expression. There, the Hoosiers were not inspired by the Grand Manner tradition of history or religious subject-matter, but rather by the more popular, contemporary theme of peasant genre, both indoor and outdoor. This, in part, was certainly reinforced by their residence in a number of the small, rural communities outside of Munich and by their daily exposure to peasant life. But the peasant genre tradition by the mid-1880s was an extensive one, in Germany as in France and elsewhere, and a thematic review of the work of many of the German students in Diez's class reveals a similar approach to sympathetic anecdote of restrained sentiment similar to Adam's *Clock Apprentice* of 1885 and to some of Steele's depictions of peasants in the Cloister interiors. What is most interesting and, at this stage, puzzling is that both the work of many of the Germans and of Steele as well is rendered in a broadly soft, painterly technique not especially associated with Diez. One may view this as heir to the transient radicalism of Leibl and his group of the early and mid-'70s, but this would not necessarily have impacted on these later artists. It may, again, be a stylistic evolution in the general recognition of the sketch as a valid end-product of artistic realization, and, in Steele's case, relate to his own specific Munich teaching under Loefftz.

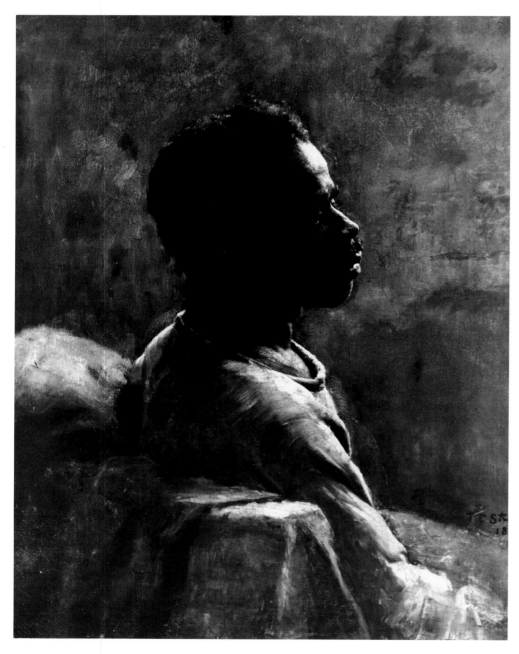

This greater freedom and breadth would seem to be even more characteristic of the outdoor work done in Munich by the Hoosiers, whether figural compositions, such as Forsyth's *Munich Woman Peeling Potatoes,* or Steele's rural landscape compositions, such as his *Road to Schleissheim.* The concern with mundane aspects of peasant living—peeling potatoes or hauling grain—had become a fascination for both artists and patrons by the 1880s when these works were created, and they were increasingly rendered in a broad, sketchy technique which quietly reinforced the fluidity of daily life. This was also true of the work of other Munich artists of the time—native, transient, or expatriate, such as Carl von Marr, probably the best-known of all the Americans to reside for decades in the Bavarian capital where he lived for almost sixty years. Marr's most famous work is a grandiose, historically naturalistic *Procession of the Flagellants* of 1889; yet, that same year, he painted a monumental peasant genre scene, *Evening,* in which the broader and more painterly treatment contrasts dramatically with the clear precision of his *Flagellants.* It is as if the two different themes allowed, or even demanded, distinct formal strategies.

In the case of the Hoosiers, however, the source for the fluid, and, at times, dramatic paint handling in landscape themes and settings is much more identifiable. Of the major Americans in Munich during the '70s, Duveneck, Chase, and Walter Shirlaw had all left that city when the Hoosiers arrived; only J. Frank Currier remained. Currier, too, was the American longest affected by the innovations of Leibl and his circle. He carried them on in Schleissheim during the '80s where he appears to have taught landscape, either formally or informally, and influenced the work of many newer American arrivals on the Bavarian scene. Currier's figure paintings in the manner of the bravura Munich work of Duveneck and Chase are nevertheless fascinatingly individual, but they do not concern us here. His Schleissheim landscapes, however, betray a boldness unparalleled at the time, certainly in American art, and they exhibit an expressive drama in rendering simplified landscape forms in charcoal, watercolor, and oil. While Steele might have consciously sought to emulate Currier and, at least, informally studied with him, Forsyth, on the other hand, reacted against Currier's slovenliness and lack of refinement in technique. The work of both painters and of Adams too, however, seems to have become indebted to this established master, particularly as seen in the illustrations which were reproduced in the important Indianapolis show, sponsored by the Art Association of Indianapolis in 1885, of the Munich work of Steele and Forsyth. Their work closely resembles Currier's art at the time. Currier's greatest brilliance, in fact, may have lain in his sparkling, dramatic watercolor landscapes, and it was Forsyth, more than Steele, who was practicing extensively in that medium at the time. His protests against the work of Currier may only have reflected a conscious anxiety to avoid too great a dependency or identification. Certainly, the expressive distortions and tendency toward formal experimentation which characterize Forsyth's later work, more than that of any of his Hoosier colleagues, is not unrelated to the very individual artistic tendencies displayed by Currier in Germany at the time.[10]

The work of the three Hoosiers in Munich necessarily was distinct even then, but our knowledge of their individual achievements is somewhat hampered by the relative paucity of these early works—more of Steele's Munich pictures seem to be known, certainly, than those of Forsyth or Adams. Still, Adams's *Nooning* of 1886, an important Munich canvas, is more traditional in both structure and expression than the relaxed and informal work of Steele and Forsyth. The relatively

**Otto Stark**
*French Garden.* 1887
Oil on canvas
18½ x 23 inches
Dailey Family Memorial Collection of Hoosier Art,
Indiana University

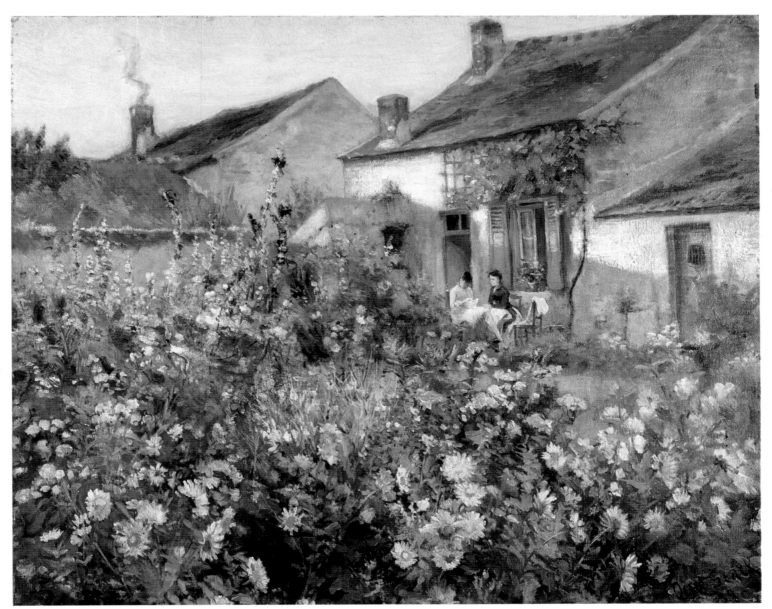

monumental peasant figures, their individual poses, and clear placement in the fields of grain are akin to the well-known contemporary work of Jules Breton in France, for instance, which the Hoosiers, even in Germany and perhaps earlier, would almost surely have known. Yet, this form of peasant genre was truly international. For artists working in Germany, the Berlin artist Max Liebermann, who often drew his peasant subjects from his visits to Holland, might well have provided a more immediate role model, and his well-known *Dutch Village Road* of 1885 exudes the same general spirit as Adams's *Nooning.* Both are ostensibly concerned with lower-class women engaged in farm work, but, in fact, the sense of toil is extremely mitigated; in both, rather comely, unweathered young women are chatting, perhaps gossiping. Adams's figures have taken a luncheon break and are disported almost as in a picnic scene, comfortably posed, while even the most heroic of these figures, in classical stance, supports a large bundle of grain on her head which actually acts also as a sun shield. The day is warm, the landscape is well ordered, and the colors are bright and comforting. The more strenuous exigencies of peasant life are totally absent.

In a larger sense, it was in their Schleissheim experience that Steele, Adams, and Forsyth became drawn to outdoor, rather than studio, painting, although Adams's *Nooning* was almost surely finally completed in the studio, even if based on field studies. The training at the Munich Academy was necessarily not only conducted in the studio, but was directed toward studio productions; landscape was never a primary, integral aspect of any academic training. The experience of painting out-of-doors, however, so eloquently reinforced by the example of Currier, and his role, whether as teacher, mentor, or advisor, paved the way for the whole-hearted commitment to outdoor painting and to a primary concern for the theme of landscape among the Hoosiers. It

is arguable, in fact, that it was the Munich experience that led, in part, to the innovative outdoor teaching of landscape in America during the 1880s and '90s, just as it may account for the relatively greater importance that landscape had for Steele, Adams, and Forsyth than for Otto Stark who trained in Paris.[11]

It must be emphasized, however, that the landscapes produced by Steele and the others, such as the *Road to Schleissheim*, were emphatically *not* Impressionist. Munich landscape was not at all involved with the French-derived Modernist aesthetic, and it is debatable whether any of the Hoosiers in Munich knew anything at all about the characteristics of the painting of Monet. Steele's *Road* is done in a painterly manner, but there is no divisionism in the brushwork, no concern for scintillating color, and he has again chosen back-lit illumination to throw the two long rows of leafless, gnarled linden trees into strong, dark relief in a thoroughly tonal manner. The strong shadows across the road create a right-angle foil for the plunging perspective of the road and its pattern of parallel ruts. Steele's German landscapes, however, may well have been "Impressionist" most in having been painted, even completed, outdoors rather than finished up, and certainly not composed, in the studio. This was Currier's practice. Ironically, he was one of the first American artists specifically dubbed an "Impressionist" in 1881 when several of his works were exhibited at the Society of American Artists. His work was also seen in these years at the annual shows of the American Watercolor Society. He was described then as believing "in the brush as an instrument for the expression of moods and feelings." It was this expressivity in paint handling, with its concomitant sketchy appearance of unfinishedness, that first provoked the term "impressionist" in American critical writing in the early 1880s before the actual concerns and formal concepts of the French Impressionists were truly known in

America. From that vantage point, though an incorrect one, Steele and his colleagues in Munich were also "Impressionists" at the time; they would go on to earn the *proper* designation in later years.[12]

Otto Stark's training differed quite radically from that of his later colleagues who studied in Munich. For one, it was more cosmopolitan even before he went to Paris in 1885 when he entered the Académie Julian, the training ground of hordes of Americans. Secondly, Paris in the 1880s was undergoing an artistic ferment comparatively unknown in Munich in the decade and compared to which even the anti-academic stance of the Leibl-Kreis would seem both isolated and transient. Indeed, by 1885, Impressionism, as a cohesive movement, was all but over. The original group would have only one more exhibition in 1886, and even then that coterie would be drastically transformed. The show would usher in the more radical forces of Post-Impressionism, although few Americans would immediately respond to the art of Seurat or Gauguin. However, that same year would bring the great display of French Impressionism to New York City, and in the years immediately following, the varying aesthetic pressures of the time would provoke an almost schizoid response in some American artists. Thus, in the manner of the favored figurative mode among both French and foreign painters, Stark composed a monumental foray into peasant genre. Heightened with dramatic intensity by candlelight in a nighttime setting, his *Qui Vient? (Who Comes?)* of 1886, was prepared for and successfully shown at the Paris Salon that year. This was a bold, academic figure piece. The forms were well structured and modelled and placed in an enclosed, geometric setting with color at a minimum, an expression of the anxieties of peasant life which were realized within the philosophical leitmotif of the three ages of man—or womankind. Such a creation was as much a bid for critical recognition as it was for immediate patronage, and it was within the tradition

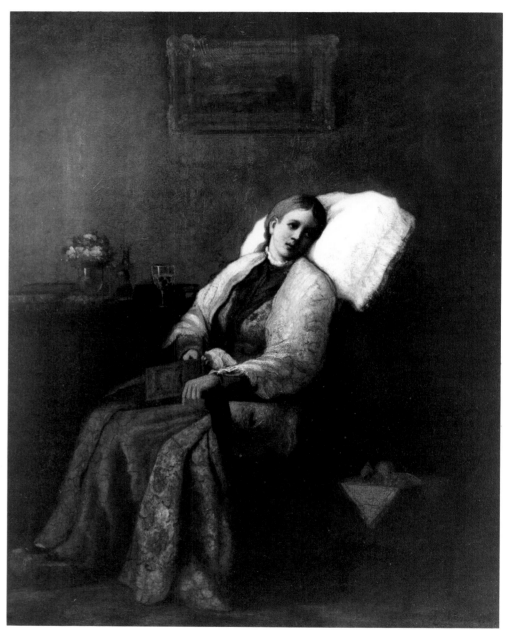

**Theodore C. Steele**
*Road to Schleissheim.*
Oil on canvas
25 x 36 inches
Indiana State Museum Collection

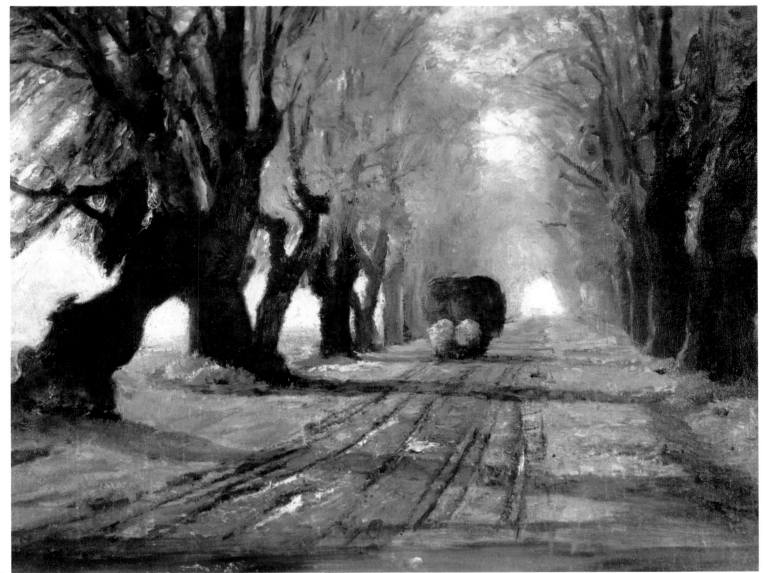

of the academically-trained painter to display the fruits of his study and justify the faith of his supporters.[13]

*Qui Vient?* is totally unrelated to Stark's own Parisian experience, except as a representation of a traditional demonstration piece, far less, for instance, than the landscapes or even peasant genre of the aforementioned Munich painters. On the other hand, a picture, such as his *French Garden* of the next year, is contemporary and intimate. It suggests Stark's own immediate response to his personal environment, to his delight in his casual life, complete with family in the expatriate environment, and even to his appreciation of the informal cultivation of a flower garden, whether his, a friend's, or a neighbor's. This work is as relaxed and informal as would have been the artist's own daily existence. It is a world apart from the portentious theme of *Qui Vient?* as it is from the traditional formalism of its aesthetic. Stark's *French Garden* may not be a full expression of the specific techniques of French Impressionism. But its delight in the daily modern world, its reveling in light, paint and color, and even its floral garden theme were standard aspects of French modernism by 1887, and it displays Stark's awareness and appreciation of the Impressionist innovations. *French Garden* thus would have been created just at the time when other Americans were beginning to explore the Impressionist mode in France —not in Paris, but out at Giverny where Monet, the attraction for artists such as Theodore Robinson, Theodore Wendel, John Leslie Breck, and others, lived. And the following year, 1888, would see another American, Robert Vonnoh, painting both his academically structured *Companion of the Studio* in Paris and his blazingly colorful *Poppies*, painted in the country-side at Grès. These works offered the same aesthetic dichotomy as those presented by Stark in *Qui Vient?* and *French Garden*.

Richard Gruelle's early painting is far less known and his artistic career almost totally undocumented until the decade of Hoosier identification. His early *Interior With Woman* of about 1880 would seem atypical in its figural and interior emphasis and in its concern with the pathos of illness. Yet the aura of melancholic enervation is quite typical of figure and genre painting of the period, while the specific details of still lifes and furnishings are more to be identified with the vernacular tradition which distinguishes Gruelle from his Hoosier colleagues. The whole scene, the sick woman and the accessories surrounding her, may well, in fact, be autobiographically related. In any case, after settling in Indianapolis in 1882, Gruelle turned to landscape painting, often rendering pastoral scenes in the Barbizon tradition which would have been a conservative form of pictorial expression even then, although it was still a dominant trend in the nation and one that would continue to characterize the school of landscape painters in Richmond, Indiana. Innovations would develop, however, in Indianapolis after the Hoosiers began returning from abroad in 1885.[14]

Steele was back in Indianapolis that year, the first of the Munich artists to reappear. It would seem that it was he who pioneered in the investigation of the different aesthetics, particularly of landscape, to which he became devoted, convinced as he was that this was the thematic basis of "modern" painting. This is not meant to imply, however, that the other Hoosiers merely followed Steele's lead and were dependent upon him; each seems to have progressed separately in his art, but along common paths and undoubtedly with frequent interaction. Then, too, it may be that Steele's primacy and the course of his development seem clearer simply because more documented, major works by him are available.[15]

Steele's first landscape, painted on his return to Indiana, was his *Pleasant Run* of 1885. Ironically, this is a masterpiece of his Munich manner, but painted in Hoosierland. It is a dramatically tonal landscape with the drama resting not in the power of the landscape or in the exoticness of the forms, but rather in the treatment of light and the powerful silhouettes of the dark trees and the banks of the stream against the back-lit white sky as reflected by silvery ripples in the gently flowing stream. The mastery of light and dark along with the strength of the forms demonstrate Steele's security in his art. The choice of the Pleasant Run area of Indianapolis was prescient. Not only was it an area which a number of his Hoosier colleagues would also paint, but it was characteristic of the landscape form that the Hoosiers would prefer all through their exploration of different aesthetic modes. Though "in" Indianapolis, it was still rural— not urban, not suburban, yet not wilderness either. It was visitable and liveable. It attracted through quiet charm and invited the gentle ramble. Above all, it *was* Indiana, the American heartland. And as Forsyth was to document, one of the major results of the Hoosiers' stay in Munich, which was derived from visiting the great international exhibitions held there in the Glaspalast, was the conviction that they should devote their art to expressing a national sense and embodying a national consciousness, as they noted had been the case of the exhibiting artists from Holland and Scandinavia.[16]

Steele's progression away from the Munich manner is interesting to examine. In 1886 he made his first bid for national recognition, showing three works in New York at the Society of American Artists: his *Boatman* and two landscapes, one of which was, at least, a German one. But that same year, he began to explore the beauties of rural Indiana, visiting Vernon and the Muscatatuck Valley where he was to paint many a canvas. Perhaps it was a combination of his increased awareness of current landscape trends in this country, along with recognition that the Germanic mode of interpretation was not suitable to his native scenery, that led him to begin to work differently. His major works of 1887 are more related to the forms and practices of the French Barbizon artists and their American followers such as George Inness. His magnificient *Oaks at Vernon* are silhouetted as large, massive forms within a deep volumetric space instead of the rather razor-sharp planes of *Pleasant Run*, and Steele now began to revel in the warmth of sunlight and the richness of the brown color tones. That year, he was commissioned by the Fletcher family to paint the countryside surrounding the family homestead at Cavendish, Vermont. His landscape was one in which he captured the natural appearance of the Green Mountains with casual ease, again adopting a Barbizon stance in the large and generalized forms and primarily tonal contrasts of hue, with green being dominant.

During the years of the late 1880s and early '90s, Steele's art continued to move away from his Germanic sources toward looser brushwork, increased fascination with sunlight, and a broader color spectrum, while devoting his interests to the Indiana rural landscape. In his *Summer Days in Vernon* of 1892, Steele has abandoned larger and solid forms in favor of vibrancy and scintillation of loosely flecked brushstrokes, carrying different colors, a sun-filled atmospheric haze obscuring details, and a rich surface treatment of paint impastos. Certainly, the prevailing tendencies in American landscape toward the adoption of a full or partial Impressionist aesthetic figure strongly here; if Steele does not quite yet appear totally committed to that modern idiom, this distinction lies in his resistance to a full chromatic range. Even so, however, this would not seem to be hesitancy on his part, but rather his enjoyment of the exuberance of the range of rich greens which dominate his canvas— from bright yellow-greens to deeper hues and darker values. By the next year—coincidentally that of the Columbian Exposition in Chicago of 1893—Steele's palette expanded in such paintings as his *Morning— By the Stream* and his *Bloom of the Grape*, perhaps his best-known landscape.

One recognizes in pictures such as these aforementioned the full maturity of Steele's coming to terms with Impressionism, as applied to the primary theme with which he and his Hoosier colleagues would be identified. The "Critical Triumvirate" of the Central Art Association in Chicago—Hamlin Garland, Charles Francis Browne, and Lorado Taft—would write about it as "conservative" Impressionism, and, in a sense, it was—if the work of French artists such as Claude Monet or even such Americans as Childe Hassam could be considered as "orthodox." But the term "conservative" suggests that Steele was unwilling to "go all the way" into the full Impressionist aesthetic. It would seem much more likely that he chose instead those qualities of Impressionism which appealed to him and which seemed the most suitable to express the beauties of rural Indiana. He would adopt small brushstrokes where scintillation was effective, but keep to broader masses of form where he wanted a monumental anchor. The neutral tones of his older Munich years would be abandoned for brighter colors, but, at least in the '90s, he preferred softer, sometimes paler tones, both to achieve harmonious chromatic interaction and to express the diffused light and soft atmosphere of the woods and rolling hills. Neutral brown would be introduced if he found that was the true color of the earth, the trees, or the leaves. For the Hoosiers, Impressionism was not a covenant to which to subscribe, but a tool, a means by which to achieve an interpretation.

We do not yet know where or exactly how Steele absorbed the strategies of Impressionism. They were everywhere "in the air" in the late '80s, after the Durand-Ruel show in New York in 1886,

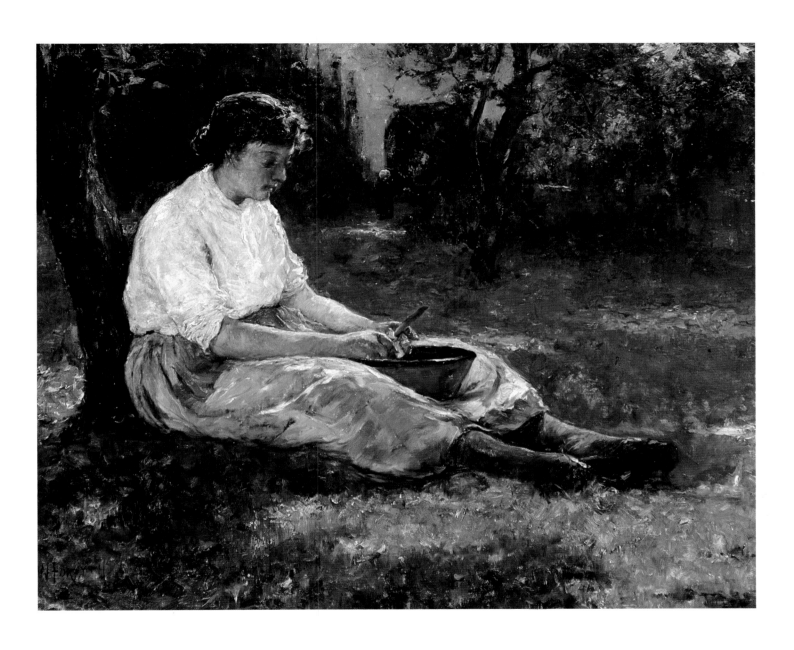

and because of the growing awareness and contacts among the American artists in France with the Impressionists. But Steele was in Indiana. We are still in need of knowing more about his experiences in the East. We know that his works were shown in New York in 1886 and that a Muscatatuck Valley view was noted in the Indianapolis *News* early in 1887 as having been acquired by the Boston Arts Club and placed on exhibition along with two other works.[17] Later that year he was up in Vermont. Such events put Steele and his art in the East, and the question arises as to whether he, in turn, had the opportunity then to view Impressionist painting–French or American? Did he not pass through Boston on his way to or from Vermont, and, at that time, might he not have seen some of the Impressionist paintings sent back by the advanced American artists from Europe?[18] Or later, did he have the opportunity of seeing the increasing numbers of Impressionist pictures on view at the Society of American Artists in New York, beginning in 1889? Nearer to Indianapolis, Durand-Ruel sent an exhibition of Impressionist paintings to Chicago in 1890 which included six works by Monet, four by Pissarro, and a Degas. They were shown in the Interstate Industrial Exposition that year. Did he, perchance, see them?

Steele's subject, as well as that of his colleagues, was Indiana, the American heartland. But Indiana had no Mt. Washington or Mountain of the Holy Cross, no broad Mississippi River, no Niagara, no Trenton, or no Passaic Falls. The question might justly be asked if, in fact, the Hoosiers painted identifiable landscapes? Beyond an occasional specific configuration or a town with a known church spire or other landmark, can a Hoosier landscape be surely Indiana, a particular place? Could Steele's Cavendish scenes just as easily be Indiana, barring a particular or idiosyncratic construction method of stone building? Possibly so. I think what is important here, however, is not that the Hoosiers did or did not introduce identi-

fiable trademarks of their home territory, but rather that they evoked a sense of place. The proof of their success is that their works still do that. Even today, although we may occasionally see a Hoosier scene which we are fairly sure depicts a known valley or woods and might have been painted from some specific vantage point, it is the sense of the familiar, the assurance of that broad middle ground between the frenzy of urban life and the mystery of exotic climes which represents the comfortable "home turf" to us. Steele and his colleagues were able to achieve this, not through the anachronistic (by then) specificity of honorable but outmoded aesthetic techniques, but through the modern idiom of Impressionism, the vibrancy of which still animates their scenes.

It should be stressed that the artists slipped into this modernity much more easily and readily in their landscape work than in their figural or portrait compositions where the academic norm was maintained. And figural work appears to have been of more significance to some of the painters than to others. While Steele continued to paint many competent, if not really inspired, portraits throughout his lifetime, figures took on decreasing importance in his landscape compositions; they became only accessories to help animate a composition and to underscore the nature of rural Indiana, a land of harmony between man and Nature. Occasionally, in his work, figures are engaged in specific chores, reminiscent of the peasant tradition to which he was exposed in Germany, but these are relative exceptions to the norm of his art. John Ottis Adams had returned to Indiana, settling in Muncie, and, even as late as 1894, he had held an exhibition of the paintings done at Prairie Dell farm there. This work still exhibited the relatively strong and solid figure painting previously seen in such Munich canvases as his *Nooning*. Even while his landscapes of the

period such as *Summertime* of 1890 show his response to the light and color of Impressionism, the figures remain more solidly drawn and more prominent than was usual in Steele's painting of the same time.

Forsyth returned from Munich in 1888, a year after Adams, and taught with Adams in Fort Wayne and Muncie. The following year, the two started an art school in Muncie. Meanwhile, Otto Stark had left Paris in 1888 for New York City, and, two years later, he and his family had moved to Philadelphia. The following year, Stark's wife died, and he returned to the Midwest, settling in Indianapolis in 1893. Steele and Gruelle were already in the city, and Forsyth had left Muncie after the closing of the art school there to settle in the Hoosier capital. Only Adams was out of the city, still in Muncie, but he was in frequent contact with his former Munich colleagues.

Thus, the stage was set in the early 1890s for the emergence of this group as representative of modernity in the center of the nation. In 1893, the eyes of the world fixed upon the Midwest at the Columbian Exposition in Chicago, temporarily, at least, displacing the northeastern seaboard as the focus of cultural activity. And the Midwest made the most of it. Not only was art featured in the greatest international display ever seen in this country, but the cultural forces at large were determined that modern art would be pursued in the region. Indeed, *Modern Art* was the name and title of the finest magazine on the arts published in this country in the '90s, and it originated in Indianapolis. The Central Art Association was born as well, with its own publication, *The Arts* (later, *Arts for America*), as a tool for education and the dissemination of information on art. The group provided lectures, classes, and exhibitions throughout the Midwest.[19]

One of the first undertakings of the Association was to bring to Chicago, in the winter of 1894, the show which had been held at the Denison Hotel in Indianapolis

that November. Sponsored by the Indianapolis Art Association, the exhibit highlighted the summer work of Steele, Stark, Forsyth, and Gruelle. Steele and Forsyth were perhaps the two most closely associated at the time; they had been, along with Adams, in Munich together. Both were teaching at the Indiana School of Art in Indianapolis and each had represented Indiana in the art exhibition at the Columbian Exposition. At the Denison Hotel, their work was joined by that of Gruelle and Stark, and when the exhibition was invited to Chicago to be exhibited by the Central Art Association at Lorado Taft's studio in the Chicago Athenaeum Building, several works by Adams were added. The pamphlet published by the Association, describing the reactions to the show of "The Critical Triumvirate," was entitled *Five Hoosier Painters* and was selectively reprinted under that title in *The Arts* in January of 1895.

Thus was born the "Hoosier Group," as the artists are recognized today–in a sense, the creation of Hamlin Garland as the leader of the Triumvirate and the major spokesman for the Central Art Association during its early, proselytizing days. The Triumvirate, who, in their first publication had detailed their reactions to the annual exhibition of American art held at the Art Institute of Chicago in October and who had expressed dismay over the lack of individuality and the absence of a truly American expression within the modern idiom, now discovered what they were seeking in the Hoosier painters. While Steele's work was the most admired, each artist was praised for his individuality, and the group was acclaimed for the artists' common expression of affection for their native soil. For Garland, the Triumvirate, and the Central Art Association, a modern American art had been born and discovered. . .and it was distinctively *of* the heartland.[20]

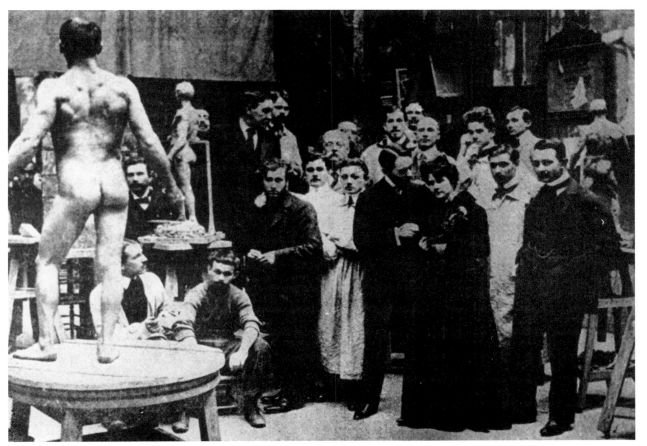

All five of the Hoosier painters had, as the Triumvirate recognized, discovered their individual voices, and all, but Gruelle, worked in a manner of at least modified Impressionism. Gruelle's pastoral landscapes continued a Barbizon-oriented bucolic sense, but his finest works, and those most admired today, are his urban scenes in Indianapolis. In a work such as *On the Canal*, Gruelle caught the vitality of labor in the metropolis, the waterway and its barges becoming a fulcrum of activity as well as aesthetic organization. But Gruelle's most famous work remains *The Canal, Morning* of 1894, a pale, Tonalist scene of the juncture of rural and urban. Its mistily rendered olive landscape forms open up to a pale distant vision of the urban panorama, featuring the dome of the State Capitol in the distance. Gruelle's masterwork is thus related to the mode of Urban Tonalism, best exemplified in the East in the New York street scenes and skyscraper renderings of Birge Harrison. Much of Gruelle's later work, however, consists of interpretations of the New England shore, painted at Gloucester, which he had begun to visit in the mid-'90s. Gloucester and neighboring Rockport were becoming increasingly popular at the time as artists' colonies, although Gruelle continued his association with Indiana traditions.

Of all the Hoosiers, figurative themes, as exemplified in such a major composition as Stark's *Tired Out* of 1894, continued to mean the most to the Parisian-trained artist. Necessarily, both to demonstrate the academic procedures learned in the Académie and to present the narrative or at least the mood of his conception, Stark's figures are well and carefully drawn, more solidly rendered than their surrounding scenery which is quite Impressionistic. Yet color and light sparkle over the figures too. They unite subject and setting, not only in a mutually shared aesthetic, but also in the projection of tranquility and quiet joy in the harmony of man—or, more specifically, women and children—in nature. *Suzanne in the Garden* of 1904 continues the

**Richard B. Gruelle**
*The Canal, Morning (Indianapolis).* **1894**
Oil on canvas
32⅛ x 38⅛ inches
Indianapolis Museum of Art,
John Herron Fund

love of the flower garden theme earlier identified in Paris, one that attracted countless American Impressionists and near-Impressionists, with the woman identified as a flower herself as an emblem of beauty.[21] Stark is at his most Impressionist in *The Seiner*, with the slow, stately movement of the youthful fisherman causing a rippling effect in myriad Impressionist strokes and in the full range of prismatic colors. In many of his later landscapes, those done either up on Lake Michigan or down in Florida, Stark opted for paler, somewhat pastel-like tones and concentrated on decorative rhythms of foliage patterns which became a hallmark of Post-Impressionist landscape in this country in the 1910s.[22]

The work of Forsyth and Adams was closer to that of Steele, who may have led the way among the Munich-trained painters toward Impressionism; Stark seems to have traveled there independently, given his experience in France. All four of them were especially concerned with the presentation of what seemed distinctly Indiana, with Forsyth's depiction of *Constitution Elm*, in the old capital of Corydon, being a case in point. Forsyth, at times, worked with the greatest abandon, adopting an almost-Expressionist technique of slashing brushwork and thick impastos to vitalize his scenes; floral patterns, as in *Our Yard*, could become almost abstract. Indeed, flowers animate the landscapes of many of the works of Forsyth as well as those of Steele, Stark, and Adams. That being so, it is hardly surprising that floral still lifes figure importantly, if secondarily, in the paintings of these artists who sometimes used bouquets, or sometimes still growing, flowering plants and bushes.

The closest associations existed among the Munich-trained artists. First Adams and Forsyth taught together, then Forsyth and Steele. In 1896, the three painters were instrumental in founding the Society of Western Artists which carried forth the exhibition program of the earlier Central Art Association on a more organized and professional level, controlled by the artists themselves. Drawn from the ranks of painters throughout the Midwest, the shows of the Society were seen in six midwestern cities yearly. The painting of the Hoosiers, Stark also included, was often deemed the finest of all the regional representations.[23]

From 1890, Steele began to explore the Indiana countryside with the companionship of Adams or of Forsyth, and, in the fall of 1897, he and Adams found the old Butler House in Brookville which they came to purchase and where they established studios. For a decade, many of the finest works of both artists were painted in and around this small town on the Whitewater River. Brookville itself was the subject of some of Adams's canvas, but he was more concerned with the casual countryside, dotted with homes and farm buildings. He was especially fascinated with the gentle flow of the river, and, even more, with the scintillating reflections of direct sunlight, colorful trees, and embankments in the rippling water. Adams's continued exploration of this theme is seen in such works as *Blue and Gold*, shown at the St. Louis Louisiana Purchase International Exposition of 1904, and the later *Brookville* of about 1915.[24] By contrast, Adams painted a good many evening and moonlight landscapes during the months spent at Leland, Michigan, where he began to summer beginning in the early years of the present century. There, the broad expanse of almost endless water is activated by the rippling glow of reflections of setting sunlight and silvery moonlight.

Steele's art in Brookville and along the Whitewater Valley developed, at the beginning of the twentieth century, toward the adoption of the full spectrum of Impressionist color range. His work done around 1904 constitutes among the purest examples of that aesthetic to be produced in Indiana. It was at this time as well that, grieving over the death of his first wife, Steele traveled two summers to the West Coast, painting the Pacific Ocean in Oregon and in Redlands, California. These renditions are vivid and satisfying canvases, but they seem just a bit impersonal as compared to the quiet affection engendered in his art by his native Indiana. From 1907, however, it was his new home and studio in Brown County that was the center of Steele's world, which he rendered, at times, in intimate views of his garden or of nearby trees and shrubbery, and, at other times, in broad, panoramic views. In many of Steele's later paintings, however, a certain Tonal preference reasserted itself. His brushwork remained vigorous, but less distinct, and his color harmonies returned to a closer range, surrendering the distinctive brilliance of the early 1900s and substituting a harmonious single-colored mistiness, a hallmark of the Tonalist style.

If Steele led the way among the Hoosiers to a cosmopolitan style, to a nativist form of Impressionism, and, incidentally, to national renown for the Indiana school, so did he also pioneer in settling in Brown County which became the major rural art colony in Indiana and throughout the Midwest, attracting artists from all over the state and the region for generations. Steele was the doyen of the colony, and his aesthetic of a modified Impressionism at the service of rural interpretation became the hallmark of Brown County art.[25] Moreover, the Brown County colony served to inspire other groups which were established in the Midwest. Artists from the larger cities set up summer studios where they worked together interpreting the local landscapes, colonies such as the Ozark Painters in Arcade, Missouri, and even Grant Wood's Stone City colony in Iowa in the early 1930s.

The artist's life might be one of relatively free expression, but it has seldom been an easy one financially, nor was it necessarily so for the Hoosiers. Like many European-trained Americans in the post-Civil War generation, the Hoosiers were able to put their training to double use not only in the practice of their art, but also in the training of others. This allowed them to earn a respectable living, however grudgingly they accepted that charge at the expense of their own creative work, and it also permitted them to pass on their techniques and their aesthetic philosophies as well. They were engaged not only in studio instruction, but in the new pedagogical form of outdoor summer teaching which promoted the out-of-doors, sketchlike, colorful approach which was inherent in their own art.

This was, indeed, the dominant style and concept in painting during the 1890s and 1900s, the height of the significance of the Hoosier Group. But their own uniqueness lay in their fidelity to their native region and in their conviction of the correctness of that faith. The Hoosiers might have migrated eastward, as brother and sister artists of other midwestern centers had done, but, instead, they remained devoted to Indiana. Indeed, Impressionism characterizes the art of almost all the regional groups and schools that proliferated during these years, for Indiana was hardly alone in making the transition in its art from the provincial and isolated to the cosmopolitan and modern. It was, however, the earliest. Other regional schools are perhaps better known today, such as the Old Lyme School in Connecticut or those that evolved in Southern California, but those developments occurred in the early years of the present century. The Hoosiers found their way and their goal early. Confidently, they integrated with their environment and their culture in a manner which fully deserves the admiration which they have continued to engender.

## Notes

1. Probably the most perceptive presentation, in recent years, of the changes that occurred in American art during the post-Civil War period can be found in the material brought together for the exhibition and its accompanying catalogue at The Detroit Institute of Arts, *The Quest for Unity: American Art Between World's Fairs 1876-1893*, 1983.

2. Clarence Cook was probably the first professional art critic who deserves this recognition; Cook began writing for *The New-York Tribune* early in 1864, although he had been associated, immediately before, with the short-lived Ruskinian magazine, *The New Path*. In the 1880s and '90s, Cook edited and wrote for his own publication, *The Studio*, one of the finest of all the nineteenth-century American art magazines. In the 1870s, Mariana van Rensselaer and William Crary Brownell brought an outstanding degree of professional competence to this new field.

3. The peasant subject has been the basis of a good deal of recent art historical study; see Richard R. and Caroline B. Brettell, *Les peintres et le paysan au XIXe siecle*, Geneva, 1983. Such presentations as these, however, almost never integrate American contributions with European ones. The American participation is further complicated by the recognition that America did not have peasants or a peasant class and that farmers were distinct from peasants, economically, societally, and, therefore, pictorially. American peasant subjects were, therefore, drawn from foreign experience. However, there was occasional critical recognition of the place of peasant subject matter in art appearing in American journals; see: *Appleton's Journal* 9 (November 1880): 480; Douglas Volk, "Motive and Subject in Art," *Limner* 1 (February 1895): 3-5. For a good survey of American examples of this theme, see the exhibition catalogue, Phoenix Art Museum, *Americans in Brittany and Normandy 1860-1910*, essay by David Sellin, Phoenix, 1982.

4. For the impact of Barbizon art in America see the exhibition catalogue of the show held at The National Museum of American Art, *American Art in the Barbizon Mood*, essay by Peter Bermingham, Washington, D.C., 1975. For American Tonalism, see the catalogue of the show held at the Phoenix Art Museum, *Tonalism, An American Experience*, essays by William H. Gerdts, Diana Dimodica Sweet, and Robert R. Preato, 1982. For American Impressionism, see William H. Gerdts, *American Impressionism*, New York, 1984.

5. For an overview on the artistic developments in the greater midwestern region, see the catalogue of the exhibition held at The Saint Louis Art Museum, *Currents of Expansion: Painting in the Midwest, 1820-1940*, essay by Judith A. Barter, 1977.

6. There is no overall study of regional developments in our art, although there is an increasing scholarly interest in individual area historical analysis throughout the nation. For an early recognition of the place of this discipline by an art historian in Wisconsin, see Porter Butts, "Regional Studies," *Art in America* 33 (October 1945): 240-244. For the history of painting in Indiana before the emergence of the Hoosier Group, the indispensable source is Wilbur D. Peat, *Pioneer Painters of Indiana*, Chicago and Crawfordsville, Indiana, 1954.

7. The aforementioned book by Peat carries the history of Indiana painting up *to* the Hoosier Group. For these artists, before the present volume, see my essay, "The Golden Age of Indiana Landscape Painting," in the catalogue of the exhibition held at the Fort Wayne Museum of Art, *Indiana Influence*, 1984. This essay deals only with Indiana landscape, but this was the major theme of most of the most important artists in the state in the late nineteenth and early twentieth centuries. Much more had been previously written on the Hoosier Group, their associates, and their followers; the sources for such information may be found in the relatively extensive bibliography accompanying my essay on pp. 57-58 of the *Indiana Influence* catalogue. In particular, see the basic studies by Mary Quick Burnet and William Forsyth, and the several essays by Eva Draegert on art in Indianapolis at the end of the nineteenth century.

8. There is no definitive study of the Munich phenomenon in American art. See the early dissertation by Aloysius George Weimer, "Munich Period in American Art," University of Michigan, Ann Arbor, 1940. Michael Quick is presently working on a dissertation for Yale University on this topic; meanwhile, see his essay, "Munich and American Realism," in the catalogue of the exhibition held at the E. B. Crocker Art Gallery, *Munich & American Realism in the 19th Century*, Sacramento, California, 1978.

9. For a thorough review of the typical work of the artists of the Munich school during the nineteenth century, see the illustrations in the four-volume *Münchner Maler im 19. Jahrhundert*, Munich, 1981-83. The works referred to in this section of my essay can be found illustrated there, and are all in the collection of the Neue Pinakothek in Munich.

10. Crucial here is Mary E. Steele, *Impressions*, Indianapolis, 1893, a lecture which Steele's first wife originally presented to the Portfolio Club in Indianapolis. There has been discussion as to whether or not Currier actually taught an *organized* class in Schleissheim; Mary Steele implies that he did, and other contemporary reports speak of him as a "teacher." In any case, it would seem fairly certain that his role was more substantial than merely offering occasional advice to his younger countrymen.

11. For the origins of outdoor teaching in America and some aspects of the role Munich played in developing this approach to outdoor study, see William H. Gerdts, "The Studio of Nature," *Art & Antiques* (May 1984): 54-65.

12. The only significant study of this artist is Nelson C. White, *The Life and Art of J. Frank Currier*, New York, 1936. For reactions to Currier's art in New York and his designation as an Impressionist, see "F. W.," "Notes on a Young Impressionist'," *The Critic* 1 (30 July 1881): 208-209.

13. The standard study of Stark is the essay by Leland G. Howard in the catalogue of the exhibition at the Indianapolis Museum of Art, *Otto Stark 1859-1926*, 1977.

14. Gruelle was recognized in a short piece by Mary Annabel Fanton, "A Reverie of the Farm," *The Monthly Illustrator* 4 (Spring 1895): 230-231.

15. Steele was the subject of numerous articles and essays in catalogues which accompanied shows of his work, and he himself lectured extensively, some of which were published. Most significantly, he is the subject of a major study, Selma N. Steele, Theodore L. Steele, and Wilbur D. Peat, *The House of the Singing Winds*, Indianapolis, 1966.

16. William Forsyth, *Art in Indiana*, Indianapolis, 1916, 15.

17. Steele, Steele, Peat, *House of Singing Winds*, 36, 194.

18. "Greta," "Boston Art and Artists," *The Art Amateur* 17 (October 1887): 93.

19. The best source for information on the Central Art Association is its own publication, *The Arts* or *Arts for America*, but it is a difficult magazine to find; no complete run for its existence from 1892-1899 is known. See also Hamlin Garland, "Successful Efforts to Teach Art to the Masses," *Forum* 19 (July 1895): 606-609.

20. See the two very significant pamphlets published by the Association, both authored by "A Critical Triumvirate": "Impressions on Impressionism" and "Five Hoosier Painters," both Chicago, 1894.

21. William H. Gerdts, *Down Garden Paths: The Floral Environment in American Art*, Rutherford Madison, Teaneck, New Jersey; London and Toronto, 1983.

22. William H. Gerdts, "Post-Impressionist Landscape Painting in America," *Art & Antiques* 6 (July/August 1983): 60-67.

23. The best source of information on the activities of the Society of Western Artists is, of course, the catalogues of their annual exhibitions. See also the notices that appeared in *Arts for America*, particularly in 6 (January 1897): 146-149; and the series by Blanche M. Howard in 7, January, February, March, 1898, 280-286; 350-359; 402-410. See also Ralph Clarkson, "Exhibition of Society of Western Artists," *Brush and Pencil* 1 (March 1898): 197-200.

24. This concentration on the scintillation of light on rippling water may have been partly inspired by the work of the Norwegian Impressionist, Fritz Thaulow, for whom this was a primary and distinctive motif. Thaulow was a "conservative" Impressionist, much admired in the 1890s, particularly in the United States. He was much written about and praised in the periodical press of the time, and he had a one-man exhibition at the Delmonico Art Gallery in New York City during that decade.

25. For art in Brown County, see Harry L. Engle, "Now Then—," *The Palette & Chisel* 1 (November 1927): 4; Adolph Robert Shulz, "The Story of the Brown County Art Colony," *Indiana Magazine of History* 31 (December 1935): 282-289; Josephine A. Graf, "The Brown County Art Colony," *Indiana Magazine of History* 35 (December 1939): 365-370; Psi Iota Xi Sorority, *Brown County Art and Artists*, Nashville, Indiana, 1971.

Theodore C. Steele working outside of his garret
studio in the library at Indiana University, 1922.
Theodore L. Steele Papers.

**Otto Stark**
*The Train.* 1896
Oil on canvas
18 x 24 inches
Mr. and Mrs. Bill Geyer

# Otto Stark

**Judith V. Newton**

**Impressionism to me has always meant the retaining of the first impression which nature makes upon us as we approach her, be it of tone, quality, harmony, light, vibration, force, delicacy, color,…and rendering this impression, if necessary, to the exclusion or at the sacrifice of details or other qualities and characteristics not so essential or vital.**

**Otto Stark**

"The Evolution of Impressionism"
*Modern Art*

Portrait of Otto Stark. Mary Stark Oakes Papers.

The notes for the Stark essay begin on page 157.

"My early ambition was to become an organ-builder,"[1] recalled Otto Stark, a man destined to be numbered among the best of Indiana's turn-of-the-century artists and regarded as one of the state's most honored art teachers.

The oldest of seven children,[2] Stark was born on January 29, 1859, in Indianapolis, Indiana, to Gustav Godfrey and Leone Joas Stark. The boy's grandfather, a wagon and carriage maker who had emigrated with his wife from Germany in 1843 to settle in Indiana, and his father, a cabinetmaker, were Old World craftsmen in the finest sense. Both men had a reverence for the artistry of woodworking which they had shared with the sensitive youngster from his earliest years. Stark was five when his father Gustav went to work for the Indianapolis Cabinet Makers' Union, a furniture manufacturing firm which was to provide the boy with his first exposure to the world of art.

Otto Stark was a sober and intense child, shaped by the demands of his large family, schooling, participation in the German Methodist Church, and a part-time job at the Cabinet Makers' Union. His parents expected him to set a good example for his younger brothers and sisters, and, for the most part, he did. There were times, however, when the normal high spirits of youth got the better of him. Occasionally, during the sweltering summer months, he and some of his classmates would follow a well-worn path to the neighborhood swimming hole where they would creep up on their unwary friends who were happily splashing unclothed in the water. Grabbing the swimmers' discarded shirts from the branches of nearby trees, the mischievous visitors would tie all the shirt sleeves into knots. "Those water-soaked knots were especially difficult to get loose,"[3] Stark would say more than fifty years later with a half-proud, half-apologetic smile as he remembered one of his favorite childhood pranks.

Young Stark was serious about learning the family trade of woodworking: "My father always said that 'an organ-builder must know carving, cabinetmaking and music' so I set about apprenticing myself as a carver and cabinetmaker in our furniture factory."[4] His training at the woodcarver's bench was sporadic at best, however, because family responsibilities and schooling had to come first. One of the youngster's daily tasks was bringing the family cow home from the grassy city commons where farm animals were left to graze by the families of early Indianapolis. "At evening, it was my lot to 'do up' the chores which included driving the cow up from the pasture. She was a rather obstreperous animal, and, in chasing her one time, I sprained my ankle. Then the doctor refused to let me keep on with my carving because it necessitated my standing at the bench,"[5] Stark explained.

While he was recovering from his sprained ankle, a lithographer came to see his father about printing a catalogue for the furniture factory. The adults' business was transacted in short order, but the impact of the lithographer's visit upon the boy was far-reaching. Stark's imagination had been piqued by the prospects of lithography, and he was intrigued by the possibilities of this new career. Finally, after weeks of debate within the family as to Stark's future plans, "one evening around the fireside, we all decided that lithographing would be a good thing for me to take up."[6] Although the talented teenager had made the decision to abandon his organ-building ambitions, his love of woodworking would be with him for the rest of his life.

With the loving encouragement of his family, Stark moved to Cincinnati, Ohio, in 1875, where he lived with his aunt and uncle. There, apprenticed to a lithographer, the sixteen-year-old supported himself by making design plates for various firms located in Cincinnati and in the surrounding towns.

Color work interested the young man, and he made a special study of it in an art class which met during the evenings. In the fall of 1877, Stark enrolled as a night student in painting, drawing, and design at the School of Design of the University of Cincinnati.[7] His first public exhibition took place at the close of the 1878 school year when he was nineteen years old. According to the June, 1878 *Catalogue of the Tenth Annual Exhibition of the School of Design*, Stark exhibited a classical drawing *Musical Faun*, selected from the school's Night Class—Antique Section. During the following year, still working during the day with a lithographer, Stark studied sculpture in the evenings at the School of Design, entering his work in two more of its exhibitions.

Hoping to expand his artistic horizons and obtain the benefits of further training, Stark moved to New York City in 1879. Working as a lithographer, designer, and illustrator, he supported himself with commissions obtained from magazines, journals, and newspapers.[8] Registered at the Art Students' League in 1882 and 1883, Stark worked on landscapes, portraits, and figures under the tutelage of William Merritt Chase, Carroll Beckwith, Walter Shirlaw,[9] and Thomas Dewing.[10] During this period, he began to contribute work to various exhibitions. In 1882, Stark's painting *Street Arab* was accepted for the National Academy of Design Autumn Exhibition and his *On the White River at Indianapolis, Indiana* was exhibited at the annual show of the American Water Color Society.

During his six-year stay in New York City, Stark conscientiously added to both his knowledge and his bank account. By 1885, the twenty-six-year-old was ready for more intensive study. Drawn by the artistic vitality of Paris, Stark decided to settle in the French capital and seek admittance to one of its famed ateliers.

It was a paradoxical world that greeted the adventurous young American when he enrolled in the Académie Julian. Paris, in 1885, was awhirl with the dancing light of Impressionism, and yet its official schools were intent upon the preservation of art within very narrow aesthetic bounds. Founded in 1868 as a preparatory studio for entry into the prestigious École des Beaux-Arts,[11] the Académie Julian had become a haven for those students who were concerned with the restrictions of the École or unable to pass its entrance examination. Like the École, Julian attempted to perpetuate time-honored artistic methodology. Its students were well-grounded in the principles of perspective, anatomy, design, and composition in order to equip them with those skills essential for the production of a first-rate academic painting.

Stark's principal instructors at the Académie Julian were Gustave Clarence Rodolphe Boulanger (1824-1888) and Jules-Joseph Lefebvre (1836-1911). As an artist, Boulanger favored extravagantly romantic ancient and oriental subjects in his work. As a teacher, he was identified with the rigid academic establishment, teaching at both the École des Beaux-Arts and Julian. Elected to the distinguished Académie des Beaux-Arts in 1882, Boulanger remained a stout defender of Julian and its traditional teaching methods against a number of detractors.[12]

Like Boulanger, Lefebvre taught at the École des Beaux-Arts, the Académie Julian, and in his own studio.[13] Reputed to be a particularly severe and exacting instructor, Lefebvre taught design with an authority no one could contest. As a painter of portraits and allegorical subjects, often with nudes and pseudo-historical themes, Lefebvre repeatedly found favor with the juries of the Paris Salon. His paintings were always accepted by the Salon which recognized his best efforts with the presentation of three medals to the popular artist.

The favorite Julian atelier of the American students, among whom were

**Otto Stark**
*Self Portrait of Stark.*
Oil on canvas
10 x 6 inches
Mr. and Mrs. Richard Wise

**Otto Stark**
*Homeward Bound.* **1887**
Oil on canvas
18 x 24 inches
Private Collection

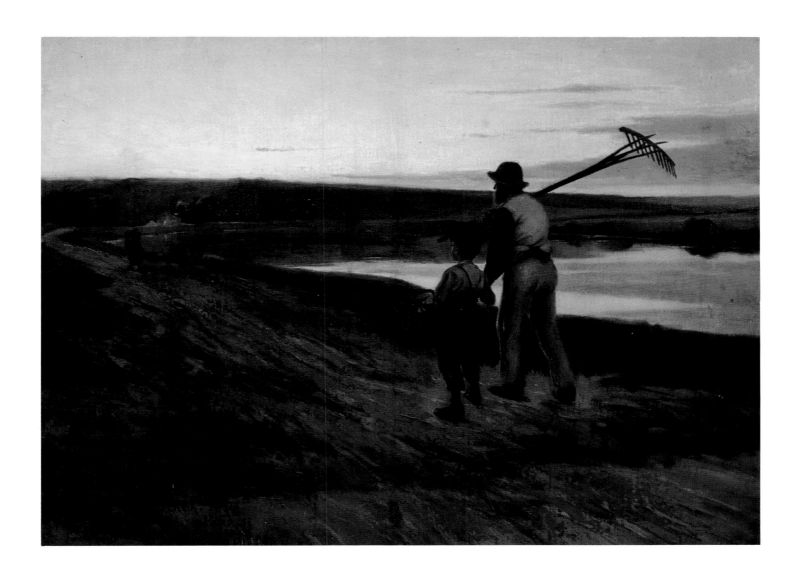

Frank W. Benson and Edmund C. Tarbell,[14] was directed by Boulanger and Lefebvre. To reach their studio, located on the rue Faubourg Saint-Denis, students had to pick their way through a pushcart vegetable market obstructing the building's entrance and trudge up a flight of stairs past a feather mattress company and a shop containing stuffed birds.

Life in the second floor school was not the place for a timid learner. Its five rooms were crowded as the students jostled and shoved one another for prize space closest to the model. The often rowdy, always outspoken French pupils enjoyed mocking the foreigners until the newcomers were able to prove themselves capable of handling the native wit.

Stark, it seems, dealt with the Gallic taunts in a characteristically gentle fashion. After suffering a broken nose during his early days at Julian,[15] he concluded that it was safer to entertain his classmates than it was to box with them. Drawing upon his well-hidden mischievous streak, the twenty-six-year-old Hoosier delighted his Julian colleagues by interrupting one of their charcoal classes with a spirited rendition of an Indian war dance.[16] Impressed by Stark's impromptu performance, the volatile French affectionately dubbed the prankster "Le Peau Rouge" (Red Skin) and readily accepted him as one of their number.

Outside the walls of Julian was Paris: a patchwork city of winding cobblestoned streets, eccentric people, cabarets, half-wild gardens, windmills, and narrow footpaths—the French Impressionists used it all in their new way of looking at naturalism. Emphasizing simple subject matter and everyday life incidents, in direct contrast to the historical, literary, and exotic subjects favored by the academicians of the Paris Salon, these avant-garde artists were interested in the impressions of the visible world rather than in the imitation of exact appearances. They perceived light as color sensations and were concerned about the fluidity of constantly changing light patterns. The painting of the variations of hue and intensity was stressed, and, in attempting to capture this shifting light upon a form, the Impressionists applied paint to canvas in small deft brush strokes.

Caught up in the artistic fervor of late nineteenth-century Paris, Stark's first year in the city passed quickly. In addition to his work at Julian, he had undertaken extra study in the atelier of Fernand Cormon (1845-1924).[17] Known as a painter of elaborate costume pictures of historical and literary subjects, Cormon, at varying times, numbered Vincent Van Gogh, Henri de Toulouse-Lautrec, and Henri Matisse among his students.

In May of 1886, one of Stark's works, *Qui Vient? (Who Comes?)*, was selected for exhibition in the Paris Salon. In April of that year, he, along with thousands of other painters, had been invited to submit three of his works to the Salon jury. Made up of academicians and elected members, the jury was charged with selecting works to be hung in the Palais de l'Industrie for the highly fashionable Salon show. Catering to the academic preferences of the jury, most of the pieces offered were imaginary scenes from history, literature, and religion; classical genre paintings, and portraits. Landscapes were not particularly favored by the jury as they were considered to be less noteworthy in subject matter. Stark was elated at having one of his paintings accepted by the Salon because its selection represented official confirmation of his skill as an artist, and it might lead to a coveted commission.

The year ended on a high note for the hardworking student. On December 15, 1886, he married Marie Nitschelm, a petite, raven-haired beauty from Paris, whom he met while he was boarding at the home of novelist Anatole France. Marie and Stark had become acquainted during the young woman's frequent visits to the writer's home where she had spent long hours with her best friend Suzanne, France's daughter.[18]

The following year was an eventful one for the young couple. Very much in love, the two explored the softly shadowed streets of Paris, while Marie shared the secrets of the colorful city with her new husband. Although working diligently to develop his academic skills through figure drawings, compositional sketches, and color studies, Stark, nonetheless, took time to experiment with the shimmering light of Impressionism. The progress of his work at Julian culminated in the selection of his *Le Soir (Evening)* for exhibition by the jury of the Paris Salon of 1887. That same year, the happy pair also welcomed a baby daughter, Gretchen Leone.

With the coming of 1888, Stark's days at the Académie Julian drew to a close. He had been thoroughly disciplined in the academic fundamentals of composition, drawing, color harmony, and expression, and yet, at the same time, he had absorbed the Impressionist teachings concerning the atmospheric effects of light on form. Work from his Paris period clearly displays this dichotomy in approach.

After having spent more than three years in Paris, Stark and Marie moved with their one-year-old child to New York City where the artist took a job in commercial art. Shortly after their arrival in New York, a second daughter was born to the family.

**Otto Stark**
*The Perils of Union Square in
the Midst of the Blizzard.*
As it appeared in *Harper's Weekly,* March 24, 1888

They named the infant Suzanne Marie in honor of Suzanne France, Marie's dear childhood friend with whom she maintained a steady correspondence.[19] Stark's parents rejoiced at the birth of the baby girl but quibbled over the selection of a non-Germanic name: "Are you really going to call her Suzanne?" they querulously wrote from Indianapolis. "Not a nice name, not one which we would like."[20]

Money was scarce for Stark and Marie as they struggled to make a home for their daughters within the artist's very limited budget. Even though his father helped with a monthly stipend from Indianapolis, Stark was forced to supplement his commercial art earnings with illustration work for such journals as *Scribner's Monthly* and *Harper's Weekly.* Marie stayed at home, keeping a watchful eye on the family's meager funds and tending to Gretchen and Suzanne. Stark and the two girls were the center of her world, and, because she had never mastered English, French was the language of the family's home life.[21]

During this period, Stark began to exhibit, finding time to paint in the late evening hours after the babies were asleep. Four of his paintings were selected for the 1888 annual of the National Academy of Design; the Pennsylvania Academy of the Fine Arts accepted three of his pieces for an 1889 exhibition, and, for the first time, he exhibited in Indianapolis at the Art Association annual in 1889.

The family left New York City in 1890 and moved to Philadelphia where Stark took a position, again in commercial art, with a publishing house. By 1891, Stark and Marie were the proud parents of four children with the births of sons Paul Gustav and Edward Otto.

**Otto Stark**
*Mother and Child.*
Oil on canvas
11½ x 14½ inches
Mr. and Mrs. Richard Wise

Shortly after the delivery of their last child, Marie's health, which had been weakened by successive childbirths, seriously declined.[22] In late August of 1891, Stark took his beloved wife back to New York for hospitalization. His father, a devout Christian, sympathized: "It was the best that you took dear Marie to the hospital; with what could happen under the circumstances, she is better taken care of there than at home. . .Tell dear Marie our heartfelt sympathy and to put herself in the hands of the Lord; He will not abandon her."[23] Despite the care of hospital physicians and the prayers of a faithful family, Marie's condition worsened. On the afternoon of November 11, 1891, she died at the Hahnemann Hospital in New York City.[24]

Stunned by his loss and faced with the monumental responsibility of raising four very young children alone, Stark turned to his childhood family for help and moral support. Although Stark's mother had died three years earlier,[25] his father Gustav, knowing only too well the pain of bereavement, agreed to look after the three older children while Stark sought employment. Stark's sister Augusta volunteered to help out with the infant Edward.[26] Within weeks after Marie's death, Stark again moved his family, this time to Indianapolis where he delivered the children into the care of his father and his sister.

By January of 1892, the artist was working in Cincinnati as a designer with the Strobridge Lithographing Company. Correspondence indicates that the children fared quite well with their strict, but loving, grandfather. Gustav faithfully wrote his grieving son of Susie's headache, Gretchen's sore throat, and the baby's first tottering steps while reassuring Stark: "The children one by one gave me a kiss for their papa at bedtime. They are as happy and wild as ever."[27]

With his children settled, Stark began the task of rebuilding his life. The years of 1892 and 1893 were a time of healing for the lonely artist. For a while, he turned away from exhibition work and produced very little artistically. Searching for something to help him adjust to the death of his wife, Stark filled his days with the soothing familiarity of lithographic work. He even took on a pupil which prompted his father to applaud him for becoming a "schoolmaster."[28]

In the spring of 1892, Stark dedicated himself to Christ. His father joyfully congratulated him: "You cannot imagine how your last letter delighted me and all others. But to express my thanks to our Heavenly Father with words is impossible for me. You say you have come to the Saviour. For the time being that is enough. It says all. He has promised that His people shall have life and their needs would be taken care of. Let it be your care to stay with Him."[29]

Renewed in spirit, Stark returned to Indianapolis in late 1893 and set up housekeeping with his other two sisters, Amalie ("Molly") and Lydia. It was a noisy household which sheltered him and his four children, his widowed sister Molly and her two children, and his unmarried sister Lydia.[30] Knowing that his children would never again lack motherly attention, the grateful artist began to attend the Roberts Park Methodist Episcopal Church—he would later join the membership on May 1, 1904—and to devote himself to the business of supporting his extended family.

In 1894, he opened a studio in the Hartford Block on East Market Street and began to teach classes in oil and watercolor. Part of his instructional time was set aside for landscape work since Stark had received written permission to work outdoors with his art classes anywhere within Arsenal Gardens, now the grounds

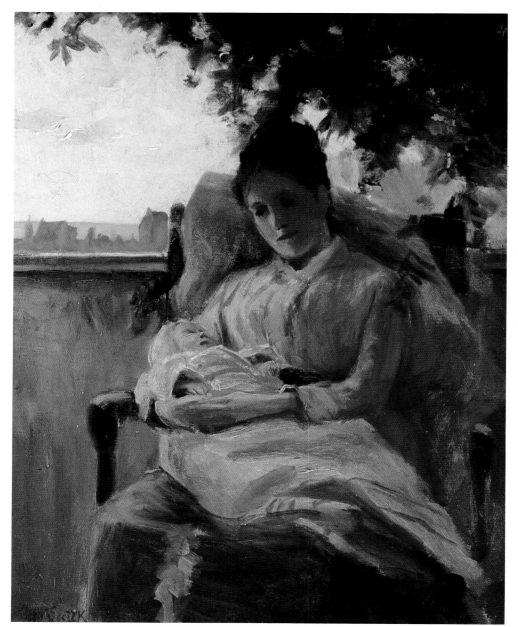

of Arsenal Technical High School.[31] The new teacher enjoyed painting out-of-doors and was grateful for the opportunity to share his ongoing interest in the atmospheric effects of light on form with his classes. No doubt he passed along to them the art student's trick of looking at nature from an upside-down position in order to see color exclusive of form.[32] On November 3, 1894, Stark held a studio exhibit of his work in his Hartford Block rooms.[33]

During that same month, Stark displayed fourteen oils and nine water-colors in the Exhibit of Summer Work of T. C. Steele, William Forsyth, R. B. Gruelle and Otto Stark at the Denison Hotel in Indianapolis.[34] With the addition of two works by J. Ottis Adams, the show was renamed Five Hoosier Painters and moved to Chicago where it opened in December of 1894.

The Chicago art critics were warmly receptive of the work of this "Hoosier Group." "We thought we had made a great discovery," explained sculptor Lorado Taft, "and we gloated with much rejoicing over the Hoosier paintings."[35] The authors of the *Five Hoosier Painters* exhibition catalogue praised the artists for their individuality, vitality, and freshness of approach and touted Stark for his "great facility and reserve force."[36] Consistent with the Impressionistic emphasis upon simple subject matter, the motifs for Stark's work had been drawn from his everyday experiences of sleeping babies and playing children. One critic approvingly noted:

*"It gratifies me to find a man who can do a thing like that, turning to such pretty little subjects as the baby asleep yonder, the child with the long-suffering tabby cat, these sunflowers with the nasturtiums, they give a pleasant suggestion of the man's interests and sympathetics."*[37]

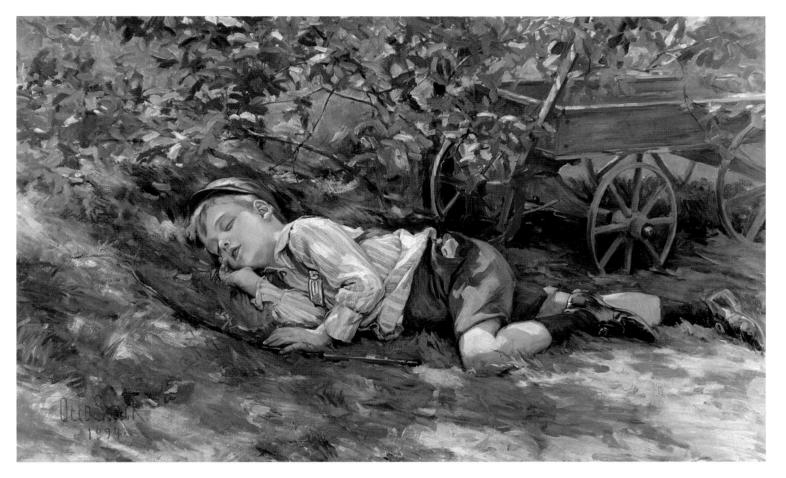

**Otto Stark**
*Sketch of Baby.*
Charcoal
18 x 22½ inches
Private Collection

**Otto Stark**
*Sketch for the Seiner.*
Watercolor
5½ x 7½ inches
James W. Brown

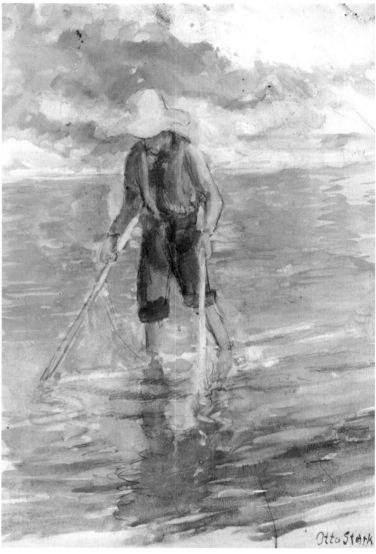

**Otto Stark**
*Pauline Leatherman.* **1896**
Oil on canvas
22 x 15 inches
Joan D. Weisenberger

The next several years were busy ones for Stark as he sought to balance the financial needs of his growing children with the production of exhibition pieces. Freed from the day-to-day details of child care, he was able to teach as well as to allot the time necessary to his development as an artist. He wrote an eloquent treatise on "The Evolution of Impressionism" for the 1895 spring issue of *Modern Art*, and, in 1896, his reputation was bolstered with the sale of an oil portrait *William N. Jackson* to the Art Association of Indianapolis for its permanent collection. In 1897, Stark joined the Society of Western Artists, an organization formed in 1896 for the purpose of holding rotary exhibitions of the work of midwestern artists, and he displayed four works in its first annual. Elected an honorary member of the Art Association of Indianapolis in 1898, the industrious artist also exhibited three paintings in the Trans-Mississippi and International Exposition at Omaha, Nebraska, that year.

Recognizing that he was unable to provide a steady enough income for his family by teaching private classes, Stark accepted the position of Supervisor of Art at Manual Training High School in Indianapolis in 1899. The year was a momentous one for the painter as he slipped back into the formal world of academia. With his appointment, a fresh element was added to the teaching of art in the Indianapolis public schools. Stark's instincts as an artist rebelled at the traditional drawing book method of teaching in which a pupil was set to copying little lithographs designed to lead him, by easy stages, through various degrees of accomplishment. According to Stark, the system was boring and lifeless, failing to teach the realities of art.

Believing that a student's art instincts should be addressed throughout the educational process, the new supervisor banished the simple drawing book exercises and replaced them with innovative exercises in pen, charcoal, and brush. Under his direction, students were encouraged, through work in various mediums, to express themselves and to develop individual skills in adaptation and invention.[38]

Shortly after the close of the school term, Stark was asked to accompany Miss Wilhelmina Seegmiller, the director of art instruction in the Indianapolis public schools from 1895 to 1913,[39] and fellow artist Richard B. Gruelle to Boston, Massachusetts.[40] While in Boston, Stark managed a side trip to Gloucester where "the roaring of the waves creates a constant music, as one after the other breaks on the sandy shore, almost at my feet."[41]

The homesick teacher described the sweeping expanse of beach in a letter to his children: "I just now returned from Sunday School, it was over an hour ago, but I had so much to look at on the way back, so I took my time…between the trees I see boats coming in and going out of the harbor, in the distance small sails disappear on the horizon…The air is cool, salty and really refreshing, I wish you all could be here. Early this morning, I took my first swim, was all alone on several miles of beach. The water was ice cold and because the hot water heater was out of order, I had to return after a short time."[42]

In becoming a member of the Manual faculty, Otto Stark had found his place, both as an administrator and as a teacher. The painter, in his work with the more artistically advanced high school students, had a way of presenting the principles of art to his classes in a deceptively simple manner. He was patient and thorough, requiring his students to work carefully and accurately. With seemingly unlimited energy, the enthusiastic new instructor often stayed late into the evenings to plan course work tailored to the needs of each student.

Indianapolis artist Elmer Taflinger, a student at Manual in the early 1900s, was greatly influenced by Stark: "Most people don't realize what Otto Stark did for the art world of Indianapolis. He is the man who inspired us all to go to New York, to do something. He was a high school teacher, but he kept abreast of New York, Chicago, Paris. One thing a lot of people don't realize is that Otto Stark had an independent reputation on the East Coast. He won his spurs in Paris, New York, Philadelphia. Then, because his wife died, he decided to raise his four children in a healthier atmosphere. He was a human being above all else."[43]

Impressed with Stark's strength as an artist, Taflinger recalled: "Of all those who put a picture together, Otto Stark was the best composer. We used to get together in New York, some of us who had studied with Stark and congratulate ourselves on the fact that we were so much better prepared than people from all over the world. We were amazed at the things they didn't know that we thought everybody knew…He was the godawfulest looking man…He had a shuffling, indeterminate gait, every part of his body was at war with another part. He had a real artist's thumb, the size of a spatula, and knobby hands. But he had a firmness and a kindness in his eyes. He fed us with letters, posters, messages from those who had left. He fired our ambition."[44]

Orpha McLaughlin Pangborn, one of Taflinger's classmates, remembered Stark as being a kind teacher: "I can just see him. He always put his finger up like this, just like in that picture of the Hoosier Group. That was a very characteristic attitude for him when he'd go around class and look at what we'd been doing…He was gentle with his criticism and soft-spoken. In one of my charcoal drawings from a live model seated on a chair, I was trying to do the whole chair very plainly. Mr. Stark came by and said, 'Orpha, you don't have to draw the whole chair; do just a portion of it so that it suggests that she is sitting on a chair.' He would teach by making suggestions and then he'd come back after I had worked on it for a while. He'd walk around the room and go from one student to another."[45]

In 1901, Stark served as president of both the Indiana Artists' Club and the Portfolio Club. A member for many years of the Portfolio Club, a group whose objectives were to bring together the various art interests of the community and to promote a spirit of artistic appreciation, Stark enjoyed acting in the club's annual play nights. A comic at heart, the talented teacher was praised for his work in a presentation of *The Workhouse Ward*, a play dealing with the quarrels of two Irishmen who were confined in a workhouse. A drama critic of that time approvingly wrote of the club members' efforts: "Much merriment was caused by the clever way in which the play was given by Mrs. Herbert Foltz, Mansur B. Oakes and Otto Stark."[46]

In May of 1902, after his responsibilities at Manual had ended for the year, Stark was asked to teach, along with J. Ottis Adams, a summer course at the John Herron Art Institute in Indianapolis. He

and Adams shared the responsibility for the painting class in oil and watercolor with Adams teaching the first half of the session and Stark taking over on June 17th, midway through the course. The class, its time devoted to out-of-doors work with models and landscape, met at the Institute for six hours each day, six days a week.[47]

Despite Stark's ambitious teaching schedule, he was still able to work, at odd hours, on pieces for exhibition. In the company of T. C. Steele, William Forsyth, and Adams, he exhibited eight works at the 1904 Louisiana Purchase Exposition in St. Louis, Missouri. His major entry was entitled *The Committee*, a large figure painting in oil of three men debating the silver question, an important political issue of the previous decade.

In 1905, Stark was invited to join the faculty of the John Herron Art Institute on a permanent basis. Listed in the school's catalogues as an instructor of composition and illustration, he agreed to give criticism in composition and illustration at its drawing and painting classes twice each month.[48]

**Otto Stark**
*Suzanne in the Garden.* **1904**
Oil on canvas
35 x 16 inches
Private Collection

With a full-time position at Manual and part-time work at the Art Institute, Stark at last felt financially able to lease a house for his family. Shortly after the start of the 1905 school year, he and his four children left his sisters' home and moved to a modest bungalow in Southport, a small community on the south side of Indianapolis. The tiny, crowded house was tended with loving efficiency by Tilly, a quiet German woman who cooked, cleaned, and "made such wonderful applesauce."[49]

The Stark teenagers brought great pleasure to their father who had watched their growth with pride: Gretchen was quiet, somewhat shy, and dark-haired like her mother, while Suzanne was blonde, more outgoing, and often a dominating force in the activities of the neighborhood children. Paul was quite short and walked with a limp because of a light case of polio contracted as a child. Edward was blond, often joking, and frequently the recipient of a lecture from Stark for some youthful bit of mischief. As a parent, Stark was a fair, but not an overly affectionate, father. An exacting disciplinarian, he had been raised by a strict German family, and he, in turn, was raising his children the same way.[50] According to his oldest daughter: "He never praised to please. I often wished he could say something good to relieve the embarrassing silence, but he never betrayed his judgment."[51]

In 1906, Stark and his family moved to a larger house in Southport. During the summer break from his duties at Manual, the vacationing teacher abandoned studio work to paint out-of-doors among the fruit trees growing in the side yard of his new house. Using his children as well as their friends for models, Stark painted a number of charming scenes of idyllic summer activities that year.

The rambling house in Southport and its spacious grounds suited the needs of the Stark teenagers as well as those of their father who deeply appreciated the tranquility offered by the quiet town. Plans to make Southport his family's permanent residence, however, were changed when Stark became so irritated by the noise of a nearby railroad that he decided to move back to Indianapolis to escape its distraction.

With his expertise in composition and illustration, Stark had proven to be a welcome addition to the teaching staff of the John Herron Art Institute. Even though, initially, he provided criticisms in the painting and drawing classes only twice each month, his impact upon the school was felt soon after he had joined the faculty. A great proponent of "sketching anything and everything," Stark instructed the students to keep drawing paper handy at all times. He urged them to sketch their homes, their families, and their friends in sketchbooks which he periodically collected for grading and critique.

Artist Evelynne Mess Daily greatly enjoyed her student association with Stark: "An odd-looking fellow, with a slender face, a little goatee and a light, soft voice, Stark was thorough as a teacher. He was serious, but had a sparkle of humor. It was fun to be in his class. He wasn't dull, but he had an interesting way of talking. He was a very gentle teacher. He was very complimentary and picked out the things that were good in your work. He inspired you. He got results out of his students."[52]

Another of his students, watercolorist Beulah Hazelrigg Brown, remembered: "Mr. Stark would tell us to do a certain composition with certain things in it, and then we'd bring it to class. We'd make up our own compositions and then he'd have all the papers up in front of him; they were usually done in charcoal. Then he would criticize one after the other. Occasionally he had to be a bit sarcastic with a lazy student or he was sarcastic when they weren't very good."[53]

**Otto Stark**
*Autumn Scene.* **1924**
Oil on canvas
23½ x 29½ inches
Art Association of Richmond,
Gift of Gretchen Stark

In addition to his teaching duties at the art school, Stark, along with Forsyth and Steele, participated in the Institute's Sunday afternoon gallery talks. Centered around the works on display in the special Institute exhibitions, the talks were designed to broaden the art appreciation of the general public. They also offered the artist-speaker an opportunity to share his thoughts with an interested audience.

One of Stark's favorite gallery talks explored the art of poster work. Focusing upon the French poster artists who had developed their medium during Stark's student days in Paris, he explained that an aesthetically pleasing poster was one in which the artist had successfully balanced the image with the lettering while simultaneously striving for effects in color.[54] Several of Stark's gallery talks were geared toward helping Indianapolis residents better understand the essence of art. While pointing to an exhibition painting which appeared strained in technique, the teacher emphasized that a good work of art should give the impression that the artist took delight in painting it.[55]

Concerned with reminding the Indianapolis public that he was still an artist as well as a teacher, Stark continued to devote his leisure time to his own work. On November 10, 1906, he exhibited paintings in watercolor, oil, and color crayon of scenes in and around the town of Southport. The exhibition was held at the galleries of The H. Lieber Company in Indianapolis. In 1907, Stark sold a second oil *Two Boys* to the permanent collection of the Art Association of Indianapolis, and, that same year, he was elected treasurer of the Society of Western Artists. Stark received an honorable mention at the 1907 Richmond Art Association Annual Exhibition, and, in 1908, he won the Mary T. R. Foulke prize at the Richmond Annual Exhibition.

In 1910, Stark purchased a small house within a short walk of the Art Institute. Located at 1722 North Delaware Street, the Cape Cod cottage, with its low-slanting roof, tiny dormer windows, and little library filled with the comfortable clutter of books and magazines, was charming. According to one of the artist's granddaughters: "It was a typical old-time house with some bedrooms on the second floor and a narrow staircase leading to them. The kitchen and the dining room were the largest rooms; it wasn't particularly a big house."[56]

The library was Stark's favorite place to relax. The quiet artist loved books, especially those by Shakespeare, Edgar Allan Poe, and Mark Twain, and he enjoyed reading from his large collection of leather-bound volumes by both French and English authors. Remembering the warmth of her grandfather's library and his great respect for books, a Stark granddaughter later recalled: "I was always given books of worth for holidays and birthdays. One was about a boy who grew skinny and tall when he ate asparagus or green beans, and who grew short and fat when he ate tomatoes or round vegetables. The illustrations were remarkable."[57]

The painter's love of fine books was an important part of his relationship with each of his grandchildren: "My grandfather always gave us a book for Christmas. They were good books with elegant illustrations. He always signed them 'Your Grandfather, Otto Stark.'"[58]

Shortly after moving his family to Delaware Street, Stark built a separate nineteen-by-twenty-two-foot studio on the lot behind his house. Using the room as an all-purpose workshop, the contented artist painted, puttered and renewed his boyhood interest in woodworking by carving frames for his favorite paintings. Occasionally he would invite some of the Institute students to his Delaware Street studio, allowing them to study his work: "He didn't do much teaching those times; it was more of a social gathering for his students."[59]

The next several years were marked by deepening relationships, both professional and personal, among the artists who had exhibited in the 1894 Hoosier Group show in Chicago. Stark, along with J. Ottis Adams, William Forsyth, and T. C. Steele, was represented in the 1910 International Exhibition at Buenos Aires, Argentina and Santiago, Chile;[60] and he, with the others, was enthusiastically active in the Society of Western Artists. Believing that the creative work being done in the Midwest deserved recognition, each artist in the Hoosier Group made an effort to participate in the Society's annual rotary exhibitions of paintings, pastels, etchings, watercolors, and sculpture.

In June of 1911, Stark and his oldest daughter Gretchen were guests at the House of the Singing Winds, T. C. Steele's home in southern Indiana. With Steele and printmaker Gustave Baumann, Stark tramped among the Brown County hills, admired Mrs. Steele's magnificent shawl collection and savored the solitude of the rustic retreat. Grateful to Mrs. Steele for sharing some of her dressmaking tips during their visit, Gretchen later wrote the artist's wife: "I took some of the fullness out of one of my underskirts and now it is so hobbly that it is almost uncomfortable. It looks so funny, too. All the girls laugh at it. Now I have to put some fullness back again. Papa is painting his studio…it is going to be brown and gray. Lovingly, Gretchen Stark."[61]

**Otto Stark**
*Suzanne.*
Oil on canvas
11 x 8½ inches
Private Collection, Zionsville, Indiana

Later that summer, Stark took Gretchen and Suzanne to the Hermitage, the home of J. Ottis Adams and his family, to stay "while Mrs. A. and the boys are at Leland (Michigan)."[62] Stark thoroughly enjoyed the opportunity to work along the banks of the Whitewater River, and the girls were "always so glad to go to the Hermitage."[63] Both daughters had continued to live with their father; Gretchen taught French in an Indianapolis school, and Suzanne had enrolled as a student in sculpture at the Art Institute. Stark's older son Paul had married, settled in Indianapolis and was employed by an Indianapolis business firm. The artist's younger son Edward was involved in the design work of the Pathfinder automobile which was being manufactured by an Indianapolis company.

In 1913, the Parent-Teachers Club of Indianapolis Public School #60 commissioned Stark to paint two large murals on either side of the school's assembly room stage. On the left side of the stage, the artist used a springtime motif inspired by the early spring blossoms in Irvington, and, on the right side, he completed the presentation with a glowing October scene taken from the hill country of southern Indiana. The nine-by-twelve-foot landscapes were Stark's first work as a muralist and were of such magnitude that he was assisted in the project by Carl G. Graf.

Stark finished the work at School #60 just one day before he was due to leave for a season of painting at Lake Maxinkuckee in northern Indiana. Wearied by the strenuous mural painting, he gathered part of his family—Gretchen and Suzanne, along with Paul, Paul's wife, and new baby—and left for the lake and a badly-needed vacation. Once there, he concentrated upon "doing nothing in particular and not caring a continental."[64] From Maxinkuckee, Stark wrote the Steeles of his mural work: "I enjoyed it as much as anything ever coming to me but when I got through I was pretty well done up," and invited them to visit at the lake, suggesting: "A change from the mountains to the lowlands might be pleasant to you highlanders and you would return to your Brown County hills with new eyes."[65]

Stark's blithe comment that he was "doing nothing" at Lake Maxinkuckee was contradicted by reports of his experimentation with a new artistic medium. According to a critic of the day: *"Stark has been working with a new medium, the combined use of charcoal, watercolor and colored crayons . . . Sometimes he puts his first color on the canvas with the watercolor and then works it over with the charcoal and the colored crayon. With another picture, he may decide to begin in the dry color and finish in the watercolor."*[66] An exhibition of Stark's work, done during his stay at Lake Maxinkuckee, was held at the lakeside Palmer House in July and August of 1913.[67]

The following year, Stark, Forsyth, Steele, Adams, and eleven other Indiana artists were hired by the Board of Health to paint a series of thirty-three murals at the Indianapolis City Hospital during the summer of 1914.[68] Working for housepainters' wages, the charitable artists followed the direction of Forsyth who had been selected to set the general color scheme for the entire project. Within Forsyth's guidelines, each artist was responsible for the design and execution of his work in an assigned area of the hospital.

**Otto Stark**
*The Bridge.*
Pastel
18 x 24 inches
Norris Collection

One of the most colorful murals in the building was done by Stark. His *Toy Parade*, a continuous frieze around the walls of the kindergarten room on the third floor, was a joyous jumble of brilliant blues, reds, yellows, browns, and greens. The panorama depicted a youngster's delight as he watched his toys coming to life: roly-poly stuffed animals paraded to a gay circus tent, an over-crowded tally-ho coach rattled along in puffy clouds of dust, a King and Queen of Toyland rode regally in a graceful gondola drawn by a team of swans, and a fully-equipped miniature train screeched to a halt to unload toy passengers. The fifty-five-year-old artist's mural was a pure flight of fantasy which surpassed even his hopes of delighting the convalescing children in the kindergarten ward.

Stark continued to work at both Manual and the Art Institute while exhibiting frequently and participating in a variety of community activities. In 1915, he was appointed by the State Board of Education to oversee the Indiana exhibit sent to the Panama-Pacific International Exposition in San Francisco, California. He exhibited as well as served in an official capacity at this exposition. That same year, he won the $100 J. I. Holcomb award for his oil *The Arsenal Bell*, and, in 1916, he designed the cover illustration for the pamphlet used at the Centennial Pageant of Indiana University.[69]

Upon America's entrance into World War I in 1917, Indiana's artists proudly contributed their time, skill, and materials to the war effort. Once again, Stark joined other Hoosier artists to work for the betterment of the community. He, in the company of Forsyth, Carl Graf, Clifton Wheeler, Paul Hadley, Anna Lou Matthews, and Bessie Hendricks, volunteered to paint life-sized posters in oil to advertise the $400,000 goal set for the Indianapolis campaign of the American Red Cross War Fund. Portraying the use of dogs in hunting for wounded soldiers on the battlefield, Stark's poster depicted a dog hovering protectively over the body of a fallen soldier lying in a clump of trees.

In 1918, Stark teamed up with Graf, Forsyth, and Wheeler to paint a War Chest signboard located on the southeast quadrant of Monument Circle in Indianapolis. The attention-getting sign pictured a great iron chest flanked on the right by a Red Cross nurse and on the left by a United States infantryman. The two figures were drawn by the artists to symbolize the agencies serving the armed forces which received the benefits of the War Chest.

Not until 1919 did Stark feel that his family commitments were at an end. He finally felt free enough to resign from his teaching positions at Manual and the Art Institute and to devote all of his energies instead to painting. His children, with the exception of Gretchen who stayed with him until his death, had grown, married and had settled elsewhere with families of their own.

Hopeful of leaving a small legacy of art to the Indianapolis public schools, Stark, in one of his last official acts before retiring, directed the painting of a series of murals in five of the local schools. Working under the supervision of the kindly teacher, the Manual art students used the themes of "Mother Goose," "The Dignity of Labor," and the "Shephard's Psalm," while learning the mural process from start to finish.

Stark celebrated his retirement from formal teaching by extending what had become an annual summer painting trip to Michigan with his close friend J. Ottis Adams. For the first time, he was able to ignore the school calendar and stay in Michigan late into the fall to catch the rich golds, oranges, and reds of the autumn woods. Since 1916, Stark had been going to northern Michigan's Indiana Woods, a mile-square thicket of pines, hemlocks, and balsams along the eastern shore of Lake Michigan, with Adams and his family.

An Adams niece remembered: "Mr. Stark had pitched two tents down in the woods at Leland, right along the beach of Lake Michigan. One tent he used was a studio; the other was where he lived with a little cot. They were right next to each other. He did his own cooking over a little stove in his tent, and I think Uncle Jack and Aunt Winnie had him over for a good home-cooked meal fairly often."[70]

Even though the two painters enjoyed one another's company—"they were always sort of teasing each other and telling stories on each other"[71]—they were careful to give each other privacy in which to work. Fascinated with the fleeting light patterns in the sky and upon the water, Stark found that his sky-reflected water compositions painted there had to be rapidly recorded. In working on the radiant sunsets over Lake Michigan, the artist would quickly sketch the scene in colored crayon, jotting down the names of the colors to be used the next morning when he would take his oils to fill in the unfinished portions of the sketch.[72] An art critic in the Leland area noted: *"Stark is especially happy in his sunsets, a favorite form of expression. Outstanding are his sunset scenes on the lake."*[73]

Stark's time in Michigan was a period of professional growth as well as a chance for the person behind the artist to emerge. Perhaps the hard work and rigid schedule to which the artist had adhered throughout his life had suppressed an innate playfulness which could finally be given its freedom. Stark began to experiment with his cooking; the stranger the combinations, the more he enjoyed them.[74] He started a "gargoyle" collection for the youngsters of Indiana Woods with bits and pieces of oddly-shaped driftwood rescued from the water's edge of Lake Michigan.

This interest, no doubt, was sparked by memories of woodcarving as a young boy or his student days in Paris when, as a struggling artist, he had worked under the shadows of the gargoyles peering down from the heights of Notre Dame Cathedral.

As a favorite guest of the Adams family, Stark was welcomed each summer by the Indiana Woods children who loved listening to the artist's funny stories: "Mr. Stark had the cutest sense of humor. He was such a funny little man and he used to hold us with his stories. We always enjoyed having him come. Mr. Stark was also quite a good sport. My older brothers and sisters had a circus one summer, and they wanted Mr. Stark, who was a little, thin, sort of bony man with a mustache, to be the ballet dancer. It was really quite a circus. Uncle Jack, Mr. Stark and Aunt Winnie painted the scenes for the sideshow, and they were perfectly beautiful. Another aunt made a ballet costume for Mr. Stark to wear, and he came tripping out to the music in his little ballet outfit and did a ballet around the ring. We all thought he was such a good sport about it."[75]

Eager to escape the harsh Indiana winter during 1920-21, Stark accepted Adams's invitation to paint with him in Florida. The two friends spent three months working in New Smyrna, a historic town in northeastern Florida. Settling in Ronnoc Park, a several thousand acre plantation which had been developed, but subsequently abandoned by a New York City financial tycoon,[76] the artists converted the former office of the landowner into a studio. Stark described their accommodations in a postcard to Gretchen: "Have good sleeping quarters: used beds. Get meals same place where we sleep, *promises* to be good. This is a photo taken in *our* park, gives you some idea of its beauty; it is no longer open to public and we have the right of way."[77] The grounds of the plantation were extensive, providing Stark with seemingly endless palms, Spanish moss-festooned liveoaks, and brightly-hued flowers to use as subject matter. An exhibition of his work done in Florida was held in his Delaware Street studio during June of 1921.

For the next several years, Stark continued to spend the summers painting in Michigan and the winters working in his Indianapolis studio. Occasionally he went down to Brookville to visit with Adams where he stayed in one of the Hermitage's tiny attic rooms. He was particularly fond of a tucked-away upstairs room there for its fine view of translucent early morning skies and mist-draped hills.

Teaching had been too much a part of Stark's life for too many years to allow him to give it up completely. Soon after his retirement, he had begun to instruct his talented young granddaughter Margaret in the basics of painting. She later remembered this valuable training: "In the studio, Grandfather gave me all kinds of painting problems. For example, he started me drawing the negative area, the space around an object, rather than the positive, the subject, so that I would, from the beginning, think of these two as equal in importance. He would say, 'Go out behind the studio and draw the space around the willow tree.' It seemed to me as natural a thing to do as to draw the tree. This was one of the most important things he could have done to develop my vision...At the end of the afternoon, during which he painted as well as I, we sat at two tall stools at a kind of kitchen bar, and ate toast and strawberry jam and drank tea. I remember his plates and cups; they were of the most brilliant deep blue design on white."[78]

Stark's love of teaching extended even to his church life. As a Sunday School teacher at Roberts Park Methodist Episcopal Church for many faithful years, he took his two granddaughters to church every week in an old touring car modishly outfitted with isinglass snap-on curtains. "His driving was perilous, for he was absent-minded and prone to running red lights. Sometimes a policeman would stop us and say, 'Oh, it's only the artist.' I don't remember his ever getting a ticket,"[79] recalled one of the artist's granddaughters. More perilous than Stark's driving to the young girls, however, was his disconcerting practice of quizzing them about the Sunday School lesson on the way home.

Although Stark had been retired from his position at Manual for six years, the inspiring contributions of the modest, unassuming artist had not been forgotten by his pupils. In February of 1925, the sixty-six-year-old teacher was honored by his former students at a reception and exhibition at Manual Training High School. Letters, tributes, and samples of work were sent from all over the world by twenty-nine working artists who had studied in Stark's classes at Manual. William E. Scott, a young black artist who had won a scholarship to Paris under Stark's tutelage, recalled that Stark had generously turned over his studio to him so that he might hold an exhibition there. Scott gratefully wrote: "We cannot do too much for Mr. Stark. All I am I owe to him."[80] Some of Stark's other students included: Elmer Taflinger, Marie Goth, Simon Baus, Helen Jacoby, Paul Hadley, Tom Hibben, and Walter White.

During the first years of the 1920s, Stark's granddaughters had frequently posed for him: "When we posed for him, about the only thing he said was: 'Stand still!' The best part of it was when we took a break for lunch. Gretchen would fix lunch and call us to come in and eat. We would sit around the table and talk, mainly to her; he didn't say too much."[81]

In the winter of 1925, the two girls sat for a formal portrait in their grandfather's studio. The budding artist Margaret remembered: "My mother had bought us brown velvet dresses which had enchanted my Grandfather and gave him the idea to paint us. He made first a pastel sketch and then a large painting. I don't think he was well then; he looked tired and I wondered if he were going to be sick. It was cold in the studio and my Grandfather made a fire in the fireplace against which we stood. My sister, closest to the fire, burned the seat out of her velvet dress. It was weird to see her wearing this dress with its peculiar hole sitting after sitting."[82]

Margaret Stark's feeling that her grandfather "was going to be sick" was sadly prophetic. In April of 1926, he suffered a stroke while visiting his younger daughter Suzanne at her home in Indianapolis.[83] The artist lingered for several days, and then, at the age of sixty-seven, died on April 14, 1926. At the end of his life, Stark had been doing family portraiture, going over early sketches and putting finishing touches on some of his older canvases. His congenial, thoughtful presence and his gentle, tolerant goodness were missed by his fellow artists, his former students, his church associates, and a wide circle of friends.

**Otto Stark**
*Threshing.* **1906**
Watercolor
10½ x 18 inches
Dr. and Mrs. Gregory C. Woodham

**Theodore C. Steele**
*Summer Days at Vernon.* **1892**
Oil on canvas
22 x 40 inches
Private Collection, Zionsville, Indiana

# Theodore C. Steele                    1847-1926

**The source of the power of beauty is unknown and no more to be explained than life itself…When you can explain the souls trembling under the tremendous chords of Beethoven's symphony, you will have explained the mystery that lies shrouded in the deep gloom of Rembrandt's *Entombment* and have discovered…the mystery of all art.**

**Theodore C. Steele**

"The Trend of Modern Art"
May, 1896

Portrait of Theodore C. Steele. Caroline Brady Papers.

The notes for the Steele essay begin on page 158.

One of Indiana's foremost artists and an articulate proponent for the development of Hoosier art, Theodore Clement Steele was born in a "little log house in an orchard"[1] near Gosport, Indiana, on September 11, 1847, to Samuel and Harriett Steele. His father, a saddlemaker as well as a farmer, operated a saddle shop on the north side of the square in Gosport, a southern Indiana town some four or five miles east of the Steele family farm.

When Steele was four years old, his family exchanged the rolling fields and woodlands of Owen County for the village life of Waveland in west central Indiana. Home of the Waveland Collegiate Institute,[2] a preparatory school for those hoping to enter college, the tiny town of six hundred inhabitants nurtured the young boy. It was there, amid the comfortable clatter of the village goings-on, that Steele was initially introduced to the concepts of color and design by an itinerant sign painter. The informative journeyman taught the lad some of the basics of his trade, giving the attentive youngster a box of cast-off paints with which to practice.[3]

With Steele's enrollment in the Waveland Collegiate Institute in the fall of 1859, he was exposed, for the first time, to an academic view of art. In addition to studying "Spelling, Fourth Reader, Spencerian Penmanship, Object lessons on Forms and Colors; Elements of Numbers; Drawing on Slates; Oral Geography; Composition & Vocal Music,"[4] he worked with Mrs. Bennett, a Waveland art teacher, on simple line drawing and design.

Encouraged by his mother, a perceptive woman appreciative of the beauties of nature, Steele painted wherever and whenever his schooling and family chores would allow. In 1860, the teenager was put in charge of a class in drawing at the Institute. "I was only thirteen years old and didn't know much about drawing, but at that I knew more than anybody else,"[5]

Steele would later say of his initial appointment as an instructor.

For the next eight years, the young man applied himself earnestly to learn all he could about the techniques of art. He must have been successful because his early work showed great promise. In 1861, Steele won a prize at the Russellville Fair near Waveland with a pen-and-ink drawing of the state of Indiana.

Eager to push his horizons beyond the curricular offerings of the Institute, Steele left his family's home for the summer of 1863 to study with Professor Joseph Tingley of Asbury College, now DePauw University, in Greencastle, Indiana. His portrait of two of the professor's children, done during that summer in Greencastle, took a prize at the 1863 county fair in Terre Haute, Indiana.[6] Steele returned to the Institute after his summer's work where he continued as both student and teacher for the next several years. He was listed in the school's 1865 catalogue as the instructor of Drawing and Painting in the preparatory department. In June of 1868, the twenty-one-year-old was one of seven men in a class of thirteen pupils to graduate from the Waveland Collegiate Institute.[7]

Upon completion of his studies, Steele began to seek portrait work, accepting his first commission in late 1868 or early 1869. It was during this period as well that he spent several months in Chicago visiting the city's art galleries and painting under the direction of Mr. St. John.[8] His instructor was very likely Josephus Allen St. John who had a studio in Crosby's Opera House at this time.

By 1870, Steele was supporting himself as a portrait painter. He had finished at least forty portraits—some had been done from life, while others had been painted from photographs[9]—of family and friends from Waveland and from the Indiana towns of Lafayette, Rushville, Peru, Rensselaer, and Greencastle.

A particularly striking portrait done at this time was that of an Institute classmate, Mary Elizabeth Lakin. Affectionately known as "Libbie" or "Bess," this lovely brunette

had always been drawn to the quiet, gray-eyed artist as he had been attracted to her. Both loved music; they often blended his mellow baritone with her warm contralto, singing in harmony to her spirited piano accompaniment at the Lakin home. Sharing countryside walks and the pleasures of reading Keats's poetry aloud to one another, the two enjoyed their time with each other. His insightful soul had found a responsive spirit within her deeply poetic nature.

On February 14, 1870, Steele and Libbie were married in the Lakin family home near Rushville. After their wedding, the newlyweds stayed in the east central Indiana town for several weeks in order that Steele might finish up four commissioned pieces before moving to Battle Creek, Michigan, in early March. During their three-year stay in that state, Steele sharpened his skills as a portraitist, only occasionally needing to augment his earnings by teaching a class in drawing. When there were no portraits demanding his immediate attention, Steele kept busy in his studio, experimenting with color and working to better his portraiture by a stronger delineation of facial anatomy.

Excerpts from a journal kept by Steele during his years in Michigan indicate that he was acutely attuned to the beauty in life and concerned with its interpretation in his work. In his writings on portraiture, Steele noted that an artist needed: "to secure a complete idea of the man or the woman. I mean by this idea of the man, a conception of the whole man. His external form, shape of his features individually and with reference to one another in making up the harmonious whole. Then a conception of the man's mind, the proper weight of his intellect, the measure of his feeling and strength of passions. Indeed, all that there is within him. Then comes the difficult task of expressing all this in the man's peculiar physiognomy. To animate the head with feeling and intellect. The eye and the mouth with the former, and the brow with the latter."[10]

Steele was as artistically meticulous in executing a child's painting as he was in doing a commissioned portrait. While working on a Christmas canvas in 1870, the sensitive painter indicated some dissatisfaction with his interpretation of a basket of holiday toys: "I have failed in securing the tender warm glow with which they were to be bathed. A lot of wooden toys, apples and candy are not particularly enticing to a man's imagination. But to a child, especially in Christmas time, as presents from Santa Claus, they are products from fairyland and are bathed in a peculiar golden light, that shines from his own happy heart. So in a Christmas picture of good Saint Nicholas, they should be painted, if it were possible, with the very lines of poetry."[11]

With the births of Rembrandt Theodore Steele, soon known as "Brandt," on November 16, 1870, and of his sister Margaret, fondly nicknamed "Daisy," on July 7, 1872, Libbie found that she missed the pleasures of sharing the babies with her family and friends in Indiana. Sympathizing with his wife's homesickness, Steele finished his portrait work in Battle Creek and returned with Libbie and their two young children to the Hoosier state in early 1873. Staying for a time in Rushville near the Lakin family farm, Steele painted several portraits, while he and Libbie weighed the possibilities of settling permanently in the state capital.

By the year's end, the Steeles had made their decision and had moved to Indianapolis where the artist opened a modest downtown studio at No. 14, McDonald and Butler's Block on Pennsylvania Street. They had barely settled in the city when the Panic of 1873 put an unexpected strain on the family's limited financial resources.

Steele, along with a number of other artists and tradesmen, was forced to barter work for necessities and to undertake odd jobs for extra money. It was at this time that he and Hoosier poet James Whitcomb Riley teamed up to paint building signs in and around Indianapolis. They made an improbable pair: the exuberant Riley hand-lettered the billboards, and the reserved Steele filled in the remaining space with decorative artwork.[12]

This unlikely collaboration was the start of a lifelong friendship between the two men. Almost weekly, Riley would come up to Steele's third floor studio, acquired after the Panic of 1873 had eased, in the Bradshaw Block on West Washington Street. There he would recite his latest poem and chat, while the artist worked on his portraits. The poet's wild gesturing and droll comments, as he relayed the news of the town, entertained Steele as well as his family who had moved to rooms next to his Bradshaw Block studio in 1876.

In later life, Steele would talk of his friendship with the creator of "Little Orphant Annie:" "Riley and I were always intimate friends, both of us being the same age. He used to try his poems out on me before they were published, he did that with all his friends, though, so far as that goes. I think that possibly the outstanding thing about Riley that impressed me was his graphic interpretation of his time and people."[13]

The relationship between the two was professional as well as personal with Steele doing three portraits of Riley, all from life. He painted the first one, depicting a sandy-haired youth with a bushy mustache, between 1877 and 1879;[14] the second, of which two copies were later made,[15] in 1891, and the third, in 1902. The 1891 portrait portrayed a mature, well-groomed Riley with ribboned pince-nez eyeglasses and light-colored hair parted neatly a little to one side. The poet, shown wearing a white wing-collar, dark tie, and black coat, was painted while seated in a huge wooden armchair. Eleven years later,

Steele did an even larger oil painting of Riley. In that 1902 portrait, a very dignified Riley, holding a pair of gloves in his right hand, was painted while standing next to a desk. A commissioned copy of this portrait was made by Steele more than a decade later.

In January of 1877, Steele was one of several Indianapolis artists to join with John W. Love—whose studio, as well as that of wood engraver Charles Nicolai, was across from his in the Bradshaw Block—in organizing the short-lived Indianapolis Art Association. The group's first exhibition of the work of several Indianapolis artists was modestly successful and proved to be an impetus for the formation of the Indiana School of Art by Love and James F. Gookins[16] on October 15, 1877.[17] Offering drawing, painting, and modeling as well as wood-carving and wood-engraving,[18] the eleven-room school occupied the top floor of the Fletcher-Sharpe Block at the southwest corner of Washington and Pennsylvania streets. Because of his father's friendship with Love, seven-year-old Brandt Steele spent long hours posing for the students of the new school. He later recalled his limited usefulness as a model: "The hypnotic effect of many heads moving up and down, as the pupils looked at me and then to their drawings, put me to sleep."[19] The Indiana School of Art ran into financial difficulties, and, after only two short years, it closed in November of 1879.

While that particular month marked the end of the first regularly organized art school in Indianapolis, it signaled an auspicious beginning for Steele. On November 21, 1879, thirteen of his friends and supporters, at the suggestion of Herman Lieber of the city's H. Lieber & Company, pledged $100 each to the artist

**Theodore C. Steele**
*Still Life with Orange.* **1885**
Oil on canvas
11¾ x 9¼ inches
Private Collection, Zionsville, Indiana

"to enable him to spend one or two years in Europe in perfecting himself in his profession."[20] In return for their generosity, Steele agreed "to repay the several amounts advanced in paintings from his own easel as soon as practicable after his return from abroad, guarantying satisfaction in each case."[21]

With $1300 in hand, the grateful Steele family, numbering five with the birth of son Shirley Lakin on July 15, 1878, set off for Munich and its Royal Academy. On July 24, 1880, they, along with artists John Ottis Adams and Samuel Richards, boarded the Red Star Line's *Belgenland* in New York for an ocean crossing to Antwerp where they entrained for Munich.

The elegant city of Munich, with its fairy-tale castles, picturesque gardens, intimate cafes, and rowdy beer halls, enchanted the family from Indiana. Until mid-fall when the Academy opened, the Steeles spent unhurried days visiting the Munich art galleries and exploring the outlying Bavarian villages as they learned the ways of King Ludwig II's (1864-1886) charming city. They savored the German folk songs, thrilled to the operas of Richard Wagner and enjoyed the festive music played each day in the Marienplatz town square.

On October 16, 1880, Steele was formally enrolled as a student at the Royal Academy in Munich. The school's Matriculation Book stated: "Number 3864; Name: Steele, Theodore, Clement; birthplace and status of parents from Iola, Kansas, America; his father, a leathersmith, Protestant; age of artist, 33; art studies, nature class; date of acceptance, October 16, 1880."[22] Upon his enrollment, Steele was accepted into the life class of Gyula Benczur (1844-1920), a skilled draftsman with the reputation of being the most artistic and the most demanding of the Academy's four professors of life drawing.

During his year of nature study with Benczur, Steele corresponded regularly with his financial backers in Indianapolis.

He told them of the Academy, its schedule, its professors, and of his joy in being able to see progress in his work: "We have no academy work in the afternoon. The working hours in the morning are from 7 to 11 or 12, so begins the afternoons principally to copying the old masters in the old Pinakothek."[23]

Steele reported to his supporters that he did nothing but draw from life while in Benczur's class: "These heads we draw life size. Generally with charcoal. Our professor does not care for light and shade and tone so much as he does for absolute and perfect contour. Holbein and Dürer are the great masters in this respect. This system of drawing touches me just where I am the weakest and will no doubt be of the greatest benefit. In addition to this regular work we draw a day drawing from the nude. Making the figure about 12 to 15 inches in length[24]…At present I am upon the drawing of a half nude figure, an old man with arms extended upon the cross… a super study of chest and throat and shoulders. We spent one month on this half figure. Drawing it very close indeed. I am intensely interested in this kind of work."[25]

In addition to being taught draftsmanship, Academy students in the drawing schools were exposed to lectures upon perspective, art history, architecture, and anatomy. Steele wrote a friend in Indianapolis: "Owing to my bad ear for German, I can get little good out of these lectures with the exception of the anatomy where I hear principally with my eyes. These lectures are by members of the faculty of the Medical College and are accompanied by dissections, the examination of the brains, models and casts. It is quite thorough."[26]

Outside of the hours spent in academic work, Steele devoted himself to copying the Old Masters in the Alte Pinakothek: "A great deal of copying is done here and much of it is extremely bad and gives no idea of the great masters they are intended to present. They get the forms somewhat often, color, but leave out the very thing

**Theodore C. Steele**
*Girl by Cloister Wall.*
Oil on canvas
16 x 25 inches
Brandt F. Steele

**Theodore C. Steele**
*Portrait of Daisy.* 1891
Oil on canvas
45 x 30 inches
Robert B. Neubacher

**Theodore C. Steele**
*Portrait of James Whitcomb Riley.* 1916
Oil on canvas
50 x 42 inches
Indiana State Museum Collection

**Theodore C. Steele**
*In the Kitchen.* 1911
Oil on canvas
24 x 20 inches
Private Collection, Zionsville, Indiana

that makes the original picture great[27]…
At present am copying a crucifixion by
Rembrandt, a small picture but of wonder-
ful power and learning. Among the old
masters, I believe, he impresses me most
strongly. Every picture by him is like a
volume by a great writer to which you can
go daily without exhausting its suggestive
power."[28]

Libbie Steele and the three children
settled into their new life with surprisingly
little difficulty. Ten-year-old Brandt and
his eight-year-old sister were enrolled in
a Munich school, while Libbie stayed at
home to tend the family's modest rooms
and two-year-old Shirley. Before too many
months had passed, young Brandt and
Daisy had become fluent in German, often
translating for their parents who learned
the nuances of the language far more
slowly.

On Sundays, the family spent much of
its free time visiting the city's art galleries.
Libbie remembered with great fondness:
"The Old Pinakothek had a charm for us
that no other place possessed. How many
hours we spent feasting our eyes on the
wonderful pictures by Rubens…And then
the glorious color of Titian; the refinement
and elegance of Van Dyck; but it was Rem-
brandt who enchanted us…Sunday
mornings usually found us at the Kunst-
Verein, a gallery where all the new pictures
were usually put upon exhibition for one
week. The large rooms were always well
filled with a quiet crowd of visitors, earn-
estly studying the pictures. They were
from all classes, the tradespeople as well
as the titled people, and always many
artists and art students."[29]

Libbie, sharing a deep appreciation of
music with her husband, later recalled
other leisurely Bavarian Sundays: "We
went very often to the churches to hear
the music, to St. Michael's especially.

**Theodore C. Steele**
*The Bloom of the Grape.* **1893**
Oil on canvas
30⅛ x 40⅛ inches
Indianapolis Museum of Art, Bequest of Delavan Smith

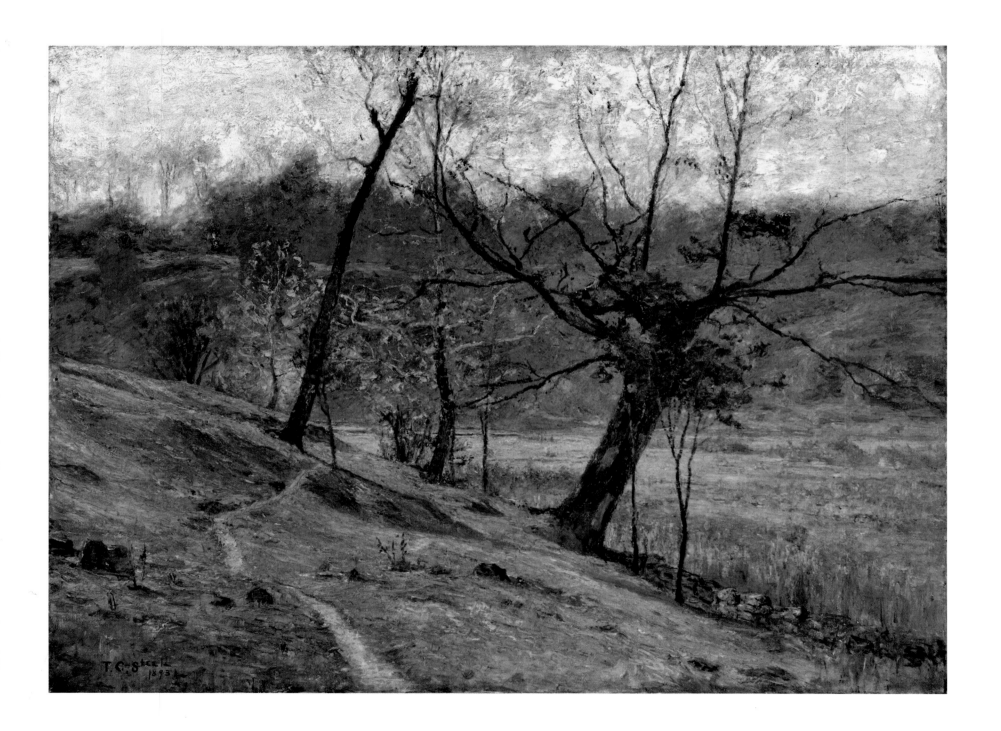

**Theodore C. Steele**
*Libbie in the Garden.*
Oil on canvas
20 x 15¾ inches
Private Collection, Zionsville, Indiana

Reaching St. Michael's, we climbed the dark and winding stairway to the gallery… The music that followed—a powerful creation of one of the old masters—stirred us to our very depths. The deep rich tones of the organ were a background against which came the vibratory color notes of the orchestra, and running through it all was a single voice of clear flute-like quality. It wound in and out like a silver stream, now lost, now again appearing, ever tranquil and sweet."[30]

In late summer of 1881, the family moved to Schleissheim, a village located along the banks of a canal that meandered from the Isar River through the grassy moors of Dachau, some six miles from Munich. At the suggestion of Boston-born landscapist J. Frank Currier and his wife, Steele rented rooms in the Russian Garten, a villa on the road between Schleissheim and Lustheim which had once been occupied by William Merritt Chase, Frank Duveneck, and Currier.

Built by a Russian artisan in stained glass as a studio and family home, the spacious villa also housed Academy students L. Harry Meakin and J. Ottis Adams along with the Steeles. The three artists used the Russian's large studio, heated by a ceiling-high porcelain stove decorated in bold relief with the story of the Apostles and the Last Judgment, as a place in which to store their paintings, colors, and easels. The second floor of the Schleissheim house became their living quarters. For Libbie and Steele, the best feature of staying at the Russian Garten was the villa's music room. With large French windows overlooking a formal garden, a rosewood piano, and shelves of books and sheet music, the room soon became a favorite gathering spot for many of the house residents and their visiting friends.[31]

During the summer, Steele began to work seriously on his landscapes under the guidance of Currier,[32] an expatriate artist who had lived and painted in Munich and in its neighboring villages since his student days at the Academy twelve years earlier. Steele wrote to one of his Indianapolis backers: "Mr. Currier, under whose criticism I have worked in Landscape this summer, says I have made some big steps in this summer's work. He says he recognized in my later work a more subtle feeling for tone and that I have broken away from the tight hard method of execution, into a method more dashing, brilliant and artistic. It has cost me no little work to do this and it gives me more pleasure than I can tell to feel I am upon the right road and progressing…He (Mr. Currier) is a man whose opinion I value very highly for he is honest and frank… He has studied here some 12 years for he considers himself still a student, though in landscape I doubt not if he has a superior in all Munich."[33]

When the Academy opened in October of 1881, Steele traveled from Schleissheim to Munich each day by train, leaving at seven in the morning and returning in the early evening hours. He entered the painting school of Ludwig von Loefftz (1845-1910), a genre and historical painter widely known to be one of the Academy's most exacting professors. Under his critical eye, Steele worked on perfecting the techniques of portrait and figure. Occasionally Loefftz corrected him for a "tendency to sweet unsound color and want of refinement in drawing and method of brushing"[34] and suggested improvement in brushing for his "methods of painting (were) bad and uninteresting."[35]

Chafing at times under Loefftz's close scrutiny, Steele, nonetheless, wrote his friend and most enthusiastic patron Herman Lieber: "I suppose that I have the good fortune to be under the best teacher of painting in Germany."[36] Despite Steele's feeling that Loefftz's ideals were often almost unattainable, he would later admit that he knew his technique had improved because of his work under this demanding professor.

**Theodore C. Steele**
*Interior Scene with Daisy and Shirley.* **1894**
Oil on canvas
28 x 22 inches
Mr. and Mrs. Lewis L. Neubacher

By spring of 1882, the family was faced with the prospect of finding new lodgings as word had come that the Russian Garten was to be appropriated by the government for use as a hospital. Rather than return to Munich, the Steeles chose to move to the nearby village of Mittenheim where they took rooms in a centuries-old monastery that had been converted into a farmhouse. Along with two classmates, one of whom was Hoosier artist William Forsyth who had come that year to study at the Academy, and a German decorator and his wife, the family occupied rooms on the second floor of one wing of the old Cloister.[37] The landlord and his family lived in the other wing, while the main building was given over to stabling the landlord's farm animals.[38]

With characteristic intuition, Libbie described the subtle appeal the Cloister held for her husband: "The building itself inside and out is an object of beauty to the Artists. Its vaulted ceilings supported by arches and pillars, its old brick and stone floors, its unevenly shaped rooms, and antique windows are inviting studies for rainy days. Its outer walls stuccoed and rich in most harmonious and delicious colors. Its sunlit court with ancient well, and picturesque figures moving about, is equal so the artists say to any Eastern scene. The Cloister and garden are enclosed with a high strong wall."[39]

The Hoosier artist spent an idyllic summer working in the Cloister and its tranquil garden as well as sketching the sweeping Dachau moors and the nearby forests of pine and fir. With the coming of winter and the promise of its bitter winds, the Steeles decided to abandon the drafty corridors of the old monastery for the relative warmth of a house in Schleissheim. In early autumn, they took rooms with the Kuttendreir family, who lived next to the Curriers, in a house which faced the village's tree-lined canal.

**Theodore C. Steele**
*Winter Day.* 1892
Oil on canvas
22 x 29 inches
Private Collection

By the start of the 1883 academic year, the family was once again settled, and Steele was able to turn his thoughts to the Academy and the rigors of Professor Loefftz's class.

For the next two years, the student artist studied with Loefftz to improve his skill, technique, and color sensitivity. His Academy figure and portrait work was characterized by an attention to detail and a palette of low color values. Even his landscapes, done with Currier in the countryside on holidays and during the summers, were marked by the Old Master gloomy dignity of somber greens, murky grays, and dull browns.

Steele made great progress studying under Loefftz. Shortly after the end of his course work in July of 1884, he was awarded a First Class prize for his painting *The Boatman* at the Academy's yearly exhibit of students' work. The Academy was hopeful that the oil might be purchased for its permanent collection, but Steele, feeling that his best work belonged in Indianapolis, sent the canvas back to his home state. An Indianapolis newspaper critic reported:

"The Boatman *is a more pretentious painting given to things simply pleasing and beautiful. It should be considered a portrait. There is only a suggestion of water and sky, and only a board for a boat. Exposed to the belt and bending at the oar, it has given the artist opportunity to display his knowledge of human anatomy. . . It is a striking picture, sufficient of itself to give its author a permanent reputation.*[40]

During the winter and early spring of 1885, Steele continued to submit his work to Loefftz for criticism, recording the professor's comments very carefully in a notebook. He worked until mid-April when he reluctantly put aside his paints to help Libbie with preparations for the journey back to the United States. With an understandable mixture of sadness and anticipation, the Steeles, on May 23, 1885, boarded the Red Star Line's *Nordland* in Antwerp for the first part of their trip

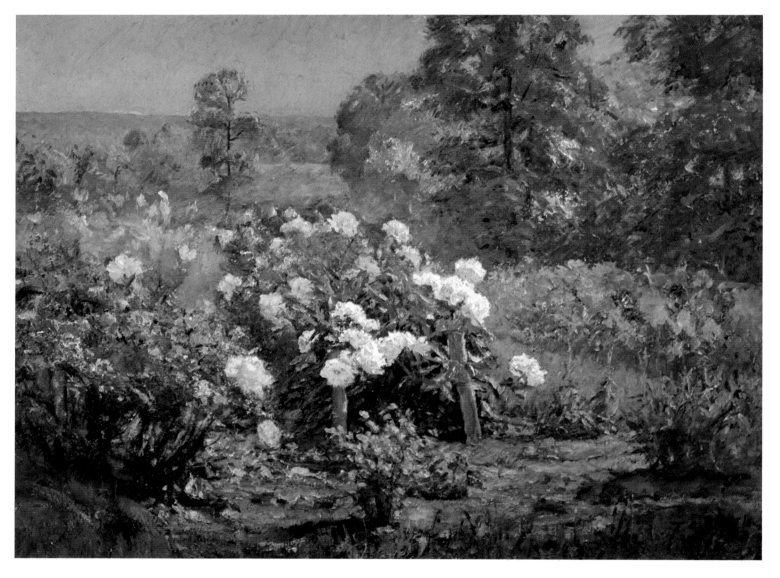

home. Their ship docked in New York on June 6th, and within several days, the weary family arrived in Indianapolis after a long, tiring train ride from the East Coast.

The Steeles' five-year stay in Munich had been a time of great joy and shared discoveries, marred only by periodic financial uncertainties. With additional pledges from his supporters enabling "him to complete a career so full of promise and honor"[41] and the sale, in Indianapolis, of some of his canvases sent from Germany, Steele had been able to finish his Academy work.

A particularly successful show during his student years had been the Art Exhibit of the Hoosier Colony in München held at English's Hall in Indianapolis during April of 1885. Sponsored by Lieber's Art Emporium, the exhibit and sale had highlighted the Munich work of Steele and Forsyth who had sent canvases from the Bavarian city for the exhibition. Catalogue illustrations for the exhibited work had been done by Charles L. McDonald, Thomas E. Hibben, Fred A. Hetherington, and Charles Nicolai, members of the Bohe Club,[42] an informal fraternity of artists working in Indianapolis during the early 1880s.

The Steeles were pleased to be back in Indianapolis. Shortly after their arrival, they leased a vine-covered, New Orleans-style house, known as Tinker Place, on the north side of Sixteenth Street between Pennsylvania Street and Talbot Avenue. The children: Brandt, fourteen years old; Daisy, nearly thirteen, and Shirley, almost seven, loved their new home. Daisy remembered: "To us children it was like living in a park. There were forest trees filled with melodious bird song; stretches of blue grass dotted here and there with stars of Bethlehem, beds of iris and tiger lilies. There were rose bushes too with cinnamon-scented blossoms and Mother had a large bed of delicately scented petunias…Father loved to paint this yard when he was free from portraits and teaching and could not get to open country."[43]

**Theodore C. Steele**
*Tennessee Appalachians.* **1899**
Oil on canvas
13¾ x 20½ inches
Mr. and Mrs. Herbert B. Feldmann

Committed to repaying those who had contributed to his Munich study, Steele opened a studio in downtown Indianapolis soon after his return and began work on the promised paintings. By the spring of 1886, he had painted fourteen portraits and had, in the process, become so exhausted that he considered giving up painting entirely. With Libbie's encouragement, however, he resumed his work after a time, painting first around the yard, then along Fall Creek, and finally in Vernon and the Muscatatuck Valley of southern Indiana.[44]

During the summer of 1886, the artist built a studio in the yard of Tinker Place, honoring a long-held wish of Libbie that his studio be located close to his home. Daisy explained: "It was a happy day when Father's first studio was finished. The dream of years had become a reality. Built in the yard of Tinker Place, northeast of the house, where there were no trees to interfere with the light, it served both as a workroom and an exhibition room. Father and Mother soon made it a charming place —a studio to which friends as well as patrons eagerly came. Many of Father's best portraits were painted here, among them were those of James Whitcomb Riley and Vice President Fairbanks."[45]

By October, Steele was rested and prepared for another winter of portrait work, recognizing that it was the major source of income for his family. According to Brandt, his father was challenged by portraiture and viewed it as "his bread and butter… As he said to me, he often had to penetrate through a coat of greenbacks on a man's face, and what he found there was interesting but not always paintable."[46]

In the late summer of 1887, Steele was commissioned by Allen Fletcher and Judge Cyrus C. Hines to paint family portraits in New England as well as landscapes of the Vermont countryside between the towns of Ludlow and Cavendish. Steele wrote former classmate J. Ottis Adams, who was still working in Munich, of his progress

**Theodore C. Steele**
*The Old Mill.* 1903
Oil on canvas
30 1/16 x 45 1/8 inches
Mr. and Mrs. Clarence Long

upon being home: "I am here in Vermont, in the mountains, near the old Fletcher homestead. Had orders for landscape work from them sufficient to pay expenses of self and family…I have done very well this summer but have not yet realized much in my work. I hope to clear a clean thousand above my expenses this summer."[47]

During the family's four-month stay in the picturesque Green Mountains of Vermont, Libbie frequently took the two older children walking along the winding trails in the surrounding hills. Brandt later recalled those special times with his mother: "She had a great love for the out-of-doors that lasted all of her life, a knowledge that came from accurate observation and sympathy. She made us understand that we were but a part of nature; that a wild thing had as much right to live life as we did."[48]

Portraiture, which continued to occupy the majority of Steele's working hours, was occasionally pushed aside to make way for exhibition work and the artist's community interests. In 1889, Steele opened an art school in Circle Hall, a building which once had been occupied by the Reverend Henry Ward Beecher's Second Presbyterian Church, at the northwest corner of Market Street and Monument Circle. Among Steele's students that year was Booth Tarkington, a promising young writer of fiction. Tarkington enrolled in a strenuous, six-day-week program at the artist's Indiana School of Art in mid-November of 1889 and worked through the winter under his private tutelage.[49]

In mid-1891, Steele was joined by William Forsyth who had left his teaching position with J. Ottis Adams at the Muncie Art School to work with Steele in Indianapolis.

Their Indiana School of Art was incorporated in 1891 by members of the Art Association who each had pledged five to twenty-five dollars annually to the school's operating fund. With the assumption of the management for the school by a board of nine directors, Steele was able to resign his administrative post shortly after the incorporation. The artist would continue to teach day and evening classes, however, until February of 1895 when he would leave to devote more time to his painting. The school would remain in operation until it would be forced to give up its quarters, in June of 1897, to make room for the expansion of the nearby English Hotel.[50]

In November of 1894, Steele displayed fourteen oils, both landscapes and portraits, in an Art Association of Indianapolis exhibition at the Denison Hotel. Renamed Five Hoosier Painters with the addition of two paintings by J. Ottis Adams, the show was moved to Chicago the following month. Impressed by the work of these Hoosier guest artists, sculptor Lorado Taft, in a thoughtful critique of the exhibit, wrote:

*"While the versatility of some of them is astonishing, the individual note is always strong. I have failed to find a single picture here which looks as if it had been founded on another man's work. They have personalities; those Indianapolis fellows. I want to know them. Steele seems the biggest man of the lot."[51]*

The Chicago critics were particularly impressed with Steele's effectiveness in handling landscapes as well as portraiture. One reviewer commented:
*"It doesn't seem possible that the same man who did those bold landscapes could do portraits in so delicate and uncertain a manner. The woman is extremely refined and the man is highly praised, by some artists yesterday, but I like Steele best when he is spreading sunlight over the hillsides."[52]*

After the success of the Chicago exhibit, Steele shared his thoughts about the work of the Hoosier Group: "Forsyth and I were in Munich together nine years ago. When we returned we worked together in Indianapolis for a while and then separated. Adams, Stark and Gruelle had the same ideas that we had and naturally we fell into a style. For nine years we have kept at it without any apparent encouragement until lately. Though together, I think we have maintained our individualities. Forsyth's work has a distinct personal element. I think he paints splendidly…Stark, too, does fine work. Gruelle is a young man wholly self-taught and somewhat defective in color, but he is overcoming that fault. His sentiment is fine, and he has a good dramatic faculty, so I expect him to become a first rate painter."[53]

Believing that "art is best developed in a country by stimulating and encouraging that which it has rather than by importing art,"[54] Steele, along with Adams and Forsyth, was instrumental in the creation of the Society of Western Artists in 1896. In addition to participating in the Society's yearly art exhibitions, the last of which was held in 1914, Steele would be elected president of the prestigious group on October 19, 1898.

Within Indianapolis, the culturally-minded artist was involved in both the city's Literary Club and in its Portfolio Club whose goal was to "bring the various art interests of the community together and promote a spirit of art interest and appreciation."[55] With poetic perception and a facile pen, Steele wrote four papers which he presented to the Literary Club over a span of fourteen years: "The Development of the Connoisseur in Art" in December of 1888, "From the Painter's Point of View" in February of 1892, "The Trend of Modern Art" in May of 1896, and "The New Movement in Art" in January of 1902.[56] A champion of the Impressionist movement, Steele enjoyed exploring art matters of the day in the papers he presented to each club. Beginning in 1890

through February of 1921, Steele would write and read twelve papers for the Portfolio Club.

While primarily a portrait painter,[57] particularly during his Indianapolis years, Steele had been drawn to landscape work long before his exposure to Currier in Munich. He had written in his art journal in 1870: "I love nature in all her forms whether in the human face 'divine' or in tree, brook and sky. My efforts to delineate, however, have been confined almost entirely to portraiture, and it is now a question with me as to whether I should make it so exclusive. Especially during the present year, I have felt strong desires to explore the beauties of the material world. And upon my earliest opportunity shall I commence a composition landscape. In the meantime, studies are to be made from nature and the mind trained to closer observation of the effects of light."[58]

Steele's fascination with the effects of atmospheric conditions upon outdoor subjects was lifelong, and he worked steadily to improve his technical skills in this regard during summer sketching trips and on holidays. With his painting forays into the Hoosier countryside, there came a gradual abandonment of the low-keyed, monochromatic Munich tones in favor of a brighter, lighter, more colorful palette. In an effort to portray light and color more accurately, Steele introduced purer hues into his pictures, working toward a looser technique and a spottier application of color. Shortly after the opening of an 1894 exhibit in Chicago, Steele had written a friend: "It was an effort with me to get away from Munich blackness into the brilliancy of light and color of my own climate, but no one was more surprised than myself when my pictures in Chicago were hung in the Impressionists' room."[59]

Summer and early autumn usually found the artist in the woods or along a stream, working on his landscapes.

**Theodore C. Steele**
*Oaks of Vernon.* **1887**
Oil on canvas
30 x 45 inches
Indianapolis Museum of Art, John Herron Fund

Frequently he would take his family with him; Libbie and the children took great pleasure in sharing the beauties of nature with Steele as he painted not far from their campsite: "When out with Father on his painting trips, he would often call our attention to the rhythm that came from the repetition of certain shapes in the trees in a landscape, the melody we could hear in the wind and the sound that water made as it rushed by the reeds in the brook. He would point out to us the colors that 'sang': combinations of colors that made us happy and others that had a somber effect. He called our attention to the fact that the song of a bird could change the whole mood of a scene before our eyes. At one time he painted two landscapes to illustrate this feeling. One he called *Song of the Mourning Dove* and the other *The Call of the Bluejay.* Afterwards he changed their names to *Serenity* and *High Noon* because he wanted the pictures to suggest by themselves, to those who knew, the quality of the songs of these birds."[60]

Daisy later recalled her father's decided preference for landscape painting and how he had always looked forward to those summers when he could be in the country: "Not a minute of these precious weeks was wasted. Sometimes Father painted on four or five different subjects a day, changing the canvases as the light changed. When he had a horse, he filled his buggy with canvases and drove out to his subjects. He was always happy in the country and came back to the city reluctantly, bringing many unfinished canvases that he worked on later in the studio."[61]

**Theodore C. Steele**
*Pleasant Run.* **1885**
Oil on canvas
19¼ x 32½ inches
Indianapolis Museum of Art,
Gift of Carl B. Shafer

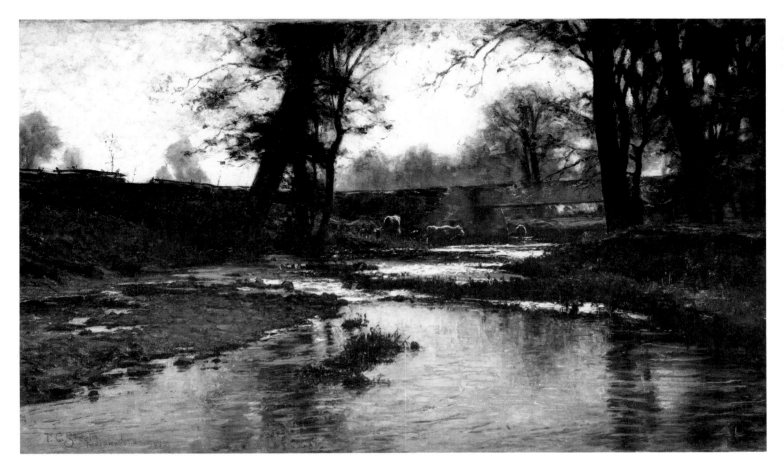

In the summer of 1888, Steele had camped with his family near the old mill at Yountsville and along the banks of Sugar Creek in Montgomery County. One year later, he had returned by himself to the same area for his summer's work, boarding at "Mother Gunkle's" in Yountsville. In 1890, Steele had spent some time painting with J. Ottis Adams along the Mississinewa River in Delaware County, and, in 1892, he had worked with William Forsyth around Vernon and along the Muscatatuck River in Jennings County. For the following three years, Steele had explored various areas of the state, working for two summers near Vernon, and another, along the Mississinewa at Black's Mill with Adams.

In 1896 and again in 1897, Steele took Libbie and Daisy with him to Metamora, a charming Franklin County village tucked away in the scenic Whitewater Valley. Boarding with her husband and daughter at a house within several hundred feet of Steele's studio, Libbie thoroughly enjoyed watching the progress of her husband's landscapes. She wrote a friend in Indianapolis: "But it is so gloriously beautiful here, and that is like a wholesome wine to one of his nature, his enthusiasm knows no bounds and he works from six o'clock in the morning until six in the evening, with an hour's rest at noon."[62]

In the late fall of his 1897 painting trip to Metamora, Steele and Adams, who had joined him for several weeks of landscape work in that little town, decided to put aside their brushes in favor of a wandering horseback ride along "the east branch of the Whitewater, then down to Brookville."[63] During their day-long outing, they came upon the old Butler House—"an ideal place for an artist, house, grounds and situation"[64]—hidden in a tangle of woods on the east fork of the Whitewater River. Intrigued with the possibilities of using the rambling old place as their permanent studio, the two artists talked with the owner only to find: "He asks too much for it, however, for our purpose we think."[65] Nevertheless, in early February of 1898, Steele and Adams decided to buy

**Theodore C. Steele**
*Morning—By the Stream.* **1893**
Oil on canvas
22 x 27 inches
Theodore L. Steele

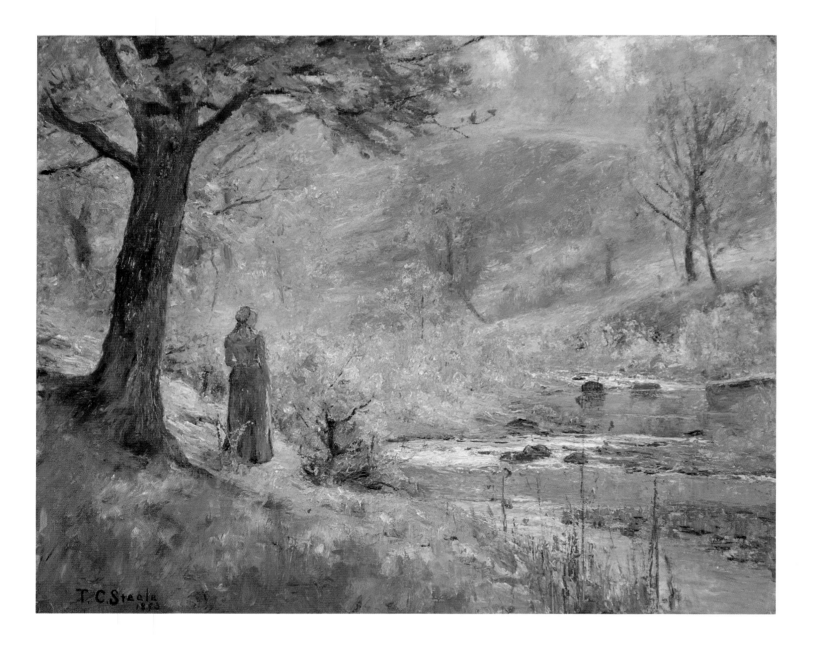

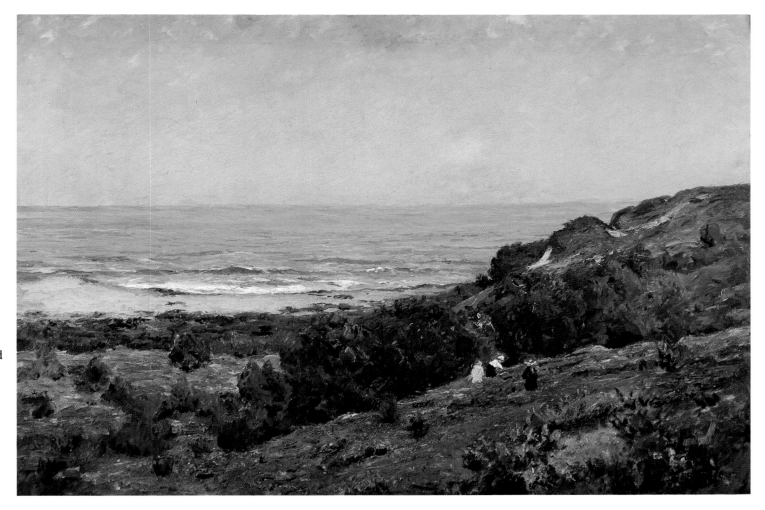

the house, financing its purchase with a promise of paintings as well as with a note payable to Butler for $200 plus one year's interest due on February 1, 1899.[66]

With the whispering beauty of the surrounding hills and the shimmering waters of the Whitewater River nearby, the Butler house offered unlimited painting prospects to Steele who was ready to settle with his family in one spot for his summers' work. The fairly extensive, but necessary, remodeling of the nineteen-room homestead was finished in late summer of 1898. Each artist had added a wing to the house; Steele's lodgings and studio on the south were joined to Adams's on the north by a deep colonial porch more than one hundred feet in length. Hoping to "have many happy days there; it is a very restful place,"[67] Libbie named the artists' newly-renovated quarters the Hermitage.

Sharing some of her childhood memories of the Hermitage, Daisy later wrote: "Here, in Brookville, in the nineties, we had our summer home. It was situated on the east fork of the Whitewater...During late summer, when the water was low, Bouncing Betty bloomed in the stream bed and the opposite bank was gay with goldenrod and purple asters...The Hermitage was built many, many years ago.[68] Its fireplace was so huge that logs we fed it always looked lost. Remodeling the house made it quite our own. My brother Brandt designed the stained glass windows for the living room, where along the walls above the wainscoting were series of paneled openings to be filled by sketches of artist friends."[69]

Steele, however, would only use the Hermitage studio for his summer landscape work, while Adams would choose to make it his formal residence after his marriage, on October 1, 1898, to Winifred Brady. Later, in the spring of 1907, Steele would sell his interest in the Hermitage to Adams before building the House of the Singing Winds in the hills of Brown County near Belmont, Indiana.

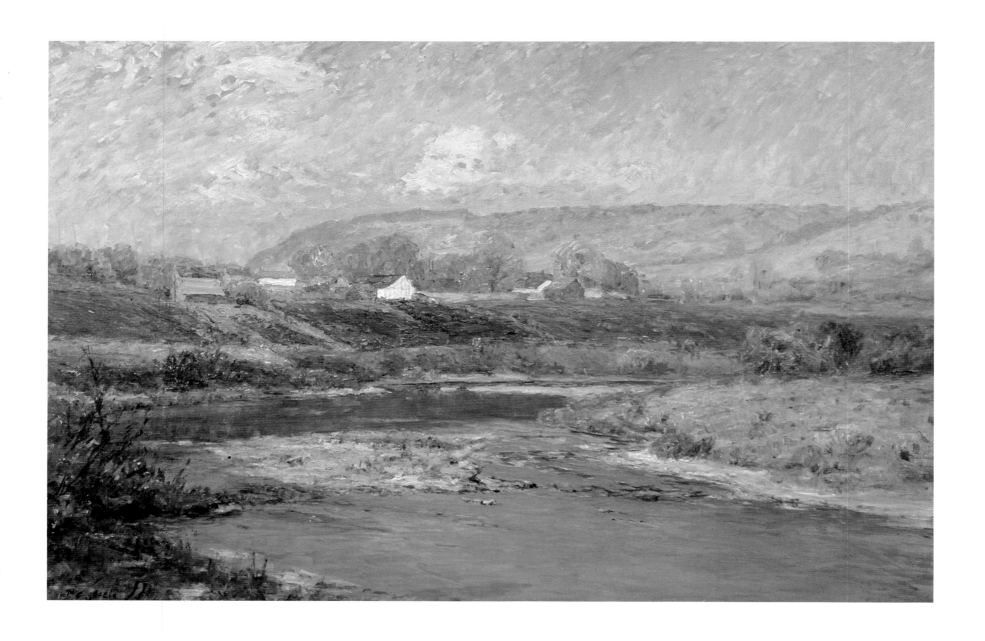

At the center of Steele's life stood Libbie. His "darling Bessie"[70] was generous and loving, giving freely of herself to her husband and her children. With deep tenderness, Steele had written to his wife from Yountsville in August of 1889: "Yes, there is something about our home that makes it our earthly paradise. It is our love for one another and because it is ruled by a wife whose heart is as big at least as her body. It is a gratification to me that though I fail in so many things, I am able to give the wife and bairns a home, or rather make it possible for the wife to make the home for she is the homemaker. Yes, I have often wished for you since you left, to walk with me and look at things, and when I have brought in my work I want to call you to see. There is no getting on without you, Bess."[71]

Libbie was not only an inspiration to the artist, but was of actual assistance in his work as well. With her gentle perceptions, she had become a valuable critic of Steele's efforts, quietly guiding her husband toward a more poetic vision of the world. Steele gratefully acknowledged her influence, admitting to his son: "I owe everything to your Mother, it was she who made a landscape painter of me, instead of a portrait painter. I always did love the out-of-doors, even as a boy, but as I grew older I saw everything through the eyes of Keats and Shelley. Your Mother taught me first to see with her eyes and then through my own."[72]

The Steeles' Tinker Place home in Indianapolis was full of love and family camaraderie. All of the Steeles were fond of music. Libbie and Daisy played the piano; Shirley, the cello, and Brandt and his father, the flute. Steele had learned to appreciate the instrument in boyhood when he had borrowed his father's flute to practice outside on a hillside near Waveland.

As a child, Brandt remembered listening to "the sound of his (Steele's) rich baritone voice mingling in the twilight with Mother's contralto, as they sang 'Beautiful Dreamer' or some other Foster melody,"[73] and "seeing my Father walking back and forth in the living room singing 'Come Where My Love Lies Dreaming' accompanied by Mother on the old square piano."[74]

One of Daisy's sweetest memories was "hearing Mother play Handel's 'Largo' in the evening hours before the lamps were lit. Mother loved the twilight and when it became too dark for Father to work in the studio, it was his habit to come to the living room to listen to her or sit with her before an open fire, talking quietly…After the evening meal, Father always read to us. Gathered around the table or before the open fire, we listened to *Ben Hur*, poems of Keats, Henley and others. I do not know whether Father chose books that were particularly musical in their diction or whether it was his own rich intonation that made his reading so melodious: But I do know I looked forward to the music of his voice as much as hearing the contents of the book…After the reading, it was Father's custom to bring to the living room the pictures upon which he had worked that day. These he studied by lamplight, sometimes humming or whistling as he tried them in different lights. Studying the day's work before he went to bed was a habit, I think, Father kept up as long as he lived."[75]

Libbie's spirited strength and deep appreciation for life were undermined by her often-weakened physical condition. A lengthy bout with typhoid fever in 1876 had not only turned her hair from black to silver gray, but it had presaged a lifelong series of health problems for the gallant woman as well. In 1894, Libbie had been stricken with rheumatoid arthritis, and, by the following spring, she had been left painfully crippled by the disease. Hoping that his wife might benefit from treatment at a sanitarium in Spencer, Indiana, Steele had rented a house near the center during the summer of 1895. After their return that fall from the southern Indiana town, the artist had written his son Brandt: "The subjects I find in Spencer have not proved the best for me and of course the constant anxiety in regard to Mama, who became much lower in health than we let you know, has had its influence. The work looks worried and shallow. The most of it is not even good realism let alone poetic interpretation."[76]

During the winter of 1898, Libbie became markedly worse, and, in the early summer of 1899, she was diagnosed as having contracted tuberculosis. Thinking that the cool mountain air might help ease her discomfort, Steele took his wife to the small village of Roan Mountain in the Appalachian Mountains of Tennessee. His painting during their summer stay openly reflected his anguish over Libbie's deteriorating condition. According to one of their grandchildren, the artist did "a picture that summer in Tennessee of a river, a very stormy sort of thing. I always thought that it was a picture of how he felt; I think he was tremendously upset."[77] The Steeles returned to Indianapolis in mid-September, and, during the evening of November 14, 1899, Libbie died.

The death of his beloved "Bessie" devastated the fifty-two-year-old artist. She had been his dearest friend, his most helpful critic, and without her, for a time, he was lost.

In the summer of 1900, Steele returned to the solitude of the Hermitage, taking Daisy with him for company. She recalled carrying pots of coffee to her father's "studio wagon," a gypsy-like caravan with seats along one side and big windows through which Steele had an unrestricted view of the Brookville landscape. There the grieving artist "was ensconced with canvas and easel, a little stove nearby to warm numb fingers. As twilight came on we would wend our way back to the Hermitage fire, stopping on the way at the shed for a few more sticks of dry beech wood. Tired as he often was, he always lingered here to see the effect of the evening sky against which Brookville's roofs and towers were silhouetted."[78]

The bereaved family continued to live at Tinker Place until the fall of 1901 when their lease ended and the house and grounds were sold to the Art Association of Indianapolis. On March 4, 1902, the Association opened the John Herron Art Institute, holding its first classes in the artist's former studio. The Steeles' elegant two-story house would be used by the Institute until 1905 when it would be torn down to make way for the construction of a larger building. Upon the sale of Tinker Place, Steele, Brandt, and Daisy—Shirley had married Almira Daggett of Indianapolis in October of 1900—moved to East St. Clair Street where they took a little row house on the north side of the street.[79]

Feeling that he needed a change and a fresh look at things, Steele planned an ambitious trip to the West Coast in the summer of 1902 after Brandt's June wedding to art teacher Helen McKay. With Daisy as a companion, he made arrangements to stay with his mother and brothers in Oregon for a time and to visit Shirley and his wife who were living in California.

During his cross-country train ride in July, the artist watched the shifting American landscape with interest. Impressed with the grandeur of the Rocky Mountains, he found them: "Clear cut, graphic and cold, unsoftened by atmospheric tints and with little charm of color, they yet fill the mind with that awe we feel in gazing into the astronomic depths of the sky."[80]

**Theodore C. Steele**
*Whitewater Valley.* **1896**
Oil on canvas
18 x 28 inches
Mr. and Mrs. Gordon O. Gates

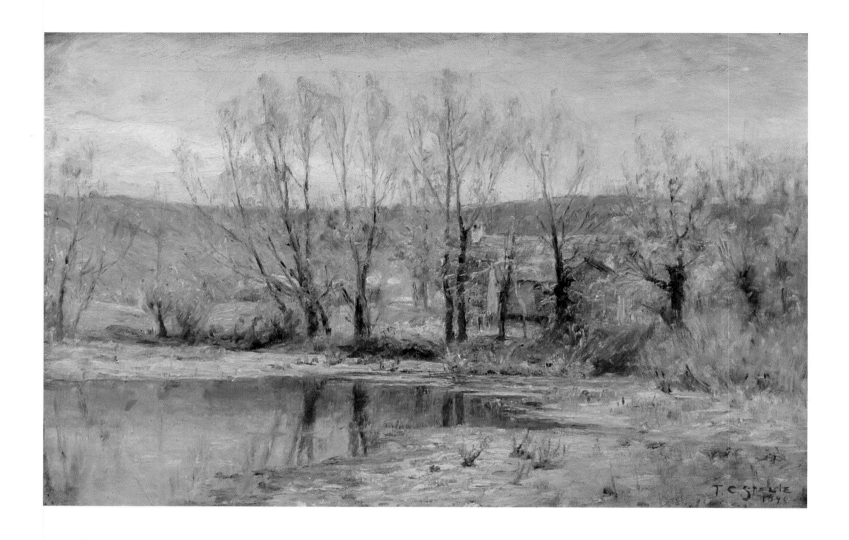

The peace of the Oregon coast, with its deep forest thickets and shaded pathways, soothed the heavyhearted artist. He would later write: "Among the most delightful memories of my life is this one of the month at Nye Creek Beach, so novel were its experiences and so marvelous its poetic appeals. I would not give the impression, however, it was all spent in moonlight walks and loitering in those picturesque lanes. There were days of incessant work. I had gone to the coast unwillingly, but fell under the spell of its charm at once and every day felt more and more the eternal challenge, the ocean, like the mountains, makes to the painter and poet for a voice and interpretation."[81]

From Oregon, Daisy and her father went to Redlands, California, where they stayed until mid-November with Shirley and his wife. During their visit, Steele was particularly intrigued with both the color and the atmosphere of southern California: "The air seems to vibrate with flashes of colored light, rose and violet, red and blue and orange, and this with a vividness and intensiveness I have never seen before…It has in it something of unreality."[82]

For the next several years, Steele divided his time between his Hartford Block studio —located in the same building as those studios belonging to J. Ottis Adams and R. B. Gruelle—another trip in 1903 to the West Coast, and summer work in Brookville. With the marriage, in June of 1905, of his daughter to Gustave Neubacher of Indianapolis, Steele's parenting responsibilities had come to an end. All of his children were happily married, and nearly six years had passed since Libbie's death. It was time for the artist to begin a new life.

**Theodore C. Steele**
*Laura's Nook.* **1887**
Oil on canvas
17 x 27 inches
Mr. and Mrs. Leo J. Kuzma

In 1907, Steele bought over two hundred heavily-wooded acres in the hills of Brown County, Indiana, and set about building a studio-home there. On August 9th of that same year, he married Selma Neubacher, who, although she was twenty-three years younger than the artist, offered him companionship, devotion, and a shared interest in art. A graduate of Pratt Institute and a member of the Indianapolis Sketching Club, Selma had become well acquainted with Steele after the marriage of his daughter Daisy to her brother Gustave. "A handsome woman of striking appearance, with a fair complexion and light auburn hair,"[83] she had served as the Assistant Supervisor of Art for the Indianapolis public schools in 1906.

Shortly before his marriage, Steele had written his son Brandt: "As I say, I thank you, for I love you now just as deeply as when you were my tottering firstborn no bigger than your own children…It (my marriage) is no sudden impulse, but long and, I trust, well considered. But in conclusion, only this, I want the love and respect of my children, and so far as Selma is concerned, no woman could have had higher ideals and motives than she has and saner views as to the finer relations with all than she has."[84]

Immediately after their August wedding, the sixty-year-old artist and his bride left Indianapolis to live, for the rest of the summer, in the recently completed studio-home high atop a windswept hill in Brown County. Accessible only by a steep road rutted with gullies and full of rocks, the newlyweds' four-room cabin held a pioneering charm for the city couple. The rustic bungalow, soon known as the House of the Singing Winds, was initially quite modest. One large room across the north side of the Steeles' new home was set up as a studio, while the other three served as the kitchen, a dressing room, and an indoor bedroom. Screened porches which extended along three sides of the house were used during the sweltering summer months of July and August for outdoor dining and sleeping.

During the nineteen years in which Steele and Selma would live in their Brown County home, they would add several rooms to the original structure, modernize the kitchen, install indoor plumbing and build several guest cottages for family and friends visiting the House of the Singing Winds. In 1916, Steele would build a lofty, barn-like studio to obtain better lighting conditions than those available in the studio area of his house. At that time, he would write his friend, novelist Hamlin Garland, of the spacious, high-windowed room under construction: "I am busy building a large studio, 30 by 50 with a 21-foot ceiling. Something I have needed for a long time."[85] Garland, to whom Steele had given a landscape painting in 1899 as a wedding present, would be able to visit the artist and inspect his airy studio in November of 1920. After getting up early to tramp in the hills with his host, he would later tell Steele: "As a landscape painter, you have made no mistake in finding your hunting ground, for I have never seen more interesting country."[86]

Upon the Steeles' arrival, in 1907, at their isolated hilltop cabin some one and one-half miles from Belmont and twelve miles from Bloomington, the artist plunged joyously into his landscape work. Selma, whose knowledge of Brown County "had been limited to hearing my brother Walter talk enthusiastically about its primitiveness and picturesqueness,"[87] was left alone to set up housekeeping and learn the ways of her hill-country neighbors.

With some dismay, Selma would later write of her first impressions of Brown County: "At the time conditions seemed incredible. Were we not but a few miles removed from a university center? And

yet there were obvious reasons why this countryside should have been left untouched by the progress of the world outside. Its people were shut in by bad roads a large part of the year. Travel was slow and very difficult. Thus, but few had contact outside their hills…There was no (enforcement of) compulsory school attendance. Very many were illiterate. Newspapers came to very few families. Intermarriage had been going on a long time. Child marriages were frequent. All the families that I knew were related. The one standard of living had become fixed."[88]

Both Steele and his wife made an effort to be gracious to the curious country folk who dared to visit the Indianapolis couple to see the artist's "under-the-house-cellar," reputed to be the first of its kind in southern Indiana. During one such visit, Selma was particularly offended by their guests' frequent spitting of tobacco juice upon her clean hearth: "Once—when it had been done and it looked too indecent to pass it by, I turned to the painter and said that there must be a way to solve this problem. 'I know,' he replied, 'we are up against a difficult situation. What can you do, when the practice is even carried on during services at church, by both minister and men? We must not lose their goodwill.'"[89]

The Steeles settled into a comfortable routine of spending their summers in the wooded hills of Brown County and their winters with relatives amid the hustle and bustle of Indianapolis city life. Socially and professionally active during his stay in the Hoosier capital, Steele continued with his portrait work as well as with his participation in gallery talks at the John Herron Art Institute, exhibitions, and formal lectures to various groups in town.

During the winter months on many Sundays, Steele made a point of going to the Art Insititute to view its new exhibitions and to talk with old friends. Formally attired in a cutaway coat for those afternoon outings, the tall, slightly stooped

artist enjoyed the chance to explain his work and to invite people to visit him at his winter studio.[90] Located on the fourth floor of the Circle Building on Monument Circle, Steele's city studio was open to visitors each day, "a plan offering a pleasant opportunity in the way of an all winter exhibition."[91]

In addition to his ongoing portrait work, Steele made good use of the scenic views from his downtown studio window. Intrigued with the architectural subject matter before him, he investigated, in a series of urban landscapes, the effects of the mists and swirling snow upon the Soldiers' and Sailors' Monument, Christ Church, and the street traffic around the Circle.

Each year with the coming of spring, the Steeles left Indianapolis for the solitude of the House of the Singing Winds. There Steele eagerly resumed his work in the Brown County hills, leaving his wife to find activities with which to fill her days.

According to Selma, the pattern of their lives was set, in many respects, by the painting needs of her husband. She was exceedingly tolerant of his rather eccentric work schedule, keyed as it was to the rhythm of nature and the ever-shifting light of the sun: "Mr. Steele believed that during a work season no landscape painter should be in bed after four o'clock in the morning. So breakfast always came early—more nearly at five o'clock than six. Dinner at midday came long before the hour of noon. After dinner came a short period of relaxation, generally consisting of some reading, music, or a short time spent together out-of-doors. Then followed the afternoon and evening hours of painting. Ofttimes, when the evening subject was a distance from the house, I carried the evening meal to him and we ate it from a mossy stone or bank."[92]

Steele's joy at being in the out-of-doors each spring was contagious. It prompted Selma to work in a small vegetable garden near the house and to oversee the planting of flower gardens "interesting enough to be placed on the painter's canvas."[93]

**Theodore C. Steele**
*House of the Singing Winds.* **1920**
Oil on canvas
30 x 40 inches
Private Collection, Zionsville, Indiana

**Theodore C. Steele**
*Snow Scene at House of the Singing Winds.*
**1916**
Oil on canvas
30 x 45 inches
Private Collection

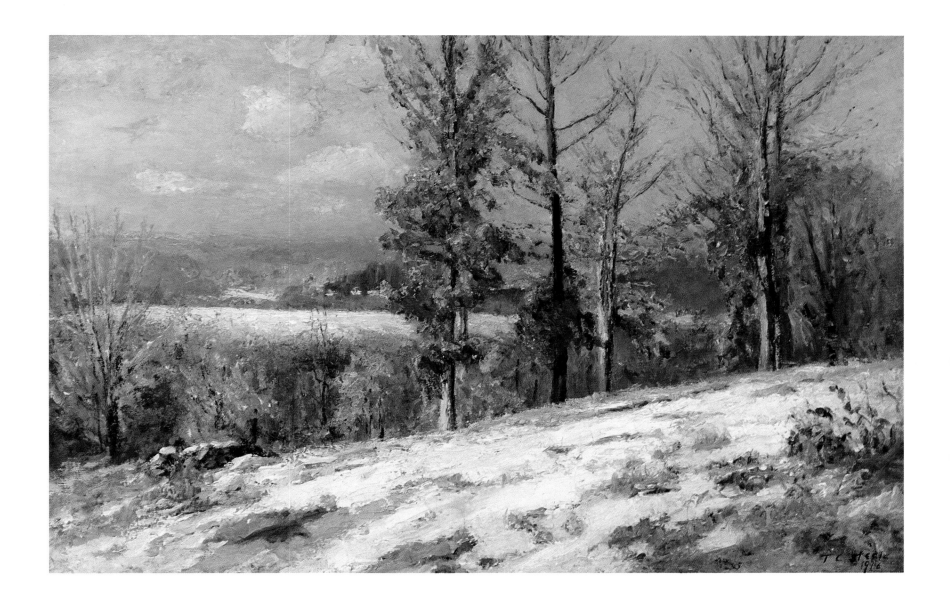

Although delighted to be able to share in her husband's work by providing colorful flower arrangements for his paintings, Selma became intrigued, during the summer of 1908, with the prospect of making her gardening ventures financially rewarding: "Plans were now developed with the idea that it might be possible to have the gardens, with additional features, supplement the general income. I reasoned that, begun as an experiment, they might prove a way of making the place self-supporting."[94]

Intent upon learning all she could about the latest techniques in family farming, Selma sent for free bulletins offered by the U.S. Department of Agriculture and the School of Agriculture at Purdue University in West Lafayette, Indiana. Curious about gardening and undaunted in trying to succeed at it, Selma began her new project with the hired help of neighboring hill folk.

In an evaluation of her progress as a commercial gardener, Selma reported in October of 1913: "First, one hill slope, of about an acre, was planted in an orchard, comprising a variety of fruit trees… Another hill slope was put into grapes, small fruits, and an asparagus bed…The first planting was done very carefully, according to bulletin directions. This happened in the preparation of a bed (16 by 120 feet) for the growing of asparagus… Not only did every plant grow, but now, after five years, the bed has become quite productive, affording surplus for sale…

The grapes came next. Each hole for planting was carefully prepared. They, too, took good root, grew into strong plants and are now supplying the family table. The same careful method was used in planting fruit trees. They are making, on the whole, a good growth… Gardening seemed to come easier than chicken raising…At first, because of inexperience, I seemed doomed to complete failure. I had never handled a hen in my life. Still, my chickens were doing about as well as those of my neighbors."[95]

In 1922, Steele was asked by William Lowe Bryan, the president of Indiana University at nearby Bloomington, if he would accept a position on the faculty as an honorary professor of art. The courtly painter was not expected to teach or lecture, but simply to become an artist-in-residence. It was the hope of the University's fine arts department that his presence on campus might lead students to a greater appreciation of beauty and a better understanding of the artistic process. With this latest honor—Indiana University had previously conferred an honorary LL.D. upon the artist in 1916—the Steeles decided to forego their annual stay in Indianapolis. Instead, they chose to live in Bloomington and to take a small brown bungalow on the east side of the campus for the winter months.

A large garret room on the top floor of the University's library building served as both a studio and an exhibition room for the artist. Decorated with second-hand furniture, window plants, Turkish rugs, and gaily-colored shawls from Selma's extensive collection, the studio quickly became a mecca for many of the University students. Steele welcomed their visits and allowed them to study his work while he painted. Occasionally he even gave an informal lecture, using his unfinished canvas to point out some consideration of technique. During mild weather, the painter enjoyed working out-of-doors, and he encouraged the students to look over his shoulder "if they (didn't) talk too much."[96]

One of Steele's grandchildren, a student at the University during the artist's appointment, would later write of his collegiate memories: "I'm glad that I got to really know Grandfather during last winter …There are several pictures that pop into my mind: one as we sat in his bungalow and he read to me from a book about John Burroughs; another of him as he talked to me up in the studio; and another of a warm day late this spring as I helped him carry his easel and a canvas or two from the campus to the studio."[97]

The students were fond of the honorary professor, naming him the recipient of a journalism fraternity award "given each year to the man on the faculty who has done the most during the year toward the general advancement of culture in an educational institution."[98] The depth of their feelings for the kindly painter was never more apparent than when, in 1924, a forest fire threatened the House of the Singing Winds. The collegians sent a delegation of volunteers who bravely fought the fire in the Brown County hills until it was extinguished and the artist's studio and house were saved.

Steele was as popular with the faculty as he was with the students. With Selma serving as attentive hostess, the painter's Sunday afternoon teas in his inviting attic studio were often the highlight of the week's events for a number of the University professors.

During his years in Brown County, Steele had occasionally visited Indianapolis without Selma, coming to town to deliver a paper, talk business, or check on an exhibit. Sometimes he stayed at his son Brandt's house, but more often, he spent several nights with his daughter Daisy and her family: "I believe Grandfather visited us as often as possible considering he was not living in Indianapolis. Anytime he came to town I believe he came to our

house to see us. I recall one occasion, due to washed-out roads, I think, he stayed with us for a number of days. He had to be occupied, and soon went downtown and bought paints and canvas, and started work along Fall Creek near our house. In a few days he was able to return home, and I don't believe any picture he started during this visit was ever finished."[99]

Although Steele had been afflicted with debilitating rheumatic fever for a time during the summer of 1918 and had suffered a heart attack from which he had recovered in December of 1925, the painter's general health, with the exception of an annoying hand tremor, had been good. The day before the 1926 summer commencement at the University, however, Steele became seriously ill. Upon the advice of friends, the ailing artist went first to Long Hospital in Indianapolis for observation and tests and then to the clinic of his friend Dr. J. H. Weinstein in Terre Haute, Indiana, for treatment of a gallbladder problem.

On July 4th, he was released from the clinic and sent home to the serenity of his Brown County hills. Selma reported to Dr. Weinstein on July 8th that Steele was in pain and was having difficulty in breathing: "These gasps for breath come at times very frequently."[100] Anxious to lessen her husband's suffering, Selma went to Bloomington to purchase supplies. She wrote Dr. Weinstein: "He is having everything that the market offers that will help towards giving him strength. I bought an electric fan and also a couch hammock yesterday—any suggestions to offer?"[101] Despite continuing medical supervision by his friend and Selma's solicitous attentions, Steele's health weakened with each passing day.

**Theodore C. Steele**
*Across Monument Circle.* **1918**
Oil on canvas
26 x 34 inches
Private Collection

Finally, in the early evening hours of July 24th, 1926, the gentlemanly painter died at the age of seventy-eight.

Throughout his life, Steele had participated in a great many exhibitions, served on several prestigious art juries and had been the recipient of a number of significant awards. As early as 1884, during his student days at the Royal Academy in Munich, Steele had won a silver medal from the school for his oil *The Boatman*, and, in 1900, his *Bloom of the Grape*, painted in 1893, had received an honorable mention at the Paris Exposition.

In 1906, Steele had been awarded the Mary T. R. Foulke prize for *The Cloud* at the Richmond Art Association annual, and, in December of 1909, he had won the $500 Fine Arts Building Prize for *A March Morning*. The Fine Arts Building award, first offered in 1906 by a Chicago corporation, was awarded annually to a regular or associate member of the Society of Western Artists during the group's Chicago exhibition. In the spring of 1926, Steele had won the $200 Rector prize with *The Hill Country, Brown County* at the second Hoosier Salon which was held at the Marshall Field Galleries in Chicago.

Steele's exhibition life had been rich and varied. He had displayed his work regularly within Indianapolis, both in one-man shows and with other artists, and had been involved in numerous statewide, national, and international exhibitions.

His work had been selected for presentation at the 1893 World's Columbian Exposition in Chicago, the 1904 Louisiana Purchase Exposition at St. Louis, the 1910 International Exhibition of Fine Arts at Buenos Aires, Argentina and Santiago, Chile, and the 1915 Panama-Pacific Exposition in San Francisco. Steele had also been chosen to serve on the art juries of selection and of awards for the 1904 Louisiana Purchase Exposition at St. Louis and the 1915 Panama-Pacific Exposition at San Francisco. According to a biographical sketch of her father written by Daisy: "Mr. Steele served on many Art juries, this fact probably losing him some awards. The members of such juries do not receive awards, the appointment itself being an honor."[102]

The painter's many contributions to art were recognized with his election, in 1913, as an associate member to the National Academy of Design. An oil portrait of Steele, required by the Academy for its permanent collection of members' portraits, was done in Boston by his old friend from Munich days, Frank H. Tompkins (1847-1922).

In many respects, Steele's paintings were descriptive of the man. Thoughtful in his consideration of others, Steele combined dignity with a quiet graciousness which was never forced. According to an art critic of the day:

*"As a rule, Steele selected those objects of nature that brought to his composition a feeling of dignity and calm— nature in repose, rather than nature in action. Although his pictures were often characterized by vigor and force in the execution, it was rare to find a suggestion of the dramatic in his landscapes...Not often did he introduce figures into his landscape composition. Occasionally, there are groups of cattle that stray through the wood pastures in his large landscapes. Steele was fond of open spaces...there is always a feeling of freedom, as one looks out, across or up vistas and wide valleys and distant hills and the blue sky above with clouds that float high."*[103]

The subtle strength of Steele's portraits, the gentle grandeur of his landscapes, and the philosophical force of his writings were tangible signs of the artist's lifelong concern with the enduring loveliness of nature. He once wrote: "What God thinks of beauty we know from the fact that he has made it so universal. From the heavens above to the earth beneath, of which we are a part, there is this continual expression of beauty, harmony and order. Day after day, the hours weave their magic; seasons come and go, eternal change, but always with its gifts of beauty."[104]

**Theodore C. Steele**
*Observatory at Indiana University.*
Oil on canvas
22 x 32 inches
Dr. and Mrs. John Shively

**J. Ottis Adams**
*Library at the Hermitage.*
Oil on canvas
27¾ x 36 inches
Mr. and Mrs. Thomas B. Adams

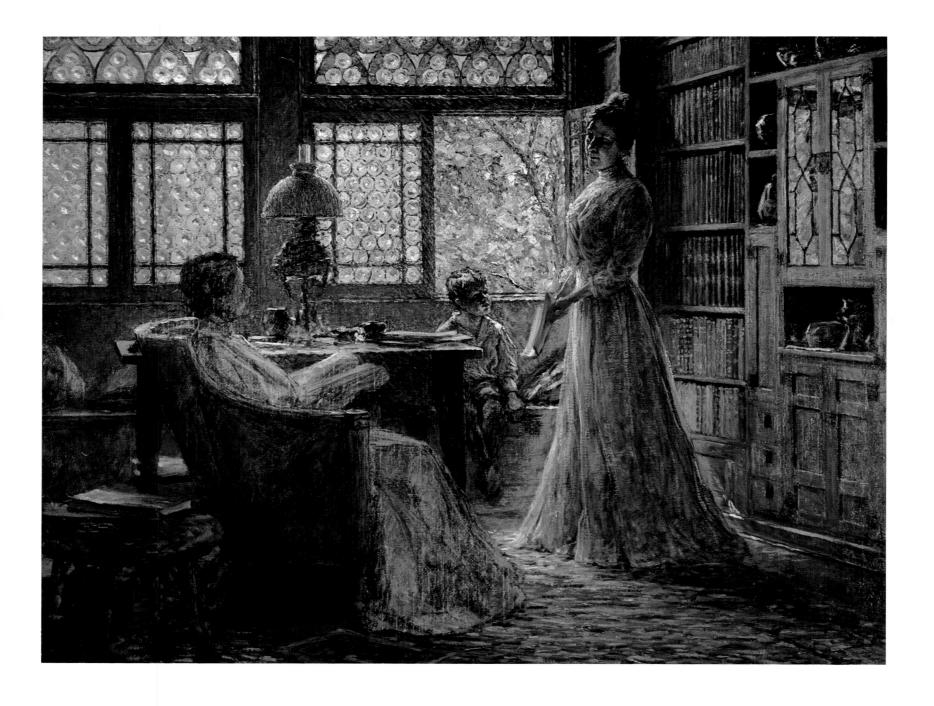

# J. Ottis Adams                1851-1927

**After two days of rain, I went out in the woods...and it seemed to me I had never seen anything that looked as much like what we picture fairieland as the woods were.**

**J. Ottis Adams**

15 October 1919
Leland, Michigan

Portrait of J. Ottis Adams. Caroline Brady Papers.

John Ottis Adams was born on July 8, 1851, in Amity, Indiana, a tiny Johnson County village which, according to Adams, contained "a vast population of sixty to seventy souls both good and true."[1] His parents, Elizabeth Strange and Alban Housley Adams,[2] moved frequently during the young boy's childhood. Soon after his birth, the family left Amity to settle first in Franklin and then in Shelbyville where Alban Adams worked as both a local merchant and a part-time farmer.

The youngster attended elementary schools in these small Indiana towns "spending most of the time trying to draw and paint,"[3] and went on to high school in nearby Martinsville when his family again moved. His high school teacher there, a perceptive young woman who was only three years older than her pupil, remembered Adams for his special ability in art. Impressed with his finely crafted geography maps, she encouraged him in these early efforts. Adams, shy though he was, responded to his teacher's interest by bringing her occasional gifts of homemade maple sugar candy.[4]

In between his schooling and farm chores, Adams spent every spare moment sketching. The eighteen-year-old's artistic ambition was fired by an 1869 Indiana State Fair exhibit in which he saw a painting *Still Life With Watermelon* by William Merritt Chase, a lad two years his senior who had been born in the neighboring Johnson County town of Williamsburg. Chase, who had studied in Indianapolis with Barton S. Hays prior to leaving for New York to work at the National Academy of Design in late 1869, received every award that summer in the State Fair's amateur division.[5] The artist's award-winning painting fascinated Adams who began to experiment with variations of the tabletop watermelon-and-knife composition in his fledgling still life work.[6]

Upon graduating from high school, Adams enrolled at Wabash College in Crawfordsville, Indiana. Personal notes that he kept in a small record book during the 1871 school year indicate that his finances were limited. The college freshman was thrifty, making every effort to spend no more than the monthly stipend from his father allowed. Meticulously recorded entries in the youth's journal reveal that the majority of his expenses went for college tuition, board, art supplies, haircuts, and textbooks, several of which were required for a Greek grammar course. An occasional ice cream soda seems to have been his only luxury.[7]

In 1872 an opportunity arose for Adams to travel to England to "commence a serious study of art in a branch of the South Kensington School"[8] in London. He cut short his schooling at Wabash—the school, nevertheless, in 1898, would grant him the honorary degree of Master of Arts in recognition of his ability as an artist[9]—and set his sights on a traditional European art education. His passport, issued on September 16, 1872, described him: "Age, 21 years; stature, 5' 10''; forehead, high and narrow; eyes, dark brown; nose, medium; mouth, small; lips, full; chin, not prominent, small; hair, black; complexion, dark; face, narrow, long."[10]

In October of 1872, Adams arrived in London and rented an inexpensive attic studio at 12 Boziers Court on Oxford Street. Although his new lodgings were inconveniently located at the top of several flights of steep stairs, they offered the young student a breathtaking view of the sprawling city's rooftops and chimney pots. To help with the cost of schooling and to supplement those funds supplied by his father, the twenty-one-year-old took a part-time job at Estabrooke's American Ferrotypes, a studio advertising its photographs as "Made and delivered in a few minutes, at 3a Tottenham Court Road, Corner of Oxford Street."[11] Entries from Adams's financial journal suggest that he was characteristically frugal, spending most of his money on art materials,

The notes for the Adams essay begin on page 159.

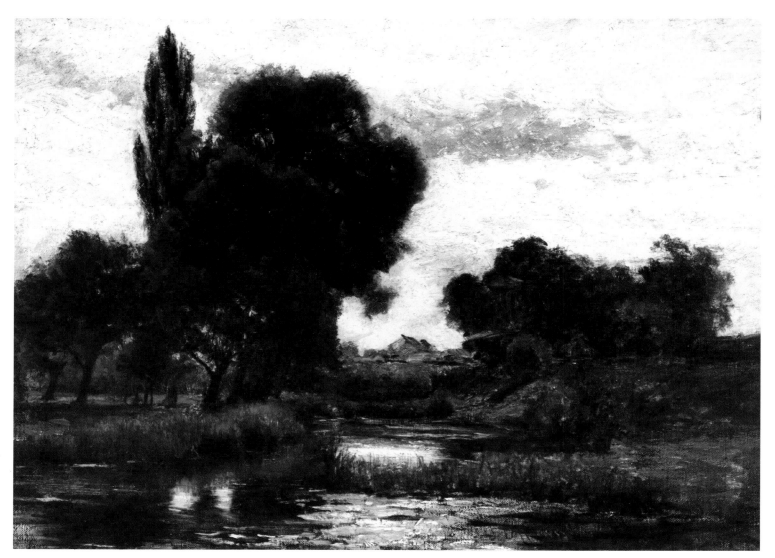

stretchers, frames, an easel, varnish, and fees to various art exhibitions. The penny-wise student obviously treated himself very little to the extras in life. Instead of the ice cream soda of Wabash days, his sole recreation in London seems to have been an infrequent trip to the theater.[12]

With Adams's enrollment at the South Kensington School of Art, the young Hoosier found himself squarely in the middle of a bureaucratic squabble sparked by the Industrial Revolution. The intention of the founders of the South Kensington school had been to train students in "ornamental art" as distinguished from "fine art" which was considered to come exclusively within the province of the Royal Academy. From its inception in 1837, South Kensington had been designed to focus upon the application of the arts to manufacturing with the hope that its students could be instructed to use their artistic skills in the decorative industries, especially in the silk, china, and furniture trades. Almost from the start, however, both the teachers and the students were attracted by a fine arts curriculum rather than a practical design course related to manufacturing.[13] As a result, the educational philosophy of the school vacillated through the years. At some points, the South Kensington faculty concentrated upon teaching industrial design, and, at other times, it emphasized instruction in fine arts.

The classes offered at South Kensington during Adams's term of enrollment included elementary drawing, geometry and perspective, architectural and mechanical design, designs, antique drawing, painting, sketching from nature, life study and models. Taught in sessions of varying lengths ranging from two to five months, some of the subject classes often spanned a multiple series of sessions.[14]

**J. Ottis Adams**
*Nooning.* 1886
Oil on canvas
$28\frac{7}{16}$ x $38\frac{7}{8}$ inches
Ball State University Art Gallery, Muncie, Indiana,
Gift of Mrs. Fred D. Rose

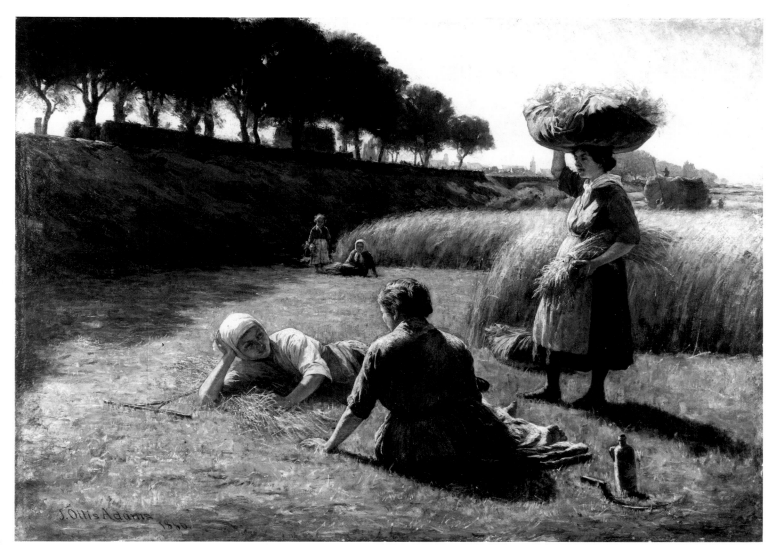

While copying the paintings of the masters in London's National Gallery, a standard academic exercise for many of the South Kensington students, Adams was drawn to the works of John Constable (1776-1837) and Joseph Mallord William Turner (1775-1851). A painter of trees, of running water, of cornfields and of cottages, Constable emphasized the appearance of the sky and clouds and the effects of light and shadow in his land-scapes. Painting rapid oil studies in high key color, he examined familiar scenes under every change of season and at various times of the day.[15]

Turner's approach to landscape work, less defined than that of Constable's, was concerned more with the subtle, the obscure impression. With an atmospheric view of form and a free manner of handling, he paid great attention to the problems of illumination. He was noted for his imaginative watercolors and oil paintings, often depicting dramatic sunsets and sunrises done in a brilliant kaleidoscope of colors. Adams's early independent study of these highly innovative English landscapists appears to have influenced his stated preference, in later years, for landscape material as subject matter.

On July 1, 1873, Adams was awarded a "Certificate of the Second Grade" granted by order of the "Science and Art Department of the Committee of Council on Education," the Parliamentary committee charged with overseeing the South Kensington school. According to the proud student's certificate: "J. O. Adams has passed a satisfactory examination in freehand drawing, practical geometry, linear perspective and model drawing."[16]

After his certification at South Kensington, Adams continued his London studies, becoming associated with John Parker (1839-1915),[17] a landscape and genre painter working mainly in water-color. On June 25, 1874, Parker wrote a Letter of Introduction to the Keeper of the Royal Academy for his student who was considering enrollment there: "I beg leave

**J. Ottis Adams**
*Blue & Gold.* **1904**
Oil on canvas
18 x 28 inches
Private Collection

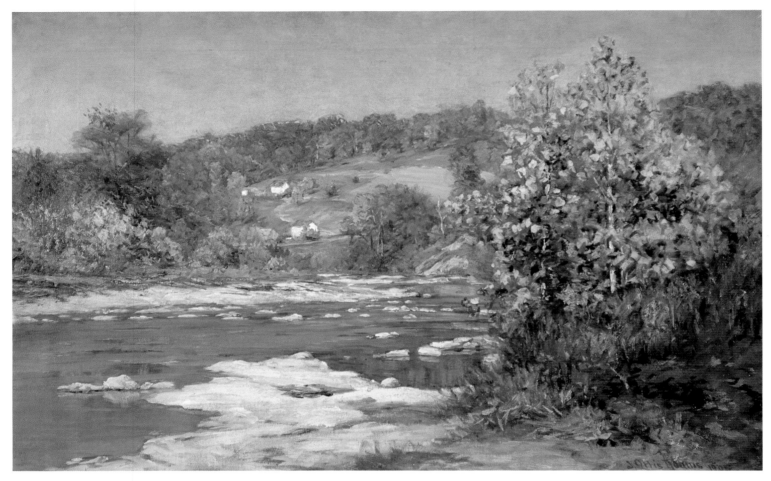

to recommend to you the Bearer, who is desirous of cultivating the Art of Painting in the Schools of the Royal Academy. If you think the specimen of the Candidate's ability presented to you with this Letter sufficient for the purpose, I request the favour of you to lay it before the President and Council. With respect to the moral character of the applicant, I can truly state that it is in every respect a satisfactory one."[18]

By the fall of 1874, Adams had decided not to pursue the admission process at the Royal Academy any further. Instead, he completed his course of study in London, and, in late 1874, the newly trained artist returned to his parents' Hoosier home in Seymour where he opened a portrait studio.

The following spring, he moved to nearby Martinsville, and, about a year later, he located in Muncie, setting up a studio in the east central Indiana town. To supplement his initially sparse earnings from portraiture, the struggling painter worked for a photographer named Gamble, presumably tinting photographs to make them appear more lifelike.[19] Unlike most of the period's photographer-painters, Adams seemed to have resisted the temptation of reproducing a photographic-like image of a subject in his portraiture. His painting retained a distinctive, artistic style.

During his four-year stay in Muncie, Adams produced a number of portraits. Because of his training at South Kensington, his copying of the Masters in the National Gallery, and his work at Estabrooke's American Ferrotypes, Adams's portraits in the late 1870s were considered among the best of those being done in the state at the time.[20] He paid close attention to facial details, sharply defining individual features while treating the body, clothing, and background in a more indistinct fashion. Adams's work was quite popular, attracting a number of commissions from the families of Muncie's

**J. Ottis Adams**
*Brookville.* 1903
Oil on canvas
22 x 32 inches
Mr. and Mrs. Richard Wise

leading citizens. One of his particularly attractive studies was an oil of Sarah Heinsohn, a young girl dressed in a dark winter costume which contrasted dramatically with a snow-covered landscape background.

In 1880, Adams learned that several Indiana artists were planning to study at the Royal Academy in Munich. Encouraged by his Muncie patrons to pursue additional training abroad, Adams addressed himself to the feasibility of financing an extended stay in the Bavarian city. Writing to William Merritt Chase in New York, Adams asked the artist, who had studied at the Royal Academy in Munich during the mid-1870s,[21] about the possibility of copying work in the Munich galleries upon commission to help defray his schooling expenses.

Chase, the Hoosier-born artist who had first inspired Adams with his Indiana State Fair watermelon still life, thoughtfully replied: "In answer to your letter of the 23rd...art students can copy in the old Gallery in Munich at any time. I believe the only restriction is that they do not allow a picture to be copied twice by the same person within one year. The Gallery is not in any way connected with the Academy. I should think what you suggest might be done. Yours truly, Mr. W. Chase."[22]

Reassured by Chase that his monetary concerns could be resolved in this manner, Adams, prior to his departure for Germany, was able to interest some of Muncie's citizens in copies of the masterworks hanging in the Alte Pinakothek, Munich's principal art gallery. Dr. W. C. Willard, who had previously engaged Adams to paint portraits of his wife and children, was among the first to commission such a piece.

It would be more than a year, however, before Adams would ship three canvases from Germany to Muncie with the accompanying paperwork: "I, John O. Adams, the undersigned, a citizen of the United States, an artist residing at Munich, do solemnly and truly declare that the two oil portraits and copy of an old master herewith in box addressed to W. C. Willard, Muncie, Indiana, are executed and produced by me, and that it is intended to ship the same to the port of New York, there to be entered, duty free, as the production of an American artist, under the provisions of Sec. 2505 of the revised statutes of the United States. John O. Adams, subscribed and sworn to this 19th day of October, 1881."[23]

Throughout his study in Munich, Adams would continue to make reproductions of the masterpieces hanging in the Alte Pinakothek. Records show that among those paintings he sent to Muncie were striking copies of *The Lion Hunt*[24] by Rubens and *The Money Counters* by Murillo. Of *The Money Counters*, one of Adams's sons later recalled: "The picture is a copy which my father made while he was in Munich in about 1885. He did quite a little work of that kind, taking orders from people in this country and using the money to pay his expenses while he was studying. This picture was originally sold, but later bought back by my mother and hung in our living room in Indianapolis for a number of years."[25]

Satisfied that his orders for copy work would guarantee at least a year of study at the Royal Academy, Adams looked ahead with quiet anticipation to his training in Munich. On July 24, 1880, he, in the company of fellow artists Theodore C. Steele and Samuel Richards, sailed on the Red Star Line's *Belgenland* from New York. Adams recorded their crossing to Antwerp in his diary: "*July 24, 1880:* Most of passengers have been sea-sick. Have had a good time laughing at them. Richards enjoyed it very much until sick himself, when he remarked that he did not see any fun in laughing at people that were sick…

*Belgenland, July 29, 1880*: 1454 miles at sea, wind blowing a brisk gale. Are having a good time. We play all kind of games such as cards, checkers, dominoes, horse billiards, pitch quoits. We have 21 passengers and seven or eight bad children, the latter at present crawling around and over the tables upon which am writing."[26]

After nearly a week at sea, Adams reported: "*July 30:* Seen in cabin in evening, at first table on one side Steele and Richards writing and Mrs. Richards playing solitaire, on other Steele's two children trying to write in imitation of their father at one end of the table. The two sisters of the two priests, one asleep, at the other end the old German and myself playing cribbage, beer. At the center table the old doctor and one of the priests playing dominoes, beer, the jolly Dutchman drinking with them and singing in German. The young sculptor reading. At the next table the fat-faced Frenchman, wife and Mrs. Spitzentatter watching them."[27]

The Indianapolis party landed at Antwerp in early August, traveled to Cologne by rail and then took a steamer up the Rhine River. Because the Academy classes did not begin until later that fall, Adams had a chance to wander the cobble-stoned streets of the city which would be his home for the next seven years.

Munich, in the 1880s, was a stimulating place in which to study for the twenty-nine-year-old Hoosier. For several generations, the Bavarian royalty had encouraged painting, filling the city's Alte Pinakothek with superb examples of the Old Masters, especially from the Dutch and Flemish schools. Picturesquely situated on the banks of the Isar River, the city, under the generous patronage of Ludwig I (1825-1848), Maximilian II (1848-1864), and Ludwig II (1864-1886), had taken great care to develop and maintain a spirited cultural life.

Almost a decade after American artists Chase, Frank Duveneck, J. Frank Currier, and Walter Shirlaw had studied at the Royal Academy, Adams would enroll in the Munich school. Located within walking distance of the Frauenkirche, a fifteenth-century church with bulbous, gold-tipped domes atop twin brick towers, and close to the north gate of the old walled section of the city, the Royal Academy's rooms had once been the home of a religious order. The gray-stoned monastery building would remain the site of the Academy until October of 1884 when the school would move to new quarters on Akademiestrasse nearer the Alte Pinakothek.[28]

Nearly three months after his arrival in Germany, Adams became a student at the Royal Academy. Its Matriculation Book stated: "Number 3861; Name: Adams, John Ottis; birthplace and status of parents from Seymour, America; his father, a farmer, Protestant; age of the artist, 29; art studies, nature class; date of acceptance, October 15, 1880."[29] The Academy professors, widely known through exhibition work, were reputed to be some of the period's more academically demanding teachers. With Karl von Piloty (1826-1886), a painter who specialized in melodramatic historical scenes, as Academy director,[30] the school required its students to have a thorough knowledge of drawing, painting, and composition before allowing the completion of their course of study.

Despite Adams's earlier work at South Kensington in London, his skills in draftsmanship were not sufficient to allow his entrance into the second stage of the school's curriculum. He was, therefore, placed in one of the Academy's drawing schools. For two years, the occasionally frustrated young man studied life drawing in the class of Gyula Benczur (1844-1920),[31] one of the best draftsmen in Munich. Often working six to eight hours each day in charcoal, Adams first copied ancient sculpture casts and then drew from live models before he acquired the requisite degree of proficiency for admission to one of the Academy painting schools.

In the fall of 1882, the Muncie student was finally accepted into the painting school of Ludwig von Loefftz (1845-1910), a genre and historical painter who was considered to be the Academy's leading master. With his entrance into the class, Adams had to put aside any reliance upon charcoal work. Professor von Loefftz, assuming all students to be well-grounded in draftsmanship, required them to paint without benefit of making an initial reference sketch. Adams and his classmate T. C. Steele were pleased to be among those working under the direction of this exacting professor. Steele explained: "I suppose that I have the good fortune to be under the best teacher of painting in Germany. The only thing his eye is so sensitive to tone and color and his ideal of technique so high that none of us can come up to it, but we are all the better for the effort."[32]

**J. Ottis Adams**
*Winifred at the Hermitage.*
Oil on canvas
22 x 29 inches
Caroline F. Brady

**J. Ottis Adams**
*Flower Border.*
Oil on canvas
13½ x 17½ inches
Private Collection

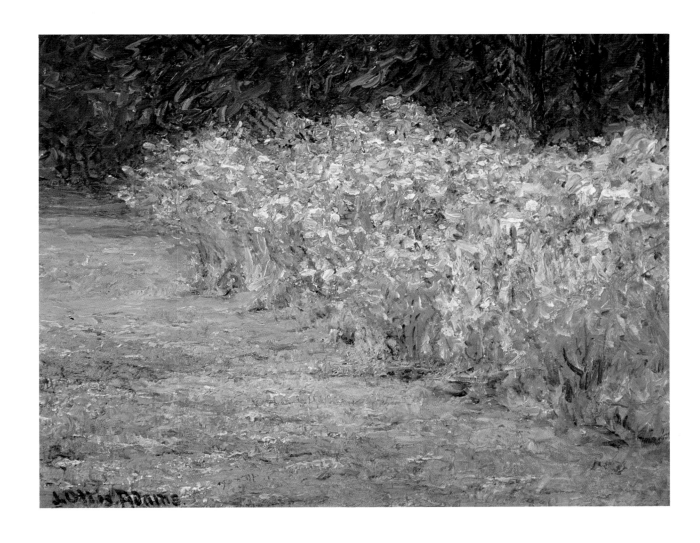

Adams studied painting with Loefftz for three years before leaving the Academy in early summer of 1885 to set up his own studio in Munich. For two years, the Hoosier artist would winter in the Bavarian city and spend his summers working in the countryside, often with Academy classmates. From one such summer's jaunt in July of 1885, he wrote William Forsyth, who had been working at the Academy in Munich since 1882, of the idyllic painting conditions outside of Munich. Urging his friend to join him in the country, Adams coaxed: "Dear Forsyth: Why the H--- don't you come out. Have expected you…every day this week. You are missing the finest part of the summer. The harvest fields are grand now."[33]

During his time at the Academy, Adams had spent the greater part of each year working within the academic regimen of the school. Like many of his colleagues, he had delighted in painting out-of-doors in the German villages during the summer respites from Academy classes. There is little doubt that, while working in the countryside, Adams had become acquainted with J. Frank Currier (1843-1909), a Boston landscapist living outside of Munich. Although ten to twenty years the senior of Adams, Steele, and Forsyth, Currier had become "intimate with a coterie which included J. Ottis Adams, William Forsyth, Benjamin Rutherford Fitz, T. C. Steele…all of whom strongly felt his influence and example."[34] Currier held no regularly scheduled landscape classes, but, for those who sought him out at his home in Schleissheim, a village near Munich, he was generous with his insightful criticism and advice.

The carefree life of the openhearted city suited Adams. Munich's theaters, restaurants, concerts, and opera were heartily enjoyed by the city's students who flocked to take advantage of reduced rates for those studying at the Academy.

**J. Ottis Adams**
*Wheeling Pike.*
Oil on canvas
59 x 90 inches
Muncie Public Library

**J. Ottis Adams**
*Wheeling Pike.*
Oil on canvas
59 x 90 inches
Muncie Public Library

Neighborhood cafes, where an evening's worth of beer, pretzels, and radishes could be purchased for only a few pfennigs, were popular with Adams and his classmates. In an atmosphere of fellowship and dense Bavarian pipe smoke, they played chess and sat about talking until all hours.

For two years Adams served as president of the American Artists' Club of Munich. [35] Organized from the informal, bimonthly dinner meetings which had been started by Chase a decade earlier, the club was a common meeting ground for many of the English-speaking students living in Munich. Particularly popular during the holidays, it gave those who were lonely a place to gather and talk of home and times past.

Despite a year of sharing a Munich studio with Forsyth who had completed his Academy training in the early summer of 1886, Adams's thoughts, in 1887, turned longingly toward home. Steele, who had already returned to the United States, wrote his friend encouragingly from Cavendish, Vermont, where he was doing commission work for the Fletcher family of Indianapolis: "You are coming home, I am glad of it. I am lonesome over here and shall be glad for some companionship… there is a whole world over here in the American artist native land, and a world with which he should be the most familiar that has been comparatively untouched. I do not refer to figure alone but landscape as well, for characteristic American landscape has been but little painted… I do not know why I indulge in these reflections, but they have been growing in my mind for some time. Probably I want to tell you if you are coming home to stay to drop all of Munich but your training. Keep the technical ability and the artistic insight, and exercise them upon American subjects, American portraits, life and landscape."[36]

**J. Ottis Adams**
*The Farm, Prairie Dell.*
Oil on canvas
21⅝ x 28½ inches
Mr. and Mrs. Thomas B. Adams

Prior to leaving Munich, Adams investigated, with his customary thoroughness, the possibility of a teaching position with the Art Academy of Cincinnati. The school was unable to offer him a suitable post,[37] and Adams, therefore, elected to return to Muncie and open a small art school of his own. In the early winter of 1887, the thirty-six-year-old artist settled in Muncie where he took a room at the Kirby House, a family-style hotel operated by the Heinsohns for whom he had done portrait work some years earlier. Renting a studio in downtown Muncie, the ambitious Adams began to teach art classes there as well as offer art instruction several nights a week in the northern Indiana towns of Fort Wayne and Union City.

Soon feeling the strain of commuting several hundred miles between the three cities, Adams wrote Forsyth who was still working in their Munich studio: "A bit of business, are you coming home in the autumn and if so, would you teach? I have a class here (in Fort Wayne) that is paying me a hundred dollars a month, above expenses…I have spoken of you to my pupils, in case I leave, and I am sure they would guarantee you at least ten pupils at ten dollars a month for the winter. I rent a room for them that they can go to at all times and give them two days a week."[38]

A grateful Forsyth responded to his friend's generous proposition: "To speak plainly in about two months from now I shall have reached the end of my rope and this calf don't hope for any more…he'll pack his kit and take the way to the land of the great bald eagle…I'll be dam'd glad to take your F.W. school off your hands in case you give it up."[39]

In the late fall of 1888, Forsyth returned to Indianapolis, and, by spring, he was making a weekly trip to Fort Wayne to help Adams with the teaching of that city's art class. Worn by the demands of their arduous teaching circuit, the two artists decided to focus their energies on starting an art school in Muncie. Located in the city's Little Block, the Muncie Art School opened in the fall of 1889, offering out-of-doors sketching, drawing from life and the antique, still life work in oil, watercolor, and pastel, and instruction in etching. Apparently both artists had been exposed to the techniques of etching while in Munich and each retained a lifelong appreciation of the artistry inherent in the multi-step process.

The catalogue of the Muncie school, in which its author Adams had "changed the future to the present tense so that it will not appear so much as an experiment as a thing already established,"[40] stated: "By reason of their thorough training abroad and their standing in the profession, Messrs. Adams and Forsyth feel justified in saying that their school offers advantages for a course of instruction in art such as is not likely to be had in any other school in the West."[41] Tuition for students was set at ten dollars per month; the hours of instruction were nine a.m. to four p.m.

The Muncie Art School lasted for two years. At the close of the 1890-91 school year, Forsyth resigned and returned to Indianapolis where he began to teach with Steele in the newly formed Indiana School of Art. Adams continued to work in Muncie and hold classes in the Little Block on East Main Street. Some of his former Muncie Art School students, who had banded together to form an Art Students' League, located their quarters close to his studio. Long after the close of the Muncie school, Adams maintained his ties with these young artists, visiting them in their studios almost every day to offer suggestions and criticism.[42]

During November of 1894, Adams was invited to contribute two paintings to an Indianapolis exhibition of the work of several Hoosier artists which was slated to move to Chicago during the Christmas holidays. Sponsored by the Central Art Association and held in Chicago's Auditorium Tower, this Five Hoosier Painters show opened to rave reviews from the city's critics. Impressed with the independence and competence of the Hoosier painters, these commentators noted:

*These men seem to have made their own art atmosphere; while not exactly hermits they have been content to work out their own salvation in that quiet town, unaided and undistracted by the jingle and shine of a brilliant society of painters. And still more remarkable is the production of such canvases as* The Frosty Morn *and* October *by Mr. Adams. He lives in Muncie!*[43]

In the spring of 1896, Adams, Forsyth, and Steele represented Indianapolis in joining with three artists from each of five other midwestern cities—Chicago, Cincinnati, St. Louis, Cleveland, and Detroit[44]—to form the Society of Western Artists. Hoping to foster an interest and an understanding of art in the Middle West by holding exhibitions of the work of its artists, a spokesman for the Society explained: "The end sought in organizing the Society of Western Artists was to unite the artists in fellowship, and by such unity strengthen their hands, individually and collectively, both in their art and in their influence."[45] With its membership embracing a majority of the well-known artists in the Midwest, the Society, during its productive years, provided a forum for the exchange of artistic ideas. Its rotating exhibition series was quite popular, attracting critical attention in each of the six founding cities.

After one of the first Society of Western Artists' annuals, Adams attempted to soothe Forsyth's upset over the critics' charges that the work of the Indiana artists who had exhibited in the show was lacking in individual expression: "I don't feel as badly about the criticisms as you seem to, although I think there is some truth in them. If we really worked alike would it be a crime? If we should all work together and work in the same way and thereby make greater improvement would we not as a group make a stronger impression? … Understand I am not advocating this similarity of work, I believe, with you, that we must fight against it. But at the same time I don't think it is such a great fault—if there were more of us it might become so, but with so few it doesn't seem so outrageous. I believe this, as we go along, as we are now, improving every year, that each of us will gain more confidence and thereby develop more individuality even if we do work together…Artists have lived and worked together before, not lost their individuality, and are we so darned weak that we dare not trust ourselves? Gruelle works alone. No sir, we will all be the stronger for it."[46]

Adams would be an active member of the Society of Western Artists, holding a number of offices, including the presidency, first in 1908 and then again, in 1909. He would exhibit regularly in the Society's annual exhibitions which would be held in each of the six cities from 1896 through 1914.

**J. Ottis Adams**
*Metamora.* 1896
Oil on canvas
18 x 24 inches
Mr. and Mrs. Bill Geyer

During the fall of 1896, Adams spent nine weeks painting with both Henry R. MacGinnis, one of his students, and Steele in the environs of the southeastern Indiana town of Metamora.[47] He and Steele had found that they were comfortable working with one another after they had painted together the previous summer along the Mississinewa River at Black's Mill.

In 1897, Adams and Steele again returned to the Whitewater Valley, some seventy miles southeast of Indianapolis. Drawn by the charm of Metamora, its old canal, and the gently rolling hills surrounding the village, the two artists, in the company of Steele's wife Libbie and his daughter Daisy, settled into this quiet town for a summer of landscape work. One day in late fall, Adams and Steele decided to forego their painting in favor of a long horseback ride "up Duck Creek to Bloomington across the upland to Fairfield on the east branch of the Whitewater, then down to Brookville."[48]

In a letter written several days later to his friend George S. Cottman, Steele excitedly shared the news of a rambling old house which the artists had discovered during their outing: "Saw some most glorious things. Called upon Mr. Butler and saw the old place, which is, by the way, an ideal place for an artist, house, grounds and situation. I have no doubt however they would ask a price beyond our means for it. We shall ask his price however. If it is for sale… Think I shall drive over with Mrs. Steele."[49] Nearly three weeks later, Steele reported to Cottman: "We have been driven and seen the old Butler homestead. Like it very much. He asks too much for it, however, for our purpose we think. We will see it again before we return which will probably be next week."[50]

Early in February of 1898, Adams and Steele bought the Butler house which had so intrigued them ever since their discovery of it on their ride of the prior fall. The two artists agreed to partially finance the purchase with painting

**J. Ottis Adams**
*Little Girl with Hollyhocks.*
Oil on canvas
18 x 24 inches
Private Collection

commissions.[51] They also gave Butler a promissory note for $200 bearing one year's interest, due on February 1, 1899, for a total amount of $248.00.[52]

With the eastern fork of the Whitewater River half circling the house and the scenic town of Brookville only one-half mile away, Adams and Steele were more than pleased with the area's painting prospects. Having at last found a spot which offered continual inspiration for his chosen idiom of landscape work, Adams enthusiastically described their new painting grounds: "With spires, quaint old buildings and stone terraces, it presents, from my point of view, much of the appearance of many of those old world towns that are a mecca of artists and students. With the winding streams, old bridges, rocky ravines, hill and valley roads, together with the splendid groupings of trees and the hills far and near for the background, unlimited motifs are afforded in the immediate neighborhood."[53]

With the coming of warm spring weather, plans for the remodeling of the Butler house were well under way. By late summer of 1898, the artists had nearly completed the renovation of the old house. Two wings, giving each painter a studio and separate living quarters, had been added as well as a porch veranda which joined Adams's studio on the north with Steele's studio on the south.

Hoping to have a flower garden in the midst of the southern Indiana woods, Libbie Steele had brought shoots of lavender lilacs from her garden at the Steeles' Tinker Place home in Indianapolis. These she clustered in a bed around the southwest corner of the newly remodeled house. Adams contributed to Libbie's gardening efforts by planting deep purple and white lilacs, stately hollyhocks, and a variety of colorful poppies near the

weather-beaten barn in the southwest corner of the yard. Impressed with the tranquil beauty of the isolated old house and the opportunity for its owners to work undisturbed, Libbie christened their new summer home the Hermitage. Sadly, she had but a short time to enjoy its loveliness as she was to die the following year after contracting tuberculosis.

During the summer, Adams had left most of the remodeling chores to the Steeles and, instead, had concentrated upon the details of his upcoming wedding. On October 1, 1898, he married Winifred Brady, a gracious, dark-haired lady twenty years his junior. He had known the almond-eyed Winifred and her sister Elizabeth, who had married one of the founders of Ball Corporation, for some time since both of them had been students in his Muncie art classes.[54]

A talented artist in her own right, the diminutive Mrs. Adams had studied at the Drexel Institute in Philadelphia as well as in New York at the Art Students' League under William Merritt Chase, Robert Blum, Douglas Volk, and H. Siddons Mowbray. She excelled in still life composition, and her work was known for its subtle beauty, artful composition, and broad use of color. According to one of her daughters-in-law: "Mrs. Adams was a kind, generous, thoughtful person, an ideal mother-in-law. She was a small woman, a little over five feet, with a quiet humor and intellectual interests. She loved her husband dearly as their friends all knew."[55]

In January of 1899, the newlyweds gave a farewell art exhibition in Muncie before moving, later in the spring, to the Hermitage where they planned to spend the summer.[56]

While Adams and his bride savored the solitude of their Brookville retreat, both found themselves drawn by the artistic excitement which was mounting in the Hoosier capital. Leaving the Hermitage to take rooms in Indianapolis during the harsh winter months, the couple alternately enjoyed the brisk vitality of the city and the drowsy peacefulness of summer in the country for the next several years.

During the winter of 1901, Adams became involved with the plans of the Art Association of Indianapolis for the establishment of an art school and a museum in the city. After receiving a sizeable gift from the estate of John Herron, with the stipulation that the local citizen's name be perpetuated in an art gallery and in a school, the Association set about complying with the terms of the bequest. It purchased Tinker Place, the gracious house at Sixteenth and Pennsylvania streets which Steele had leased for nearly fifteen years, and converted it into space suitable for a gallery and an art school. Steele, since Libbie's death in November of 1899, had found the house full of painful memories, and he was more than pleased to vacate it for the Association's use. The official opening of the John Herron Art Institute on March 4, 1902, was a gala affair, attended by women in their most elegant ball gowns and men in their dapper swallowtail coats.[57]

Shortly after the Institute's opening, Adams became one of its faculty members. During the summer of 1902, he and Otto Stark shared the responsibilities for the new school's painting class in oil and watercolor; Adams taught the first half of the course, and Stark, the second. For the next four years, Adams was the Art Institute's principal instructor of drawing and painting, conducting both a day class and an evening class in "Drawing and painting from life and the antique." His classes met each day from nine a.m. until nine-thirty p.m. with several hours allowed for the noon and evening meals. The conscientious instructor even taught a Saturday class in "Drawing and painting from life and the antique" for those adults and high school-aged children who were unable to attend the Institute during the week.[58]

103

J. Ottis Adams
*Summertime.* 1890
Oil on canvas
14 ³/₁₆ x 20¹/₁₆ inches
Ball State University Art Gallery, Muncie, Indiana,
Permanent loan from the Frank C. Ball Collection,
Ball Brothers Foundation

According to his pupils, Adams was a dignified and courteous teacher who guided his classes with a gentle kindness. Julia Graydon Sharpe, one of his former students, remembered: "One day a pupil, desiring to attract attention, had covered a canvas with paint very dashingly put on with a palette knife. When Mr. Adams came to it in turn he stood and looked long and earnestly and, at last, 'Well! Well!' was all he said. Finally bending over the embarrassed pupil, he said in the kindest way, 'Now suppose you use that palette knife once again and scrape off all that very nice paint, and then study the model carefully. Use your eyes and mind as well as your brush. Be honest, never affected.'"[59]

Because of the demands of his teaching schedule, Adams and Winifred stayed in Indianapolis during the school year, living first in the city and then in Southport, a small community south of town. In an effort to continue his painting outside of the classroom, Adams rented space, along with Steele and Richard B. Gruelle, in the Hartford Block Studios on East Market Street in downtown Indianapolis. He also exhibited during his teaching years, winning a bronze medal at the 1904 Louisiana Purchase Exposition at St. Louis for his oil *Iridescence of a Shallow Stream*, painted near Brooklyn in Morgan County, Indiana.[60]

At the close of the 1905-06 school year, the fifty-five-year-old artist resigned from his position at the Art Institute to return to Brookville with Winifred and their three young sons: John Alban, Edward Wolfe, and Robert Brady. Hoping to work year-round at the Hermitage and to raise his children in the country, Adams made the house their formal residence with his purchase of Steele's ownership interest on April 14, 1907.

In December of that year, Adams won the $500 Fine Arts Building Prize, awarded during the annual exhibition of the Society of Western Artists in Chicago, with his *A Winter Morning*. Gruelle, a member of the Society, wrote to congratulate his friend: "Taking up the *News* tonight I find you have won the prize given western artists. I want to not only congratulate you but also to share the joy the honor must bring to you and Mrs. Adams. I sincerely hope this will not only mean that you will take a new 'hitch' and (illegible) for greater recognition. I would suggest that you take up a singular line of subjects. And make further excursions into the beauties of 'Winter'…I don't mean for you to sing the same song, but follow this recognition with a renewed effort toward higher attainments. I find that when our best men in the East have found the things they could do best, they have usually forged ahead along the same lines until they have usually placed themselves, slangly speaking, 'on easy street.'"[61]

Before moving permanently to the Hermitage in 1906, Adams and his family had spent their summers enjoying the woods, the river, and the friendliness of the Brookville area. In his southern Indiana studio, the artist had pursued his painting, and occasionally had taught a very informal class in landscape technique.[62] His casual instruction of one or two pupils ended, however, during the summer of 1910 when he opened a small art school at the Hermitage. In a booklet announcing his *Summer Class in Landscape Painting*, Adams described the scenic beauty of the Brookville area, assuring prospective students that the town could be reached "by a branch of the Big Four railroad. Furnished rooms may be obtained at prices from $1.00 to $1.25 per week and day board from $3.50 to $5.00 a week. Students will have the privilege of one of the Hermitage studios."[63] The tuition for the school was ten dollars per month or fifteen dollars for the full seven week term, payable in advance.

The Brookville summer landscape school continued for at least four years. Muncie artist Francis Folger Brown, who studied every summer with Adams while he was in high school, rented a room at the Hermitage each year and stayed for the full seven-week course. According to Brown, Adams did not consider himself to be a good instructor. Watercolorist Beulah Hazelrigg Brown explained: "My husband used to say that Mr. Adams would remark that Mr. Forsyth was a better teacher than he was because Mr. Forsyth was more severe, and that that's what it took to be a real good teacher. Francis really liked Mr. Adams and described him as not only a very fine painter, but also a wonderfully kind and inspiring teacher."[64]

While Adams was committed to his landscape school for the better part of each summer, Winifred and the boys escaped the heat of southern Indiana by taking a yearly trip to Leland, Michigan, where the weather was cooler. The Adamses had built a roomy Victorian cottage on a bluff overlooking Lake Michigan in 1905, and the family had always anticipated its annual visit to the lakeside Indiana Woods. There, in a heavily-timbered section along the eastern shore of Lake Michigan, a number of Muncie families, many of whom were members of the Ball family, had built cottages fronting the beach. The azure-colored Adams cottage, nicknamed Bluebelle by Winifred,[65] was just north of her sister Elizabeth's summer home.

The Adamses thoroughly savored their summers in Michigan. For Winifred and the boys, it was a chance to share boat rides on nearby Lake Leelanau, impromptu fishing expeditions, evening cook-outs and icy swims in Lake Michigan with Elizabeth Ball and her family. For Adams, when he was free of his school responsibilities, it was a time to experiment with capturing on canvas the magnificient colors of the ever-changing sunsets over Lake Michigan and the golden shafts of sunlight filtering through the towering pines of Indiana Woods.

Anxious to join his family in Leland at the close of his Brookville landscape school, Adams would travel north each summer, often inviting his friend Otto Stark to work at the Hermitage in his absence.[66] Upon his arrival in Michigan, Adams would customarily retreat to the second floor of his cottage where he had converted the northwest corner bedroom into a studio. One of his favorite nieces recalled how her Uncle Jack would sit on the porch of Bluebelle overlooking the lake and make rapid sketches of the sun sinking behind the Manitou Islands. He would then expand the sketches with oils or watercolor in his studio the next day, saving forever the glowing sunset of the previous night for his Indiana Woods neighbors.

Part of Adams's sunlit Michigan days were spent strolling along the beach. With a companionable pipe clenched between his teeth, he would walk the shoreline, picking up stones along the water's edge. Because of a congenital hip deformation which caused one leg to be a bit shorter than the other, Adams was required to wear a built-up shoe and carry a cane. "We could always tell when we were on the beach that Uncle Jack had been there because we'd see the cane mark. His leg didn't slow him down at all. I always understood that was one reason he took up painting because he couldn't get out and play the games that all the other boys were playing,"[67] explained his niece.

The comfortable pattern of the Adamses' family life was shattered during the spring rains of 1913 when Brookville's placid Whitewater River became a vicious torrent, sweeping aside nearly everything in its path. Winifred, who had been nursing their sick son John Alban in the National Sanitarium at Martinsville, was spared the agony of watching the destruction of part of her riverside home by the turbulent waters. Adams and their other two sons, however, were at the Hermitage during the flood to witness the rampaging river. Barely escaping with his life, the disheartened artist settled his frightened children into temporary housing before dejectedly writing his wife: "The flood was simply awful; when I looked out at daylight yesterday morning the water was up under the apple tree by the kitchen door. I got the boys out and we hurriedly dressed…Until nearly noon we did not know whether we would ever get out. We first saw the chicken house, then the wood shed and the den go, and then the kitchen being undermined, and soon after that, my studio. . .With time things become more discouraging, as far as our house is concerned we can never live in it again; what was the northwest corner of your bedroom is down in a hole of water almost as deep as the river and my studio in another to the north of the house. I can look down into my bedroom, from what was the hall dining room and see my bed and the bottom of my bureau sticking up."[68]

**J. Ottis Adams**
*Cabin in the Indiana Woods, Leland.*
Oil on canvas
22 x 16 inches
Private Collection

Three months after the flood, Winifred and the boys, at Adams's insistence, left for their annual pilgrimage to Michigan. The artist stayed on alone at the Hermitage, trying to salvage what he could of their once elegant home. While there had been relatively little damage done to Winifred's studio—she had taken Steele's old painting quarters as her workshop— there was much repair needed in Adams's studio.

At the close of the school year that spring, Stark, who had been teaching in Indianapolis, traveled to Brookville to help his friend with the dreary cleanup job: "No description or pictures could adequately give an idea of the destruction and ruin of the place. I went in with a joke on my lips but instead found a lump rising in my throat in seeing it. Mr. Adams was planning to rebuild in a modified way to use more as a summer house than as permanent quarters. The family may stay with the house for another winter until a decision is made for the future. Brookville is much changed with many houses having been utterly destroyed."[69] Despite their loss, Adams and Winifred were reluctant to give up their house in the country for a permanent move to the city. They, like many others in the area, decided instead to stay in Brookville and rebuild that portion of their home which had been destroyed by the flood.

In 1914, Adams was presented with another opportunity to work with his longtime friends. He, along with Forsyth, Stark, Steele, and eleven other Indiana artists, became involved with the painting of thirty-three murals at the Indianapolis City Hospital as a philanthropic gesture towards beautifying the institution. Under the direction of Forsyth, who had been designated to set the general color scheme for the ambitious undertaking, the artists worked at housepainters' wages to decorate various areas in the hospital.

Most of the artists lived in Indianapolis and were able, therefore, to paint their murals in the building. Adams and Steele, however, chose to paint their canvases in their respective studios in Brookville and Brown County rather than move to the Hoosier capital for the duration of the project.

Despite Adams's preference for living in the country, the rustic isolation of Brookville began to take its toll on the health of the sixty-four-year-old. During the winter of 1915, he suffered from a severe attack of grippe, and, upon his doctor's orders, the ailing artist went to Florida to recover from the effects of the influenza. Adams convalesced in the home of J. W. Hargrave on Big Bayou, south of St. Petersburg[70] on the Gulf of Mexico. As his strength returned, the Hoosier painter became intrigued with the sub-tropical landscape around him and decided to stay into the spring to explore artistically St. Petersburg's brilliantly colored vines, flamboyantly hued flowers, and the rippling moonlight on the water of Big Bayou.

In early spring of 1916, he wrote Winifred who was living in Indianapolis: "I would be happy if I only had you and the boys down here with me; it seems too selfish to be enjoying all this alone. I am surely much better, have an enormous appetite—great trouble in keeping from eating too much—am able to work four or five hours a day without fatigue, in fact feel just about normal."[71] A month later, in a letter of gentle humor to his family, Adams told of picking "up a funny looking thing in the yard this morning, about as long as a small hen egg but flatter with a fibrous outside. It was a mango seed. They say that it is necessary for an amateur, when attempting to eat a mango, to get in a bathtub, they are so juicy and slippery."[72]

Concerned about the effects of Indiana's bone-chilling winters on his health, Adams decided that he would spend several months each winter working in the warmth of the Florida sun. In December of 1916, he and his son Edward settled in St.

Petersburg at the Lewis family's boarding house. There Edward busied himself with schoolwork—he had enrolled as an eighth grader in a local school—and Adams began to examine the shifting patterns of light among the palms and the Spanish moss-draped live oaks. Adams wrote his wife and two sons: "Edward bathed in the Gulf of Mexico, but, as he had a bath in the Bayou yesterday afternoon, the Gulf was not seriously contaminated[73]…Edward and I are just in from a canoe ride. Edward paddled, went out to the mouth of the Bayou, about a mile…We are finding out about trees, birds and mollusks. We watched a conch feeding on an oyster and saw it afterward bury itself in the sand under a clam. Edward has started his shell collection."[74]

Despite his yearly stay in Florida and the family's annual summer trip to Leland, Adams's thoughts remained in Indiana. The Hermitage was his home. It was a place for his friends, among them Otto Stark, William Forsyth, L. H. Meakin, T. C. Steele, and George Jo Mess, to gather and a spot where he could putter as well as paint.

Challenged by the intricacies of design work, Adams took great pleasure in having assorted projects under way around the Hermitage. He had drawn the plans for a large carved cabinet in his studio, had designed the heart-shaped leaded-glass windows in the library and had fitted the room's doors and drawers with ingenious hardware. Many of the books in the library

had been hand-decorated by the artist who had first begun to design the covers of linen-bound books during the opening days of his art school in Muncie.[75] In the cellar under the Hermitage, Adams tinkered with picture frames on a workbench cluttered with frame parts, bottles of oil and varnish, brushes, and tacks. Nearby were the workbenches of the three Adams boys where each youngster had put together a number of childhood masterpieces under the watchful eye of his father.

In his later years, Adams spent nearly as much time working in Michigan and Florida as he did painting in the Brookville area. He was accompanied on many of his trips by Otto Stark, his good friend who had retired as the Supervisor of Art at Manual Training High School in Indianapolis at the close of the 1918-19 school year.

In September of 1919, Adams and Stark, who had been a regular summer guest at Indiana Woods since 1916, began a tradition of extending their stay late into the fall to capture the brilliant reds, yellows, and oranges of northern Michigan's autumn foliage. Although the two artists often painted together, they kept separate quarters. Adams stayed in Bluebelle, while Stark worked and lived in two tents pitched side by side near the Adams family cottage.

In late September of 1919, Adams wrote Winifred who had returned from Michigan with the boys: "Work is going better with me than it has for a long time and I would like to see it through[76]…Mr. Stark is feasting on mushrooms, the woods being full of them; I haven't tried them myself, think one of us had better be prepared to take care of the one that is poisoned. Sliced ripe tomatoes in Taco flour and fried make a good dish, says Stark. I tried it tonight and find it is true, try it…Stark has just been in, returned the butter he had borrowed."[77]

Writing one year later from Michigan, Adams shared with Winifred some of his frustrations: "Between my work, getting my meals and having Mr. Stark as a visitor in the evening, I don't find much time for extras…Have three potboilers and one picture underway; unfortunately, the picture was started for a gray day which we got so many of last year…Mr. Stark invited me to go out in Alban's boat this afternoon, but I felt I must stay home and write; besides his adventures are more interesting as stories than experiences."[78]

Prior to the Chistmas holidays of 1920, Adams invited Stark to accompany him on his yearly excursion to Florida. Instead of working in St. Petersburg, the two artists settled in Ronnoc Park, formerly a several thousand-acre plantation outside of New Smyrna, a historic town in northeastern Florida. Converting the landowner's dilapidated office into a studio, they spent three months painting the moss-laden forest and brightly colored flowers which bloomed profusely over the abandoned area. Adams described the park: "The grounds have been very beautiful and are now quite picturesque. Excepting one workman we are the sole occupants. There is much that is paintable right in the grounds."[79]

Despite his deep friendship with Stark, Adams preferred to work alone. In fact, the reserved artist returned to New Smyrna for the next five years without the company of his friend. Florida's vegetation, so different from the serene landscapes of Indiana and Michigan, sparked a new interest in the nature-loving painter. The sun's reflection from the stiff-bladed palmettos, the play of light on the gray-green Spanish moss, the opalescent shimmer of the sea fog—all these Adams pursued with brush and palette. Eager to continue his winter work in New Smyrna,

he had a studio built there in January of 1922. He also purchased two pieces of property in the Florida town for "$10 and other considerations of value" on April 10, 1923[80] and on April 19, 1924.[81]

When Adams came home from New Smyrna in the spring of 1926, the seventy-four-year-old artist was not well. Nonetheless, he continued to work at Brookville in the spring, and then, with his family in Leland late in the summer. He wrote Winifred from Michigan after her seasonal return to Indianapolis: "I am about the same, some days feel better but invariably drop back again. If you and Alban are coming up I think I'll give up and go back with you. The only good I am doing here is to get now and then a little work done around the cottage."[82]

Early that fall, Adams came home to Indianapolis where his doctor recommended an operation for an intestinal disorder. After the surgery, Adams never regained his health, and he died in his Indianapolis home on January 28, 1927.

Throughout his life, the quiet, unobtrusive artist had exhibited his work with regularity in the Midwest. In addition to participation in the annuals of such organizations as the Society of Western Artists, the Art Association of Indianapolis, the Cincinnati Museum Association, the Muncie Art Association, and the Art Association of Richmond, he had exhibited in national as well as international exhibitions. Adams had won a bronze medal at the 1904 Louisiana Purchase Exposition in St. Louis for his landscape *Iridescence of a Shallow Stream* and the $500 Fine Arts Building Corporation Prize in 1907 for *A Winter Morning*, a landscape painted from his Brookville studio window. In 1909, he had been awarded the Mary T. R. Foulke prize at Richmond for his landscape *A Winter Day*, and, in 1910, the artist had received an honorable mention for *A Frosty Morning* at the International Exhibition of Fine Arts at Buenos Aires, Argentina and Santiago, Chile.[83] His *A Bit of the Whitewater* was exhibited at the 1915

Panama-Pacific International Exposition in San Francisco, California.

One critic of the day summarized Adams's work:
*"His pictures are not of the sort that leap to the eye or reach out and seize the attention against competitors in the gallery. His interest was less in obvious beauty than in the beauty that often goes unperceived."*[84]

His lifelong friend William Forsyth agreed: "Not much had he to say of the things he did. He was content to let them speak in their own way…Men he loved, and books he loved, and many beautiful things, but the great love of his soul was the out-of-doors and the open road. Taking the road to anywhere with him and seeing the gray dawn breaking on the rim of the world— this permitted a glimpse of his real self. To have loafed with him in the shadows of the trees at noon and in the silence of the night, spent long hours watching the shifting shadows while the river sang, was to know how deeply he loved the ever-changing moods of the out-of-doors and the art that tried to picture them."[85]

**J. Ottis Adams**
*Street in New Smyrna, Florida.*
Oil on canvas
29 x 22 inches
Indiana State Museum Collection

**William Forsyth**
*Alice with Parasol.* **1900**
Oil on canvas
20 x 14 inches
Forsyth Family Collection

**To live out-of-doors in intimate touch with nature, to feel the sun, to watch the ever-changing face of the landscape, where waters run and winds blow and trees wave and clouds move, and to walk with all the hours of the day and into the mysteries of night through all the seasons of the years—this is the heaven of the Hoosier painter.**

**William Forsyth**

*Art in Indiana*
Fall, 1916

Portrait of William Forsyth. Indiana University-Purdue University at Indianapolis Archives.

The notes for the Forsyth essay begin on page 161.

"My earliest memories are of the Ohio River. To me, indeed, it is 'La Belle Riviere' and always will be. Even to this day, my first glimpse of it brings a joyous throb to my heart and an involuntary catch in my throat,"[1] recalled William J. Forsyth, one of Indiana's leading artists during the early part of the twentieth century and a pivotal figure in the development of the John Herron Art Institute in Indianapolis.

Born on October 15, 1854, in the Ohio River town of California[2] in Hamilton County, Ohio, Forsyth was the oldest of Elijah and Mary Forsyths' four children.[3] His father, who had left a cargo hauling business along the river because of a bronchial condition, farmed on a limited basis, ran the town's post office and served as the local justice of the peace[4] during the family's stay in California.

The young boy savored his childhood years in that small crossroads community not far from Cincinnati: "At the end of the village was the school house and beyond it the broad commons, the playground of the village boys where every game known to that generation of boys was played and played to the limit in its proper season. Then there was the river with its never-ending attractions at all seasons…All life to me was play. I lived it, ate it, slept it in all its forms. I do not remember ever being in the house except to eat and sleep or on occasion when forcibly detained."[5]

According to Constance Forsyth, one of the artist's three daughters, her father's assertive nature was evident very early in his youth. "He was an awful fighter," she reported. "He said he never passed a grade in grade school because he was always failed at the end of each year for bad behavior."[6] Forsyth was spared the humiliation of repeating the year's work, however, with the appearance every fall of a new teacher in the village's one-room school. Ignoring the recommendation of her predecessor, the unsuspecting schoolmarm would allow the small-statured, but quick-fisted, boy to advance to the next grade with his friends.

Forsyth would later explain his reputation as a young ruffian: "Except that I sported no curls, I looked more like a girl than the youthful sportsman I really was, and that was the cause of much trouble. For my looks were very deceptive and other boys were apt to presume upon them if not acquainted with other peculiarities, one of which was a certain readiness with my hands, a given temper and an absolute ignorance as to the proper time to quit fighting, generally leaving that part of the affair to the other fellow."[7]

Long before he had started to school, the boy's artistic abilities had become apparent. "Like all boys, I could draw, perhaps it was a little more natural, I do not know, perhaps it was only because I practiced it more than others, but I cannot remember when pencil and chalk and color were not familiar to me…More or less of a nuisance, I, no doubt, was marking things up as the mood seized me till a vacant room possessing a big old-fashioned mantel painted black was assigned to me, and this mantel served excellently as a blackboard and, on rainy days, I let loose all I knew of men and things to my heart's content and bothered by no one."[8] With pieces of colored chalk, Forsyth sketched "the sight of marching men,"[9] who were passing in front of his house during the Civil War, and lively duck hunting scenes to the delight of the neighbors who periodically inspected the boy's work on the Forsyths' black mantel.

Recognizing that his childish figures could hardly be called "art," Forsyth explained: "Still, this was not art, just expression. There was no wonder in it to me at least, but the day of enlightenment was to come."[10] The sensitive boy's awareness came with his discovery of a bit of driftwood caught in the tangled weeds along the river's edge: "It was a piece of straight-grained pine about a foot long and out of it had been fashioned a

human figure only partly finished…It might have been a crude performance; I really do not know. But to me it was a marvel: here, skill of human fingers was evident…I have seen the masterpieces of the world and years have gone to the training of my own hands, and perhaps I also have done a little in art, but this little figure opened the gates to me and sent me on the long, long road, the quest that never ends, the insatiable desire to express, in art, a little of the fullness of that beauty of the world."[11]

When Forsyth was ten, his family moved west to Indiana, settling first in Versailles for several years and then in Indianapolis. The successive moves failed to diminish the lad's ever-growing enthusiasm for artistic expression, and he begged his father for help in locating a painting instructor. Acquiescing to his son's repeated requests for art lessons, Elijah Forsyth took the fifteen-year-old to the studio of Indianapolis artist Barton S. Hays[12] with the intention of enrolling him as a student. The prohibitive cost of Hays's instruction and the relative immaturity of the boy, however, made the venture impractical.

Four years later, during the financial Panic of 1873, Forsyth left high school to work with his younger brother John in earning extra money to help support the family. The two boys painted houses in the German neighborhoods of southside Indianapolis with Forsyth showing particular skill in painting the "stained glass" window decorations which adorned many of the elegant old homes.[13] Although he worked with design and color all week, the teenager never gave up trying to learn more about art. He haunted the H. Lieber & Company Art Emporium in downtown Indianapolis, intently studying the pictures on display in the store's windows,

and became an avid reader of John Ruskin, using the English critic's essays on art as a substitute for classroom instruction.

With pencils in hand—he eschewed serious color work until later in his career—Forsyth spent his Saturdays sketching in the countryside. On one such excursion, he met Indianapolis artist John W. Love,[14] who had just returned from several years of study at the famed École des Beaux-Arts in Paris, and a small group of Love's friends who shared an interest in outdoor painting. Forsyth continued to see these artists during his weekend outings, but, while admiring them a great deal, he characteristically chose to work alone.[15]

Forsyth never finished his last year of high school. According to his daughter Evelyn: "He was ashamed to go back to high school later, so he went on and studied by himself. He studied math and everything he could on his own. I bet he read more books, more magazines, more papers than anyone else in the world. He liked both fiction and non-fiction. He loved romantic novels which were historical."[16]

Forsyth's abiding interest in literature began when he first discovered the writings of William Shakespeare which "held him in thrall."[17] "I have often wondered," the artist would later confess, "how men can go through a long life and not know this world of beauty and wisdom and adventure lying at everyone's elbows, and yet men do this very thing and more. They do not seem to miss it or care if they do. Especially is this true of the poets, the true teachers, the seers and the prophets."[18]

In the late fall of 1877, Forsyth realized his dream of studying art in a classroom with his enrollment as one of the first students in the newly formed Indiana School of Art in Indianapolis. Located on the third floor of the Fletcher-Sharpe Block at the southwest corner of Washington and Pennsylvania streets, the school had opened on October 15, 1877.

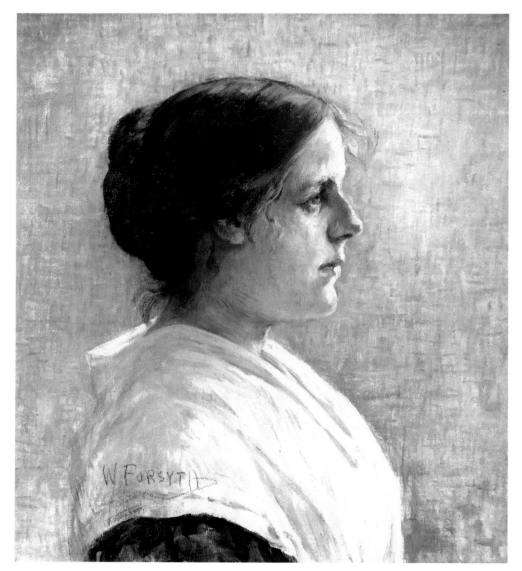

Founded by Love and Indianapolis artist James F. Gookins,[19] it had been established in response to citywide interest generated by an art exhibition which had been held by the two men earlier in the year. The eleven-room school occupied almost an entire floor. It offered instruction in perspective, anatomy, sculpture, figure, landscape, and decorative painting in oil and watercolor as well as in freehand drawing, machine, and architectural drawing. Courses in engraving, lithography, wood-carving, and ceramic painting were also taught.

Of those on the Indiana School of Art's five-member faculty, Forsyth was most influenced by Love who served as both assistant director and drawing instructor for the school. Feared by students who did not understand how art could be anything more than a pleasant avocation, Love, a master draftsman, was "almost merciless as a teacher…a strong tonic to those who appreciated the motive of his severity."[20] Although the school, from its inception, had been crowded with pupils from Indianapolis and around the state, the anticipated public patronage for the venture never materialized. Unable to sustain the school's operation financially— Love and Gookins had opened the school at their own expense upon receiving assurances of forthcoming support— Gookins left the school after the close of its first year.

Love took over as director of the school for its second year, trying to obtain sufficient financial support from sources other than tuition. During the early fall of 1879, he became ill. From his brother's home near Shawneetown, Illinois, where he was recuperating, Love wrote Forsyth

who had become a close friend as well as one of his more talented students: "Please state to Mssrs. Fletcher and Sharpe that I wish to keep the rooms. Also state to them that I expect a better school this year than have yet had[21]…It is impossible for me to come in time as I am scarcely able to walk…Close school until October letting each scholar understand that it will begin again then. Have the newspapers state that it is simply a vacation and promptly[22]…Find out in any way you can how many scholars are ready to start in… There will be no free list this year except in your own case and I expect to find use for you so that if the school pays, I can afford you some kind of a salary, the amount depending entirely on the income and expenses of the school. I mean to open the school sometime the first of October."[23]

Despite Love's best intentions and his efforts to reduce the school's operating expenses, he was forced to suspend classes shortly after they had begun in November of 1879[24] since the needed public support never appeared. Love, weakened by his long illness and disappointed with the failure of his school, died at the age of thirty in June of 1880.

Shortly after the closing of the Indiana School of Art, Forsyth and a number of his friends who had studied there banded together to continue their painting. They rented a studio consisting of a suite of rooms opening onto the court of the building in which their former school had been located. Forsyth remembered with fondness his fellow Bohe Club members: Fred A. Hetherington, Thomas E. Hibben, Charles Fiscus, Will Ebbert, Frank Scott, and Charles Nicolai, regulars, and George Cottman, Clarence Forsyth, and Hartzell Stem, associates.[25]

"A half-dozen or more of us rented studios that faced the court in the building," the student-artist explained.

"We organized a Bohemian Club. But the name was too long for the studio glass door. We could only get the letters Bohe on the door and that is how it came to be called the Bohe Club…The meetings we held at our studio were not regular, but more like social affairs. Our hearts were on art of any kind…The members of the Club did a great deal of experimental work and sketching. We were acquainted with the neighborhood and even went to Brown County to paint…No one gives these men credit for discovering the beauties of Brown County because it was so long ago. We were explorers on hiking and sketching tours. We made explorations all over this part of Indiana, especially to the south of Indianapolis."[26]

In the fall of 1881, after painting at the Bohe Club and working in his own studio in the Ingalls Block, Forsyth was offered an opportunity to study in Europe amid "the schools, the associations, the Art atmosphere, Old Masters and the general feeling of a living interest in Art."[27] He chose to attend the Royal Academy in Munich rather than the École des Beaux-Arts in Paris because the German school was relatively inexpensive and more open in its acceptance of foreign students. The twenty-seven-year-old Hoosier was also attracted to the Bavarian Academy because it had been the training ground for the noteworthy American artists Frank Duveneck, J. Frank Currier, William Merritt Chase, and Walter Shirlaw a decade earlier.[28]

With the promise of financial backing from his good friend and fellow Bohe Club member, Thomas E. Hibben,[29] Forsyth began to make plans for the ocean voyage to Europe. After being advised by Theodore C. Steele, who was already working in the Munich school, to pack "a couple of heavy double-breasted, double-backed, blue flannel midishirts…for this terribly changeable climate,"[30] Forsyth traveled to New York where he visited with Hoosier artists Otto Stark and William Merritt Chase before departing for

**William Forsyth**
*Negro Model.*
Oil on canvas
24 x 18 inches
Private Collection

Antwerp on December 24, 1881. He later wrote his patron Hibben of the afternoon with Chase: "Oh dear, you should see his studios! He has three of them or rather two and his private room which is as nice as his studios. They are all fitted up with all manner of bric-a-brac of the richest description…with old carved furniture and rich hangings."[31]

It was a blustery day in early January of 1882 when Forsyth arrived at the Steeles' home in the German village of Schleissheim, some six miles north of Munich. Brandt Steele, the artist's son, remembered giving directions to an English-speaking stranger on the road: "On the way to school one morning, we met two men coming along the road, with paint boxes on their backs…One was very tall…By comparison, his companion was quite short. He wore a very small hat on the side of his head and a cigarette in the corner of his mouth. We were stopped and the little fellow called out, 'Hello Bub, where is your Father?' I answered him in German…I was uneasy, they had spoken to me in English and it seemed to me that I had seen one of them before."[32]

After staying with the Steeles for several days, the prospective student went to Munich with the hope of convincing one of the Academy's drawing professors to accept him in mid-year: "I showed my work to Professor Benczur, Friday. He liked my work, said I had fine talent, but his school, in fact all the schools are so crowded, that I cannot get in at once. He would have admitted me anyhow but said it would be unjust to others who are waiting."[33] At Benczur's suggestion, however, Forsyth began work in a private Munich studio until a spot for him could open up at the Academy.

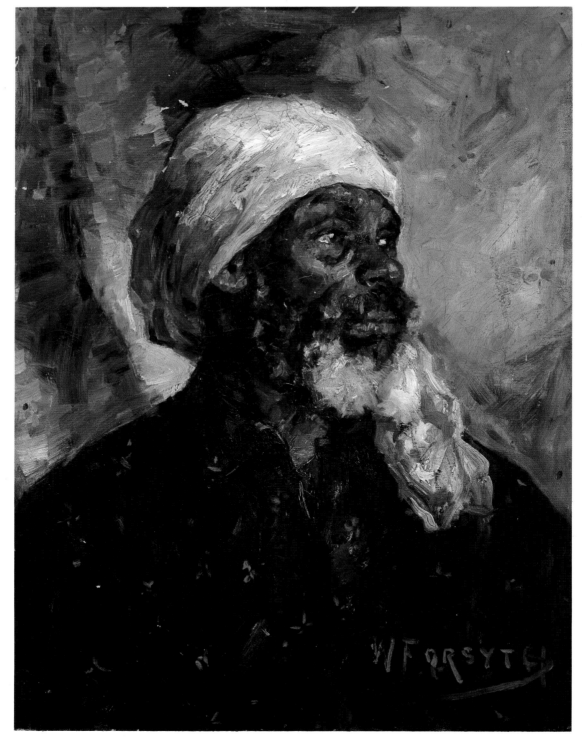

**William Forsyth**
*Constitutional Elm.*
Oil on canvas
24 x 18 inches
Nancy and Dick Beatty

Within two months of his arrival in Germany, Forsyth had moved to Mittenheim, a tiny village near Schleissheim. There he and an Academy student took two rooms and a kitchen, "for about half the sum I paid for one at Schleissheim,"[34] on the second floor of a centuries-old monastery which had been converted into a farmhouse. The Steele family would later join Forsyth at the old Cloister in Mittenheim, taking rooms in one wing of the building during the early summer of 1882.

Happily settled "in a place that is really something like a home to me,"[35] Forsyth described the monastery to Hibben: "Away back in the past the monks said their prayers and chanted where now the art student from over the sea sings his careless song and smokes his pipe…little remains as it was in the past. The interior has been refitted for modern use…the old kitchen remains the same and is now used as a place to boil potatoes for the cattle…The courtyard on sunny afternoons is a marvel of light and shade: four or five trees stand in the middle around the pump and they cast beautiful shadows on the old walk, and picturesque fingers of light cross and recross while poultry scratch idly about."[36]

Despite having to walk several miles to the station in Schleissheim to catch the Munich train, Forsyth and his friend relished the daily tramp to town. He explained: "Having a passion for nature and the out-of-doors, we thoroughly enjoy our morning and evening walks to and from the station…At the station we meet several more art students who live out at Schleissheim, Steele among them, and on the way to town we usually talk art and nature. One would think from our conversation that we didn't live on anything else."[37]

**William Forsyth**
*Cliff Road.* 1903
Oil on canvas
32 x 24 inches
Flanner and Buchanan, Inc.

In the spring of 1882, Forsyth was formally accepted as a student in the Royal Academy. The school's Matriculation Book stated: "Number 4124; Name: Forsyth, William; birthplace and status of parents from Indianapolis, America; his father, a painter, Protestant; age of artist, 27; art studies, nature class; date of acceptance, April 18, 1882."[38]

An opening in the drawing school of Gyula Benczur (1844-1920) had become available, and, with great enthusiasm, Forsyth began to work in charcoal under the award-winning Hungarian painter who specialized in portraits and historical pieces. The Hoosier artist wrote Hibben of his first few weeks in class: "Benczur, my professor, is a stunning fellow and gives stunning criticism, so stunning sometimes you don't get over it for a couple of days. Every once in a while he goes through the whole school and regularly lays 'em out; everyone old and new, good and bad, no exceptions, and takes the conceit out of us in a way that is perfectly lovely[39]... Benczur's school is crowded to death. A perfect forest of easels fill the rooms and a man who comes late on Mondays can barely find room to draw. In the head room, there are three models posed at one time, fifteen fellows or more around each head. Standing at my easel, I can, at most any time, touch men of four or five nationalities."[40]

Forsyth moved from the Cloister at Mittenheim in the fall of 1882, taking a fourth-floor room in town "opposite the great passenger depot of Munich on the broad 'Bahnhof Platz.'"[41] His new quarters were only a five-minute walk from the Royal Academy. The distinguished school, housed in a building adjoining the church of St. Michael on Neuhauserstrasse, had once been a monastery "belonging to some wealthy old brotherhood of monks."[42]

116

**William Forsyth**
*Gate at Mittenheim.*
Oil on canvas
15¼ x 24½ inches
Private Collection, Zionsville, Indiana

Having written Hibben that "one thing is certain, John Love's training was excellent, so that I have no bad habits to shake off,"[43] Forsyth easily obtained a student seat in the drawing school of Nikolaus Gysis (1842-1901) for the fall term. Benczur had left his teaching position at the conclusion of the 1882 school year to assume the directorship of the Royal Academy in Budapest, and his replacement Gysis, a genre painter, was "reputed to be one of the best draughtsmen here."[44]

In addition to his charcoal work with Gysis, Forsyth attended Academy lectures on perspective and anatomy, "not so much on account of the lectures themselves for I don't understand a great deal of them, but for the purpose of learning more German."[45] Given by well-known Munich surgeons, the anatomy lectures were of particular interest to the Hoosier artist: "Usually I go there immediately from the drawing school on Wednesdays and Saturdays and take my place with the droves of other fellows from the other schools. The lecture room is like a small theater, with circles of seats rising high toward the ceiling…As you turn aside to ascend to a seat you see something gruesome in a white cloth and stretched upright on an iron frame. As you look closer you see a ghostly arm dangling downward and catch a glimpse of blue toes between an iron clamp."[46]

After winning an honorable mention for his work with Gysis at the exhibition of student work in July of 1883, Forsyth felt sufficiently at ease with his draughtsmanship to seek admittance to one of the Academy's painting schools. He wrote his benefactor: "Among the painting schools of which there are four: Loefftz's, Lindenschmit's, Wagner's and Seitz's, the first undoubtedly led. He is the best and the most popular professor in Munich and always has more applicants for admission to his classes than he can accommodate.

His school is always crowded to excess, and when a man fails to get in with him, he is very much pitied…He is the only professor I should care to study with."[47]

In a later letter to Hibben, the excited artist announced: "I went to Professor Loefftz not long ago to see about entering his painting school and was accepted at once…I consider myself fortunate, as some whom I consider better draughtsmen than myself, have had no end of trouble in entering in with him. He seemed to be very well pleased with my work, and even condescended to *praise* some of it[48]…I think there is something bigger than an honorable mention waiting for me in the painting school, for I always was and always will be a better painter than draughtsman, and it was only to strengthen myself in my drawing that I have stayed so long in the black and white school."[49]

In the fall of 1883, Forsyth began his study of figure and portrait with Ludwig von Loefftz (1845-1910), a genre and historical painter with "that rare faculty of stimulating and bringing out the very best that is in a student."[50] Forsyth reported: "This lower room of ours is very crowded, numbering in all about thirty pupils, most of them new…All new men go into the lower school and if a man makes progress or becomes a 'favorite,' he is promoted to an upper school after one *semester*, sometimes before…Although I haven't painted a head since leaving America and *very* few even there, I, according to the judgment of my comrades, made the best head in the room. The professor liked my work too, saying that my color, tones and handling were very 'agreeable' to him and told me particularly to keep my handling.

**William Forsyth**
*Shakertown, An Old Kentucky Home.*
Oil on canvas
18 x 24 inches
Frank and Betty Stewart

**William Forsyth**
*Garden Patch.*
Oil on canvas
26½ x 37 inches
Private Collection

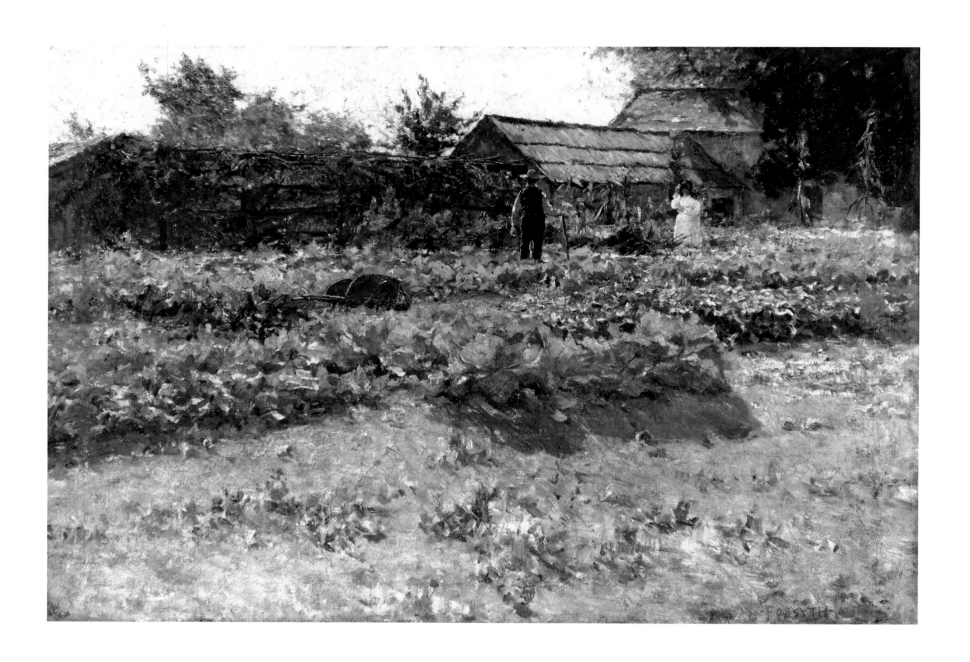

William Forsyth
*Backyard.*
Oil on canvas
24 x 20 inches
Robert Stephens

Now if I can only keep it up all year, I'm in hopes of doing something respectable before school closes next summer."[51]

After several months of work in the painting school, Forsyth wrote to Hibben that Loefftz was an especially demanding teacher: "Our painting professor Loefftz is a terror! I can tell you there isn't a fellow in the class but who has a very decent respect for him. When he enters the door, the silence is almost painful. You might almost hear a pin drop, there is not sound to be heard save that low earnest voice of the master."[52]

Although unassociated with the Academy, J. Frank Currier (1843-1909) exerted a strongly felt artistic influence in Munich. A landscape painter from Boston, Currier had chosen to make the Bavarian city his home after studying at the Academy with Duveneck, Chase, and Shirlaw in the early 1870s. A close friend of Steele—the expatriate artist and Steele shared studio space in Schleissheim—Currier was greatly respected by a number of the American students at the Academy who sought his criticism for landscape work during after-class hours. Forsyth, "the only rebel in the Schleissheim camp,"[53] was not impressed with the village's resident artist or with the undisciplined nature of his technique in oil: "Currier paints with a savage dash and an utter contempt for all refinement of form, loading his paint in places half an inch thick…He never pretends to work on a picture more than a few hours, and never touches it afterward nor paints from his studio…His execution is usually very bold, but terribly careless and usually ragged and slovenly. But sometimes he gets brilliant color, but it oftener ends in rich blackness or crude gloom."[54]

Acknowledging Currier's "stunning" work in watercolor and his potential as a "capital" etcher, however, Forsyth grudgingly admitted: "To a certain extent his influence is for good, and I shall try to get all the good out of him I can, but as for becoming a Currierite, that is out of the question. I'll be myself or nothing."[55]

For three years, Forsyth concentrated upon refining his color sensitivity and technique under the strict scrutiny of Loefftz. He made steady progress in his work at the Academy painting school, exhibiting at the Munich International Exhibition and receiving two more honorable mentions at the annual year-end competitions. Finally, the Hoosier artist won a sought-after bronze medal at the 1885 exhibition of student work with his oil *Kathie*, a study of a dark-robed woman in a shadowy setting.

During his four years at the Academy, Forsyth had done little else but study. The only relaxation he had allowed himself was an occasional evening at the opera or a few idle hours at the American Artists' Club of Munich. Organized from bimonthly dinner meetings which had been initiated by Chase a decade earlier, the Artists' Club had become a popular gathering spot for English-speaking students, especially during the holidays.

Forsyth, who served as the club's secretary for four years, described one of its Christmas celebrations to Hibben: "Saturday night the American Club celebrated their Christmas by a Christmas tree and a bowl of punch and had a howling good time, loads of fun…The club room is usually decorated by works of members, past and present, works by Duveneck, Chase, Shirlaw, McEwen and Currier, but Saturday night it was hung to the low ceiling with evergreens, holly, palm leaves and bunting of national colors…Men kept dropping in, each batch of newcomers increasing the sweet uproar, jokes were bandied about, conversation increased, some applied themselves to beer, some filled up with things substantial to fortify themselves for the coming siege…All manner of things which the ingenuity of depraved art students can imagine are given, tin trumpets, wooden and tin toys, baby rattles, sausages, bottles of wine, fish…including some things which I dare not mention."[56]

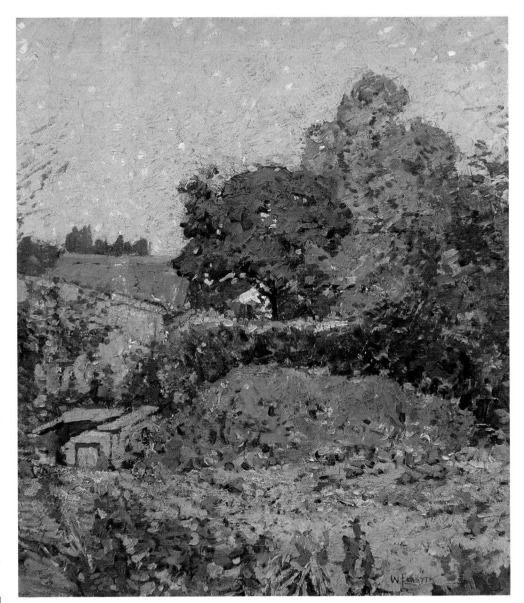

**William Forsyth**
*Three Little Girls on Steps.*
Watercolor
11 x 13 inches
Eugene and Mary Henderson

During Easter vacation of 1885, Forsyth and an Academy classmate took a sketching trip to Venice, spending several days hiking in the Tyrolean Alps on the way back to Germany. Hoping to finance this long-awaited vacation by selling some of his work, Forsyth, along with his Hoosier classmate Steele, had shipped a number of paintings to Indianapolis for a joint exhibition and sale to be held at English's Hall during April of 1885. Engraved pen-and-ink illustrations for the exhibition catalogue entitled *Art Exhibit of the Hoosier Colony in München* were done by Bohe Club members Hibben, Fred A. Hetherington, Charles Nicholai, and Charles McDonald. A newspaper critic of the day determined:

*"The works of Forsyth are characteristic of the man: original, vigorous, strong, bold. He is an experimenter, and each study, in whatever medium contains a motive, a scheme of color, of light or of composition to justify its existence...Pre-eminent in the exhibition is Forsyth's* Old Man... *Strongly drawn, good in color, full of character and fresh qualities, the* Old Man *is expectant, yet contented and meditative."*[57]

After returning from his holiday in northern Italy, Forsyth finished his last year at the Academy. Upon the completion of his formal study, he opened a studio in Munich in the fall of 1886 with fellow Hoosier artist J. Ottis Adams.[58] For two years, Forsyth worked in that studio although Adams, lured by thoughts of home, left for the United States in the fall of 1887.

During the harsh Bavarian winter months, especially after Adams's departure, Forsyth spent long hours drinking coffee and reading the English papers in the Cafe Union "where English-speaking students most do congregate."[59] On Sunday mornings, the solitary artist usually visited the Kunst-Verein, a gallery where the most recent works of the German painters were put on display for one week: "On a Sunday you meet a constant stream of people going and coming, crowds of ladies, crowds of gentlemen, crowds of military men, and any quantity of art students…who, having leisure on that day, rush off to see the latest things."[60]

As soon as the weather allowed, Forsyth abandoned the gray light of his Munich studio for the brilliant sun of the countryside and the comfortable familiarity of its scenic villages: "Unterschleissheim, most picturesque of hamlets with its tall poplars and red roofs, seems half buried in the flat rye fields which sweep away to the distant hills…To the westward, the moors, with their scattered birches, stretch away to the hills with Dachau perched upon their southern point. Southward, beyond the pine grove, lies Schleissheim. The Avenue of stumpy old lindens from Schleissheim ends just in front of the monastery."[61]

Devoting his time almost entirely to landscape, Forsyth made great strides in both oil and watercolor while painting outdoors in a "great studio whose roof is the blue ether and whose windows are curtained with the changing clouds."[62] As he explained to Hibben, his work, marked by masses of light and shade giving a rich harmony of color, was "almost all in one direction: truth of tone and color, light and breadth with as much loyalty to detail of drawing as is consistent with unity of impression."[63]

In April of 1888, Forsyth received a letter from his former studio-mate Adams who had settled in Muncie, Indiana, a year earlier. Asking if he would be interested in teaching art in Fort Wayne, Indiana, upon his return to the United States, Adams had written: "A bit of business, are you coming home in the autumn and if so, would you teach?…You could probably sell some of your work here and also most likely get considerable portrait work to do."[64] Forsyth enthusiastically agreed, writing Adams: "I'll be dam'd glad to take your F.W. school off your hands in case you give it up."[65]

Forsyth left Munich on September 24, 1888, to return to the Hoosier state. By spring, he was commuting from Indianapolis to Fort Wayne to help Adams in his teaching there. Drained by the demands of constant travel, the two artists decided to curtail their itinerant teaching in favor of opening a traditional art school in Muncie. During the summer of 1889, they mailed circulars describing the curriculum of their new school "to friends and to persons known to be interested in art."[66]

Concerned about the competitive threat posed by Steele's recently opened art school in Indianapolis's Circle Hall, Adams wrote Forsyth who was still living in the Hoosier capital: "How is the Indiana School of Art? Where is it and what kind of a start have they made? We want to know all we can about it now for it is an opposition affair[67]…You did not tell me everything about Steele's school, how many pupils, what kind of rooms, how he conducts it. We want to outdo him in everyway possible for someone will come along that will visit the two schools and make comparisons, and ours must show up when it comes to that."[68]

The Muncie Art School, located at the Little Block, opened in November of 1889.

With Forsyth and Adams listed as the school's only instructors, it offered out-of-doors sketching, drawing and painting from life, drawing from the antique, drawing from objects, still life painting in oil, watercolor and pastel, and etching. According to the school's 1889-90 circular: "The works of Messrs. Adams and Forsyth done during their long stay abroad, consisting of pictures, studies and sketches in oil, watercolor, pastel, black and white, etc., are available to the students for the purpose of study and reference; also, fine collections of photographs, and reproductions from the best masters, old and new."[69] The tuition for students attending the classes was ten dollars per month.

Despite the popular acceptance of the Muncie Art School, Forsyth was never wholly comfortable with the life of the small Indiana town. At the end of the 1890-91 school year, he left his teaching position with the school to return to Indianapolis where he felt more at home. There he became involved with Steele's Indiana School of Art as a principal instructor.[70] Although Steele would resign from his responsibilities at the school in February of 1895, Forsyth would continue to teach its day and evening classes until June of 1897 when the school building would be torn down to make way for the expansion of the nearby English Hotel.[71]

**William Forsyth**
*Our Yard.*
Oil on canvas
20 x 24 inches
Penny Ogle Weldon

During November of 1894, Forsyth displayed twelve oils in an Art Association of Indianapolis exhibition which was invited to Chicago for a holiday showing in December. Impressed with this visiting Five Hoosier Painters exhibit, Illinois art critics approvingly commented upon Forsyth's "strength and freshness"[72] of technique. Finding that the works displayed were "impressions of Indiana landscapes by keen, sensitive and refined artists,"[73] the commentators lauded the Hoosier Group:

"*(The artists are) producing such fresh vital work. They are of the few who are doing the right thing. They are painting their own fields as they see them, with a real affection. This love of theirs is real or it wouldn't show so strongly in their work. About their individuality— it seems to us that their liberty in Indianapolis has developed each one of them on personal lines. The more freedom from convention, the more individual the result,* after *the man has had his training.*"[74]

According to Forsyth, the success of the Hoosier Group show in Chicago helped to point up the fact that "there was a band of artists at work in the West so closely united in aim that it approached the definition of a school of painting."[75] With pride, he recalled how several of the Hoosier artists, after returning from their studies in Paris and Munich, had decided to settle in Indiana and apply their training to the things they knew best.

In an article written years later, Forsyth would say of the Hoosier Group: "A singleness of purpose has been the animating principle of this group of painters and their pupils: To paint their pictures here at home, to express themselves each in his own way and yet hold closely to that local truth characteristic of our particular spot of earth and interpret it in all its varying moods that are its charm—this has held them faithful to their original intentions, has bound them together with a common purpose,

and whatever success they have achieved is due to this. Even the appearance of their pictures testifies to the truth of this, for however much they may differ as to individual expression, treating the same subjects, influenced by the same moods of nature, trained in the same schools, associated together more or less for years, using even as occasion demanded the same technique, there is a family likeness, indefinite perhaps, but yet a likeness, binding them together into perhaps as near a school of painting as has been developed in this country—certainly in the West."[76]

Wanting to focus interest upon the art being done in Indiana as well as around the Midwest, Forsyth, with fellow Hoosiers Steele and Adams, joined fifteen other midwestern artists in 1896 to form the Society of Western Artists. The group, with its charter members drawn from Chicago, Cleveland, Detroit, St. Louis, Cincinnati and Indianapolis, sponsored a rotary exhibition which traveled annually to each of the six founding cities. According to one of the organization's members: "Our exhibition, the first of its kind in the United States, has enabled our artists of the Middle West to keep in touch with the others' work and there has grown up, unconsciously, perhaps, an exhibition distinctly marked by choice of subject and individual expression which makes our Annual Exhibition unique in the exhibitions of the country."[77]

Beginning with the group's opening exhibition in December of 1896 through its last annual in 1914, Forsyth was an active member of the Society whose membership, in time, included a majority of the well-known artists in the Midwest.

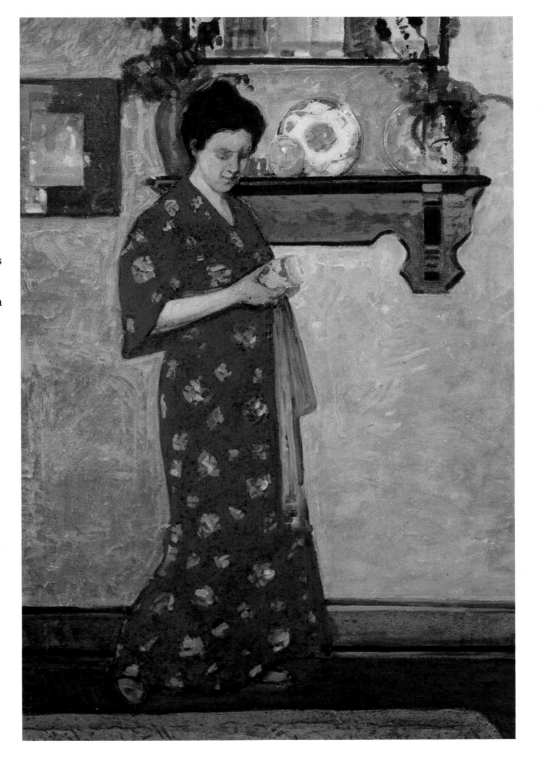

**William Forsyth**
*Twilight, Moon over Red Barn.* 1908
Oil on canvas
28⅛ x 24 inches
Private Collection, Zionsville, Indiana

Throughout the organization's eighteen-year history, Forsyth exhibited regularly in the annuals and served in every office except that of treasurer.

After teaching classes nearly year-round, first with Adams and then with Steele, Forsyth customarily saved several weeks toward the end of each summer for himself. During the 1890s, he explored some of the more scenic spots in the state, painting at Vernon in 1891, Hanover from Logan's Point in 1893 and 1894, and Corydon in 1896.[78]

In the summer of 1897, Forsyth took his two younger sisters, Elizabeth and Alice, and one of his pupils, Alice Atkinson, to Cedar Farm, a friend's childhood home located on the Ohio River near Brandenburg, Kentucky. Alice, a serene young woman with curly brown hair and serious dark eyes, had studied at the Chicago Art Institute and had taught school in Vincennes, Indiana, before returning to Indianapolis to study with Forsyth in 1895.[79]

One of the artist's daughters later wrote of this momentous trip: "After the sisters had left to return to Indianapolis for the opening of the school year, Miss Alice Atkinson and Mr. Forsyth stayed on. Early on a sparkling fall morning, accompanied by a friend, they took the morning boat up to Louisville where Miss Atkinson of Oxford, Benton County, Indiana, became Mrs. William Forsyth at the Grace Episcopal Church on October 14, 1897. They returned to Cedar Farm on the evening boat to spend their honeymoon, staying on until the snow fell and the icy winds of winter encompassed the great valley of the Ohio River."[80] Alice, eighteen years younger than Forsyth, proved to be an ideal balance wheel for the talented artist. As reserved as he was ebullient, as thoughtful as he was impulsive, she would gracefully share a life shaped by the demands of art with her husband.

The newlyweds returned to Cedar Farm the following summer, taking with them several of Forsyth's students: "Besides sketching or painting every day, they

swam, boated, built huge fires on the beach at night and made candy. The young ladies, much to Mr. Forsyth's disapproval, taking in a farm dance or two. And as a climax to the summer, they gave a play called 'Madam's Revenge'…Not satisfied with just the people at Cedar Farm for an audience, they posted signs at the crossroads inviting the neighborhood. Everyone within buggy distance came and the play was a great success."[81]

After the close of the Indiana School of Art in 1897, Forsyth began teaching art classes in the Union Trust Building in Indianapolis during the winter and spring months of each year. In the late summers, he pursued his beloved landscape work, painting with Alice in the crimson-leafed valley of the Whitewater River near Brookville in 1899 and 1900 and outside of the charmingly quaint old state capital of Corydon in 1901 and 1902. He explored the steep-walled cliffs of Pleasant Hill near Shakertown, Kentucky, in 1903 and the serenity of the gently rolling Indiana hills outside of Martinsville in 1904.[82]

Without a doubt, the work done during the artist's summer retreats reflected his great love of the out-of-doors. With a deft touch and a dramatic flair for color, he delighted in giving expression to the loveliness of his state. He explained the artistic challenge of trying to capture a bit of nature on canvas: "Ordinarily people only see the form, and not the mood outdoors. To them, the clouds are white, the sky is blue, the trees are green. But the artist sees a great deal more than this. To him the most attractive things are those that are expressed in some subtle way."[83]

Wishing to live amid the natural beauty he loved so well, Forsyth, in April of 1906, moved his family from 938 Fletcher Avenue in Indianapolis to the village of Irvington, a tiny community of wooded, winding streets on the outskirts of the city. Bounded by Pleasant Run Parkway on the north, Emerson Avenue on the west, English Avenue on the south, and Arlington Avenue on the east, Irvington— the home of Butler University until June of 1928—combined the charm of a small town with easy access to Indianapolis. Surrounded by open country, the self-contained village had a strong community life, yet it was only a half-hour's ride on the interurban to the city's down-town area.

The Forsyths, numbering five with the births of daughters Dorothy in 1899, Constance in 1903, and Evelyn in 1906, happily settled into the rambling hillside house tucked away in the woods on the corner of Emerson Avenue and Washington Street. Alice quickly organized the household, and, with gentle calmness, she soon made the Forsyth home the center of neighborhood activity for her husband and three young children.

Pleased with having intriguing subject matter to paint everyhere he looked, Forsyth encouraged wild flowers, trailing vines, and bramble bushes to grow unchecked around his new house. According to one of the Irvington youngsters: "They had a wonderful backyard. When you went out the back door of the house, there was a huge bed of flowers, the kids' swing and a playhouse surrounded by more flowers. In the far back, there was a tiny graveyard surrounded by overgrown bushes and brambles. We loved to play back there."[84]

Shortly after his move to Irvington, the artist built a separate studio which was connected to the nine-room house—a "sort of 'put-together' house with a porch here, a porch there and lots of personality"[85]— by a short, screened walkway. Off-limits to the neighborhood children, Forsyth's workshop was "always piled high with stuff[86]…He had a practice of leaning his stretched canvases, drawings and watercolors around the walls on the floor and of balancing them on chairs for display. He allowed people to come into his studio and select their paintings to buy. He also gave his work away as wedding presents, letting the favored bride or groom come in and choose a painting."[87] In the middle of his studio was Forsyth's work area with its tubes of paints, brushes, and half-done sketches partly hidden by a screen upon which the artist had painted the griffin of his Scottish clan crest in brilliant green.

In the fall of 1906, Forsyth joined the faculty of the John Herron Art Institute in Indianapolis, replacing J. Ottis Adams as the principal instructor in drawing and painting. Since its opening in March of 1902, the Institute, initially located in Steele's former residence at Sixteenth and Pennsylvania Streets, had increased its art school enrollment dramatically. By 1905, the school and museum—both of which had been established by the Art Association of Indianapolis in accordance with a bequest in the will of Indianapolis citizen John Herron—had outgrown the space available in Steele's old house and studio. The two-story house had been torn down, and the studio, razed to make way for the construction of new quarters for the Institute. Its enlarged facilities were completed about the time Forsyth accepted his teaching position at the school.

Years later, the veteran teacher would proudly say of the Institute with which he was associated for nearly three decades: "The art school is a flourishing and noteworthy part of the Institute's work, not only where regular students of art may acquire the principles of drawing and painting and design, but also where, through an arrangement with the public school board and a special tax, hundreds of pupils from the public schools supplement their regular school art work. Also, by courses of lectures on all departments of art work, by gallery talks, musical programs and an ever-changing interest in the exhibitions, it is sought to bring the public into closer and closer relations with the Institute."[88]

**William Forsyth**
*Brookville.*
Oil on canvas
17 x 24 inches
Dr. and Mrs. Jay Weiss

**William Forsyth**
*Pleasant Run, Irvington.* **1917**
Oil on canvas
24 x 31¾ inches
Private Collection

**William Forsyth**
*Pleasant Run.*
Oil on canvas
18 x 24 inches
Mr. and Mrs. David J. Hyde

Short, wiry, and energetic, the blue-eyed Forsyth quickly earned his reputation as being a fiery, sometimes sarcastic teacher. According to one of his life class students: "Mr. Forsyth was short, a lot shorter than most men, and I believe that is why he had that feisty way about him, to make up for his height. He was rather severe as a teacher. He'd usually criticize by looking at a student's work and saying, 'That's not good.'"[89] When he was displeased with a student, he "wouldn't even stop to criticize his work. He would just pass him by, pass by his easel, never saying a word. He would act as though the student wasn't even there in the class."[90]

Another student remembered the artist's brusque teaching method: "In his classes, the students would pick a spot in the room from which they wanted to draw the model. When class started, they would come in and start to work. Then Mr. Forsyth would come in and begin the class by going from easel to easel sharply pointing out problems and answering questions. Occasionally, he would take some charcoal and show the student how to do it better. He criticized everybody. He didn't care what he said."[91] Between classes, however, Forsyth made a habit of going outside to sit on the back steps of the school to smoke one of his ever-present cigarettes and visit with some of the students. "He was one of us and after class, he would just talk to us about things in general."[92]

For all his blustering, Forsyth was gruffly supportive of his students. The peppery teacher, throughout his years at the Institute, remained committed to helping the pupils with their extra-curricular activities and personal concerns. One time he put his lively wit to work by acting as a comic auctioneer for the Institute's spring fund-raiser, and, upon another occasion, he got involved with creating dance decorations for a school costume party. Forsyth was even willing to help those who had completed their work at the school. He would go out of his way to visit a onetime student's studio to look over the young artist's work and offer constructive criticism.

Supportive of his students, even at a distance, Forsyth would keep up an active correspondence with several of his pupils during World War I. Shortly after the signing of the November 1918 armistice, he would write to a former student stationed in France: "The confusion in all walks of life consequent on the war and its sudden close is very evident and it will require wisdom and patience before things settle down…The school is in a bad way, and I don't see much change for the betterment soon…Don't lose any opportunity to see things, I'd even try to get my stay extended if such were possible. You may never have the chance again. I know what it means to have lived and seen while over there. Well, here's to your luck and hoping you won't have to come back too soon."[93]

In addition to his teaching responsibilities, Forsyth, along with Otto Stark and T. C. Steele, gave gallery talks at the Institute. The artists' weekend afternoon lectures, open without charge to teachers and children of the public schools as well as to members of the Art Association and their families, were helpful in interpreting the museum's exhibitions. Using the talks as an opportunity to explore areas of art not ordinarily considered by the public, Forsyth chose such topics as "The Evolution of Landscape Painting," "The Birth of Everyday Art of Genre," and "Methods in Art." During one lecture, he focused upon his etching work in Munich: "They call etching one of the minor arts. I don't see anything minor about it, unless one judges it by the work of the small fry. It means genius of the highest type. It has not only line, but also a vivid suggestion of color. I never tire of studying an etching, for there is always something fresh to see in the work of a master etcher."[94]

For a number of summers, after the close of the Art Institute school year, Forsyth offered a class in outdoor painting at his studio in Irvington. Popular with the students, the informal class worked in the sunlit fields and along Pleasant Run Creek near the Forsyth home, learning landscape techniques from a craftsman. One of Forsyth's daughters remembered tagging along with the students: "I was about four years old and I followed those summer classes all over the yard and across the street to the meadow. They would paint outdoors in the open country along Pleasant Run Creek. Daddy allowed my sisters and me to go along with them. We could wade in the creek as long as we stayed within sight of the last easel, wherever that last student was painting. We had a lot of freedom to play, so we didn't pay them too much attention."[95]

During the summer of 1914, Forsyth put aside his Irvington landscape class to supervise the painting of thirty-three gaily-colored murals at the Indianapolis City Hospital. He, as well as Stark, Steele, Adams, and eleven other Hoosier artists,[96] was hired by Dr. T. Victor Keene, president of the city's Board of Health, to work at housepainters' wages on decorative murals for two of the hospital's unfurnished wards. As the project's supervisor, Forsyth selected a color scheme for the ambitious undertaking, allowing the fourteen artists who were giving so obligingly of their time and talent to have complete freedom in composition and execution.

With the exception of Steele and Adams who painted in their respective studios in Brown County and Brookville, the artists worked in the hospital. Many even moved into the building as they brought its blank walls to life with festive children's story illustrations, inspiring Biblical scenes, misty Indiana landscapes, heartwarming holiday scenes, and portraits of twenty-four Indianapolis children. Because few of the artists were familiar with the techniques of working directly on plaster, most of the painting was done on a heavy canvas which was glued to the wall.

Forsyth, who enthusiastically approved of the artistic venture, spent many long hours working on his own landscape in the entrance hall while overseeing the general project. According to one of his daughters: "Daddy picked up an unidentified 'bug' going around the hospital and he really suffered from it for several months. I remember he slept downstairs on the library lounge so he could get up and walk the floor at night without disturbing the rest of the family."[97]

Forsyth's life outside the classroom was defined by the same characteristic verve as were his mercurial relationships at the Institute. He was outspoken, sometimes tactless, and never at a loss for words. A voracious reader since boyhood, the self-educated artist often displayed an impressive grasp of world politics, history, and literature while attending the meetings of several of the Indianapolis clubs. An enthusiastic member of both the Portfolio Club and the Literary Club, Forsyth liked nothing better than a spirited exchange of ideas at each of the clubs' meetings. One member later recalled: "Mr. Forsyth was a man who always knew the answers. He read and I think, when he wasn't painting, he read some more. He was well-informed and he knew what he was talking about. He loved a good argument and had a terrific memory. I've heard him, in later years, at the Portfolio Club when he would pop up and question anything. When he agreed with what the speaker had said, he would laugh and chuckle. He seemed to be pleased to find someone who knew something and, what's more, who said something."[98]

**William Forsyth**
*The Pool.*
Oil on canvas
24 x 28 inches
Mr. and Mrs. R. Stanley Lawton

**William Forsyth**
*Chicken Coop.*
Oil on board
21 x 16½ inches
Marge and Park Wiseman

At ease before the public, Forsyth took great pleasure in performing in amateur theater productions. When his schedule allowed, the part-time actor worked with the Little Theater Society of Indianapolis, appearing in several of its plays as well as sketching pictures for the group's promotional newspaper stories. The multi-talented artist also belonged to the Irvington Dramatic Club, a group which occasionally opened its study meetings to the public for a formal play presentation. According to one of the local thespians: "Mr. Forsyth was a play in itself when he was in any of the plays. He never gave exact cues. He had a sense of the play, but it was the way he wanted it, rather than the way it was written. Whoever was in a play with him had to just follow along with the sense of the dialogue because Mr. Forsyth would be making up the lines. This routine made the play comical and it added more spice. When Clifton Wheeler and Will Forsyth were in a play, we really had a ball."[99]

Irvington's Dramatic Club was not alone in benefiting from the skills of the neighborhood resident artist. Forsyth periodically visited School #57 at the corner of Ritter and Washington streets to show the elementary pupils "how to paint." Encircled by children perched on folding chairs, he would sit at his easel in the auditorium, patiently answering the excited questions of his youthful audience. Forsyth not only did a marvelous series of seasonal landscape murals for School #57 in 1922, but, upon the graduation of each of his children from the school, he presented it with one of his prized paintings. He later repeated this generous gesture upon the graduations of his three daughters from Shortridge High School and Butler University.

Because of the relatively flexible nature of his work, Forsyth was able to be home a great deal more than those with regular office hours. According to one of his daughters: "Daddy's working schedule would be partly determined by when he taught. He didn't teach every day at Herron, so, on the other days, he would paint at home, out in the studio or out-doors.[100] If he wasn't teaching, he was painting. If not painting, then he was working in the yard or garden. If not gardening, then he was reading."[101]

Enjoying the freedom to pursue his wide-ranging interests and hobbies, Forsyth was quite proud of his garden and in having flowers in it "from frost to frost."[102] Wearing the "awfulest sweater you ever saw,"[103] he spent many happy hours tending his flowers and trimming the luxuriant hedge along the Forsyths' front walk on Washington Street. With the exception of his favorite painting spot north of the house where the artist had encouraged the tangled vines and dense underbrush to grow unheeded, "he did quite a bit of yardwork. He planted a lot of bushes and flowers and worked in the vegetable garden."[104] Despite his best efforts and to his mild disgust, however, Forsyth was unable to grow roses with any great success.

Family picnics along Pleasant Run Creek, when the artist and his wife would tuck drawing paper and pencils into a food-laden straw basket, were favorite outings for the Forsyths: "When we went on picnics with our parents, Daddy would never stop talking about the sky. He'd tell us, 'Watch the clouds move, feel the wind, see the trees.' He and Mama would test us, saying, 'Now you can tell exactly what kind of tree that is just by its shape.'"[105]

During the long, dark Indiana winter nights, Forsyth turned his attention indoors. He would read, or, while listening to music—"he loved hearing the opera and the New York Philharmonic on our radio when we finally got one"[106]—he would carve decorative designs on the frames for his special paintings.

In 1924, Forsyth's teaching duties at the Art Institute were expanded to include a position on the faculty of its summer school at Winona Lake near Warsaw, Indiana. Headquartered in the rambling Winona Hotel, the school offered students a six-week course in Fine Arts, Teachers' Training, or Commercial Art. Listed in the Institute's 1924-25 catalogue as the fine arts instructor for the summer, Forsyth focused his classes upon the figure out-of-doors and landscape work in oil and watercolor. Heartily enjoying "the outdoor vacation and art program (which) included fishing, boating, swimming and hiking,"[107] the artist returned every summer for nearly a decade to the Winona Lake school as both teacher and public lecturer. One of the summer students remembered: "We were outdoors most of the time working on landscapes with an emphasis on trees, water and foliage. It was a very intensive course which met five days a week for the most of each day. Sometimes, for fun, we would take boat rides, but usually we worked."[108]

After the close of the Institute's 1927 summer term and before the opening of its fall session, Forsyth took a brief, well-deserved vacation to the New England coast. Drawn by the solitude of the rocky shoreline, he returned there again in 1929. Painting for several weeks each year around Gloucester, Massachusetts, Forsyth became intrigued with the atmospheric effects of the misty rain which fell during both of his visits. His work, mainly seascapes done in watercolor, reflected this interest as he portrayed the subtle beauty of sky and water with a mingling of grays, violets, lavenders, and greens.

During the Institute's 1930 summer hiatus, Forsyth worked briefly in California, hoping to get a new perspective and "to keep from getting one-sided."[109]

In August of 1931, he revisited Europe on a two-month whirlwind trip through England, Scotland, France, Germany, and Switzerland. In many respects, the journey was a deeply personal one for the seventy-seven-year-old artist. He lingered in a favorite gallery or two, retraced the steps he had walked as a young art student some forty years earlier in Munich and paid silent homage to the war dead among his Scottish clansmen in the majestic Edinburgh Castle.

With deepening economic concerns affecting individuals and institutions alike, the John Herron Art Institute was not immune to the financial upheavals of the Great Depression. Hoping to bolster flagging public support for the Institute, the board of the Art Association of Indianapolis triggered a reorganization of the school's staff with its appointment of Donald Magnus Mattison, a Prix de Rome winner from Yale University, as director. With a mandate from the board to broaden the school's educational base and to upgrade its fine arts instruction, Mattison, in May of 1933, announced that Forsyth, Clifton Wheeler, and six other members of the faculty would no longer be teaching at the school the following fall.[110]

At the close of the 1933 spring term, Forsyth left the school which had been his home for so many years. According to one daughter: "He was crushed even though his friends rallied around him as best they could."[111] Financially unprepared for the abrupt termination, Forsyth found work with a federal Public Works Administration program doing two large pieces in tempera for the Indiana State Library. His daughter Dorothy signed with the Indianapolis public schools as a substitute teacher, and her sister Constance, a talented artist in her own right, painted an occasional portrait to help the family budget. Alice, with her customary aplomb, encouraged her industrious family's efforts and quietly tightened the purse strings to match the Forsyths' diminished income.

**William Forsyth**
*Self Portrait - The Smoker.* 1928
Oil on board
20 x 16 inches
Susan and Robert Stephens

In February of 1934, Forsyth suffered a heart attack and, upon doctor's orders, spent the rest of the spring and early summer in bed. With the coming of hot weather, he was able to dress and enjoy several hours each day in the yard. One of his daughters remembered: "He was never well after his heart attack. He would sit on a bench in the sun in our yard and the neighbors would come over to sit and talk with him. He got so tired. It seemed as though the backyard was always full of company."[112]

Believing that it was important to paint a little each day, the ailing artist made an effort to work through the fall and winter months as his strength allowed. On March 29, 1935, however, the eighty-year-old Forsyth, who had "lived his painting twenty-four hours a day,"[113] died of kidney failure after a brief illness.

Throughout his life, the volatile painter had exhibited widely, displaying work in prestigious national and international exhibitions as well as in the neighborhood shows sponsored by the Irvington Union of Clubs. An active participant in the Society of Western Artists annuals from 1896 to 1914, he had been an articulate advocate for the development of regional art.

Forsyth's illustrious exhibition career had begun shortly after his return from Munich when, in 1893, three of his canvases had been accepted by the World's Columbian Exposition in Chicago. Serving on the selection jury as well as exhibiting at the 1904 Louisiana Purchase Exposition at St. Louis, the Indianapolis educator had won a silver medal for his Shakertown watercolor *In The Afternoon* and a bronze medal for his Kentucky River *Late Afternoon* in oil.

Forsyth had taken the bronze at the 1910 International Fine Arts Exposition at Buenos Aires, Argentina and Santiago, Chile, with his *Twilight*. That same year, he had also been the recipient of the $500 Fine Arts Building prize given for his *The Last Gleam* at the Chicago annual of the Society of Western Artists. In 1912, the artist had won the Richmond Art Association's Mary T. R. Foulke award with his *October Morning* after having received an honorable mention at the Association's yearly show in both 1906 and 1911. Again capturing two medals, this time at the 1915 Panama-Pacific International Exposition in San Francisco, Forsyth had been awarded the silver for his watercolor *A Sunny Corner* and the bronze for his oil *The Red Hill*.

In 1928, the seventy-four-year-old artist had continued his lengthy history of prize-winning work with the award of the $300 Chicago Galleries Association purchase prize for a marine landscape, done the summer before in Gloucester, and a $100 first prize for his oil *The Last Winter* at an exhibit of thirty-five Indiana artists at Ball Teachers College in Muncie, Indiana.

Clearly, Forsyth's work—strong in technique, vigorous in approach, and spirited in color—reflected the man. With a distinctly characteristic blend of quicksilver wit, affectionate loyalty, utter integrity, and biting honesty, he had spurred his Institute students on to artistic heights for nearly thirty years. His life had been filled with the love of his family and the satisfaction of knowing he had expressed "a little of the fullness of the world's beauty"[114] in his work.

Daughter Dorothy helping William Forsyth paint,
Shakertown, Kentucky, 1903. Constance Forsyth
and Evelyn Forsyth Selby Papers.

**Richard B. Gruelle**
*Sunset.*
Oil on canvas
10 x 16 inches
Mr. and Mrs. Bill Geyer

# Richard B. Gruelle

## 1851-1914

**Like a gardener on the silvery side of life, who is found among the plants and flowers which he has nurtured and seen grow into the fullness of nature, so has he for years watched the development of this beautiful collection, and with loving care constantly added and weeded out until one would linger long ere displacing a single object.**

**Richard B. Gruelle**

*Notes: Critical & Biographical*
April, 1895

Portrait of Richard B. Gruelle, 1914. Peg Slone Papers.

The notes for the Gruelle essay begin on page 162.

Richard Buckner Gruelle, a talented artist and one of Indiana's more lyrical late nineteenth-century writers, was born in Cynthiana, Kentucky, on February 22, 1851. Among the youngest of the eight boys and three girls born to John Beuchamps and Prudence Moore Gruelle,[1] he spent the first six years of his life in the tiny Kentucky town where his father was the local tanner. In 1857, the Gruelle family moved north to Illinois, settling first near Bourbon and then in the small Douglas County village of Arcola.

Gruelle dreamed of being an artist from his early childhood, "drawing on everything he could find."[2] Reprimanded by his teacher for drawing during school hours, the young boy was often chastised for "wasting his time in such a foolish manner."[3] He refused to give up his attempts at art, however, and, with the whole-hearted encouragement of his mother, the youngster painted for the enjoyment of his friends after school. Inspired by the traveling panorama shows of the mid-1800s in which a succession of pictures wound between two cylinders was projected in front of a lamp, Gruelle imitated this popular form of theatrical entertainment in his childish way: "He used to give exhibitions to the children of the village with a lantern improvised out of a joint of stove pipe and bits of glass upon which were painted scenes representing the battle between the Merrimac and the Monitor. They were his favorite subjects. With the aid of a tallow candle and bits of powder, these exhibitions were given in the barn and an admission of five pins was charged."[4]

At the age of twelve or thirteen, Gruelle, forced by the financial necessity of helping his parents feed the large family, quit school to seek employment. Holding fast to his dream of becoming an artist, the teenager was, nonetheless, obliged to look for odd jobs in the village and on the surrounding farms.

In an autobiographical letter written years later, Gruelle traced these early years in a somewhat stilted fashion, often referring to himself in the third person. After describing his short-lived attempt at being a farm hand in 1864, Gruelle wrote: "He decided that, as he intended to be an artist, he would apprentice himself to the village house and sign painter and learn the trade, thinking that the use of paint and the mixing of colors would be an advantage to him and, at the same time, enable him to earn a living…Our young apprentice proved to be very useful in the shop. In those days, a house painter had to mix all his own tints and to do this required no little skill. Our young apprentice soon found favor with the boss because of his ability to match tints."[5]

Gruelle recalled his first serious efforts at art: "Rainy days and Sundays found our young apprentice endeavoring to paint pictures using common house paints and, for his canvases, old insurance cards which were given him. His boss predicted great things for him. He was so interested in him that if he worked three days in the week, a week's wages was always allowed him."[6]

The enthusiasm and ability of the aspiring young artist soon attracted the attention of the village's tradesmen. Gruelle was asked to paint a sign for the town's new restaurant, receiving in payment *Chapman's American Drawing Book*, one of the best publications on art instruction at the time. Gruelle remembered his pleasure in receiving the book: "This proved to be a valuable first for the boy as it gave him his first instruction in how to draw and paint."[7] Shortly after finishing the sign, Gruelle was taken aside by the village cabinetmaker who offered to show him "how to make stretchers and how to size and prepare canvases and make an easel."[8] Impressed with the lad's interest, the old craftsman gave him a copy of *Bouvier's Manual of Painting*, a volume on oil painting by an early French artist which "proved of great help to me."[9]

**Richard B. Gruelle**
*Capitol Building in Washington.*
Watercolor
19½ x 25½ inches
Keith Uhl Clary

According to Gruelle, to whom the "fragrance of sweet jasmine in the woods was not so sweet as the smell of new canvas and new tubes of color,"[10] a new world opened to him with the gift of his first set of artist's materials. He gratefully remembered: "A young lady who was attending a college in the East returned to town. Among her studies was that of painting. When she saw what the boy was doing, she immediately gave him all her materials, paints, brushes and a roll of new canvas and all the tools essential to a professional artist, declaring, at the same time, it was a shame to waste them upon such things as she was doing and a person like me to be deprived of having them."[11]

After serving a three-year apprenticeship with the village painter, Gruelle was declared a qualified workman and a full-fledged partner of the Arcola artisan. The youth put in long hours at his trade during the day, saving the evenings for a study of portraiture from the books in his meager art library. After damaging his health with recurring bouts of lead poisoning from the constant use of lead-based paints, the ambitious artist decided to quit house painting and to try earning a living from portrait work. Because of the limited demand for formal portraiture in the pioneer town of Arcola, most of his work consisted of painting posthumous portraits from daguerreotypes.

Gruelle's efforts as a portraitist proved to be financially unsuccessful. Discouraged, he gave up painting and moved to western Illinois where he took a job with an engineering corps involved in making a survey of the area's railroad. During the project, Gruelle was asked to sketch the likeness of one of the contractor's children who had become ill and died unexpectedly. Heartened by those who thought he had captured the spirit of the child in his sketch, the artist decided to move to Decatur in central Illinois to try portraiture once again. Gruelle later recalled painting that fateful portrait: "This proved so successful that the young artist was induced to locate at Decatur, Illinois, and open a studio. He lived and practiced his art there for some two or three years, alternating portrait painting with giving lessons."[12]

During his stay in Decatur, Gruelle met, courted and wed Alice Benton whose Scotch-Irish family had moved to Illinois from Massachusetts when the girl was a teenager. One of Gruelle's sons recalled hearing, as a child, about the early years of his parents' marriage: "I remember Father telling of passing the Benton home often, and of seeing Mother out in the yard raking leaves. We have no knowledge of how they finally met, but I know that Mother was working for a Decatur photographer at about this time, and it may have been in his photo studio that the meeting occurred. We haven't the date of their wedding, or any knowledge of how long they lived in Decatur, after this important event."[13]

For a short time after leaving Decatur, the Gruelles lived in Cincinnati, Ohio, where the artist was employed by a firm which manufactured steel safes. According to Justin Gruelle, his father's "job was to paint landscapes on these products. He also started to attend a life class at night. This was the first opportunity that he had of obtaining a traditional art education."[14]

In September of 1876, Gruelle's father died. The dutiful son ended his art study and returned with Alice to care for his mother and an aged aunt in Arcola. He remembered that time in his life with some sadness: "Thus again, the would-be artist found himself isolated from any art influences so that he had to go out and solicit orders where he could get them, always painting portraits of deceased people from photographs."[15]

Upon the death of his aunt, the artist left Arcola with his wife, mother, and young son John who had been born on December 24, 1880. The Gruelles first lived in Gainesville, Florida, where they stayed for a time with one of the artist's older brothers. Then, in 1882, they came back north, taking a house near the Lockerbie Street home of James Whitcomb Riley in Indianapolis. The move was a propitious one for the thirty-one-year-old artist as he would later, in 1891, illustrate "When The Frost Is On The Punkin" and "The Old Swimmin'-Hole" for the Hoosier poet.

After locating in Indianapolis, Gruelle took up landscape painting in oil and watercolor, choosing scenes around the city for his subjects: "Prior to coming to the Hoosier Capitol, he had essayed to little else but painting portraits, save now and then, he had made attempts at landscapes. But the environment of the Hoosier Capitol proved to be very tempting to him and his efforts in this line proved very successful. Each year showed a steady advance in his work, and especially in his work in watercolor which has steadily found a growing appreciation among the people."[16]

With Gruelle's settling in Indianapolis and with the return to central Indiana in the late 1880s of fellow artists Theodore C. Steele, William Forsyth, J. Ottis Adams, and Otto Stark, the foundation for the development of Hoosier art was laid. Uncomfortable in the presence of these formally-schooled artists, Gruelle maintained: "Not withstanding this influx of thoroughly trained talent, Mr. Gruelle has steadily held his own."[17]

During the administration of President Benjamin Harrison, Gruelle was invited by art connoisseur Herbert Hess of Indianapolis, who was working as the chief clerk in the Department of Justice in Washington, D.C., to paint in the nation's capital. At the urging of his friend, the artist spent several seasons in the early 1890s artistically exploring the environs of the East Coast city. He held several exhibitions during this period, placing many of his colorfully vibrant watercolors in the private collections of Washington's residents. Gruelle later noted, with pride, that one of his best canvases was bought for the home of Justice Joseph P. Bradley of the United States Supreme Court.

In the spring of 1892 during a painting trip to Washington, the Indianapolis artist was invited to nearby Baltimore, Maryland to examine the nationally recognized art collection of industrialist William T. Walters. Gruelle recalled his feelings upon seeing the magnificent paintings: "The first thing that impressed me on entering the gallery was the personality of the collection. Another thing I noticed was its wide range, both in regard to subject and style. It was confined to no school or nationality, and while there were scores of the greatest paintings ever brought to our country, there was not a bad picture in the room."[18]

Overwhelmed by the scope of the collection, Gruelle wrote Carl Lieber, a friend and patron in Indianapolis, vividly describing several of Walters's paintings. The letter was shown to Joseph M. Bowles who, in the fall of 1892, asked the artist to review some of the more outstanding pieces in the collection for the first issue of his soon-to-be-published magazine *Modern Art*.[19] With misgivings, Gruelle agreed to write an article for the monthly art publication: "Entirely inexperienced, it was with fear and trembling that I approached the sacred spheres of the works of the greatest masters of the century, lest in some way I should mar or do discredit to their matchless beauty by a feeble attempt to translate into words

**Richard B. Gruelle**
*Landscape.*
Oil on canvas
26 x 19 inches
Joni Gruelle Keating

these pictures, born of feeling."[20] A copy of *Modern Art* was sent to Walters who, after reading the artist's well-written account of his treasures, sent word that he wished to meet the article's author.

Gruelle remembered his first meeting with the wealthy collector: "In inviting me to visit him in Baltimore, Mr. Walters did not state what he desired. Consequently, on my arrival at his home, he informed me that he wished me to write a book for him on his collection to consist of word paintings descriptive of the pictures. I protested my ignorance, having never written a page of manuscript in my life. Said he to Mr. Gruelle, 'I have been looking for you for twenty-five years. I have tried the best writers on art in the country and you are the first man I have found who could write a word painting such as I want for this book.' All protestations upon my part were in vain and I was compelled to undertake the work."[21]

During the initial meeting, the two men worked out the details for Gruelle's upcoming stay in Baltimore. The artist recalled being particularly impressed with Walters's hospitality: "I sincerely thanked him for his kindness, saying that I was not used to such treatment. Stepping up to me and patting me on the back, he said, 'Mr. Gruelle, there are times that we all need someone to pat us on the back and I want to say to you that I want you, while you are in my home, to feel just as you would in your own home in Indianapolis. I mean you can go upstairs, into the cellar, into my bedroom, into my parlor, anywhere. You must feel, while in my house, that it is yours. I have given strict orders that while you are here taking notes of my pictures, no one shall be admitted. I want you to be alone with the pictures.'"[22]

Throughout the following year, Gruelle devoted himself to the cataloguing of

Walters's collection, making "many pilgrimages to this Mecca of art, gathering the inspiration from the pictures."[23] Finishing his work in Baltimore by July of 1894, the incipient author gratefully noted "the kindness shown the writer by Mr. Walters"[24] during his research for the book.

Gruelle's two-hundred-seventeen-page *Notes: Critical & Biographical*, edited by J. M. Bowles, would be published in April of 1895. The limited edition book, printed on thick vellum paper stock by Carlon and Hollenbeck Press in Indianapolis, would become one of the most highly prized volumes on art at that time. With poetic tenderness, artful insight, and a graceful pen, the Hoosier writer had managed to paint vivid "word pictures" of the masterworks of such artists as Millet, Rousseau, Corot, Dupré, Delacroix, and Gericault.

Of Millet's *The Potato Harvest*, the gifted artist-raconteur had written: "*The Potato Harvest* is a very characteristic Millet and full of his best inspiration…In the immediate foreground a peasant woman holds a sack into which a man is emptying potatoes. These figures are round and statuesque. They have the movement of living realities, the real ponderosity of life. Size and vitality are felt at once. The costumes are somber and in harmony with the sentiment of the nature around them, a thing Millet never missed. Just back of the figures are sacks filled with potatoes. They are stacked, ready to be loaded into a picturesque and awkward cart which stands beside them. The left side of the picture is dark and sober in color. A shower is passing by and the dark purple gray of the rain as it falls from the clouds is marvelously realistic. There is a truth about the painting of this shower that has rarely been attained by one. You can see the passing of the clouds, and the effect of movement in the falling rain is remarkable…The right distance is flooded with rich golden sunlight which, seen through the pelting rain, is glorious in its glowing."[25]

**Richard B. Gruelle**
*Along the Ohio.*
Oil on canvas
20 x 24 inches
Private Collection

After completing the manuscript for his *Notes: Critical & Biographical* in the summer of 1894, Gruelle turned his attention to the upcoming Art Association of Indianapolis exhibition to be held at the Denison Hotel in November. The show in which Gruelle displayed seven oils and three watercolors attracted considerable attention in Indianapolis and prompted an invitation from the Central Art Association to exhibit the following month in Chicago.

The Five Hoosier Painters show opened to popular acclaim in Lorado Taft's Chicago studio during the Christmas holidays of 1894. The Critical Triumvirate of sculptor Taft, painter Charles Francis Browne, and novelist Hamlin Garland, in writing the exhibition catalogue, was the first out-of-state group to comment upon the work of the Hoosier painters.[26] Impressed with Gruelle's "strong landscape feeling,"[27] particularly in his *Passing Storm*, they stated:

*"He sees the local color of objects instead of their relation in the atmosphere...Gruelle is an artist but not a colorist. He seems (to be) working in black and white."*[28]

While hoping that the success of the Hoosier Group exhibits and the public recognition of *Notes: Critical & Biographical* might help to compensate for his lack of formal art training, Gruelle, nevertheless, worked diligently to improve his color sensitivity and technique. His efforts in this regard must have been successful because fellow artist William Forsyth noted: "Unfortunately he (Gruelle) had no advantages of training and his sincere love of nature was hampered in expression all his life. Nevertheless he enjoyed great popularity—possibly as much as any artist locally ever did. Possibly there are more of his pictures owned in Indianapolis than of any other artist."[29]

The turn-of-the-century art critics as well as the residents of Indianapolis were warmly supportive of Gruelle and his work. One writer found the artist's perceptions to be keen and analytical with the dominant note in his strikingly original paintings being a feeling for symmetrical grouping.[30] Another writer commented: *"(Gruelle) has gained a definite place through his charm of individuality and fine executive ability. His treatment of difficult problems such as examples of breaking waves against ponderous rock and rugged coast (in his marine landscapes), and his skillful handling of subtleties of color and tone show him to be a master in these technicalities."*[31]

Shortly after *Notes: Critical & Biographical* was published, Boston lithographer Louis Prang of the Prang Educational Company visited Gruelle in Indianapolis to congratulate him upon his discerning treatment of the Walters collection. Impressed with the artist's capabilities, Prang commissioned Gruelle "to come up to 'Old Gloucester' and try what I could do with the subjects that could be found in that picturesque old fishing town."[32] The midwesterner, who had never seen the ocean before traveling to Gloucester, remembered his feelings of apprehension about taking the commission work: "During my trip, I was continually chiding myself for going for I realized how difficult is the task of painting the ocean. When I reached the shore and gazed and gazed and gazed, I felt not that I was in a new land, but more as if I were clasping the hand of an old friend."[33]

During the summer of 1897, Gruelle relished tackling the technical challenges presented by painting the commissioned seascapes for Prang, finding that "there were elements in nature to which my feelings responded. I was busy from sun-up to sun-down and frequently made moonlight and night sketches."[34]

The artist had found his niche. Drawn by the rocky shoreline of the Atlantic Ocean and the barren starkness of the

sea-coast stretches, Gruelle delighted in capturing the marine landscapes on canvas. His younger son Justin later recalled how much his father had enjoyed what eventually became annual painting trips to Cape Ann: "Thinking back to these yearly sketching expeditions, I am amazed at the amount of work he accomplished in the short six weeks or two months that he was on the East Coast. Besides the many watercolors and oils that he brought back, there were the sketchbooks filled with these beautiful pencil drawings. On most of them he made notations as to color of sky and rocks. I can still remember the eagerness with which the family looked forward to seeing the final results of each Gloucester trip, taken from the trunks and boxes."[35]

As was his custom each year upon returning, Gruelle would hold a winter exhibit in an Indianapolis studio, highlighting the landscapes done around the Hoosier capital and the Gloucester paintings of the previous summer. His most important work during this period was a series of large marine landscapes entitled The Drama of the Elements. The first painting in the series, *A Drama of the Elements*, was presented during Gruelle's April 1901 show; the third, *The Song of the Sea*, was shown at the artist's March exhibit in 1903.

Despite repeated, sometimes lengthy absences from Indianapolis,[36] Gruelle remained very much a family man. He was devoted to his wife Alice and their three young children: John, Prudence, and Justin as well as to his brothers and sisters who had located in the Indianapolis area. The artist and his family lived at 29 Tacoma Avenue[37] in a sparsely settled section of town. Their three-room house, with a pantry off the kitchen and a back porch, was a modest dwelling without the comfort and convenience of plumbing or electricity. It was sufficient for the family's needs, however, until 1896 when Gruelle

**Richard B. Gruelle**
*Home of the Artist.*
Oil on canvas
20 x 26 inches
Indiana Memorial Union, Indiana University

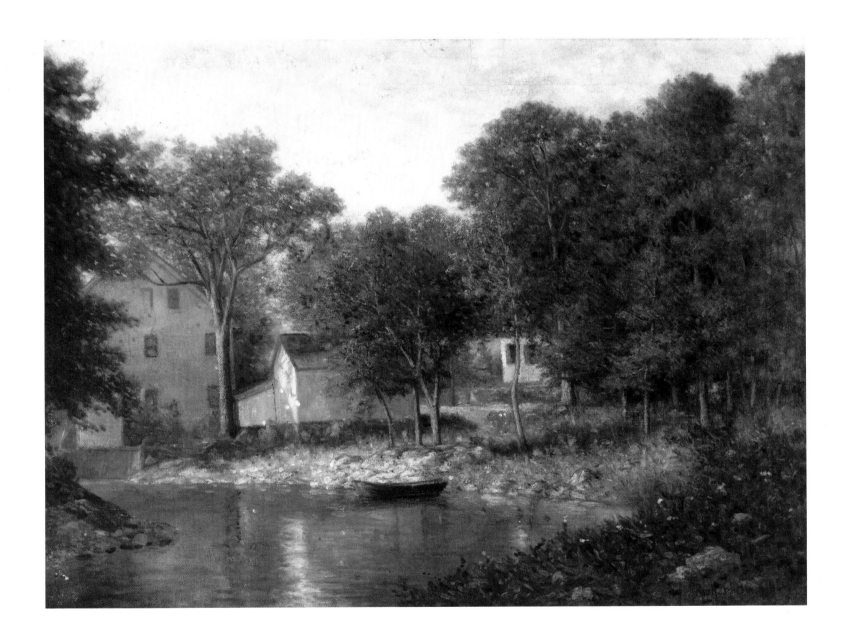

added a second story to the house to accommodate his growing children and their dog "Billy, the four-legged companion of those early years."[38]

One of Gruelle's sons fondly recalled his childhood years on Tacoma Avenue: "A short walk east of our home was a small stream called Crooked Run, with a little red bridge over Michigan Street, which at that time was a dusty country road. My father did a lot of sketching over the surrounding countryside and I remember especially one painting of this old bridge and the meandering brook beneath it… The two lots at the left of our house remained vacant for quite a few years and we youngsters had the run of this area also. We had a cow staked out there during the daytime, and, as a result, it became known as the cow lot, and was the general meeting place and play area for the neighborhood children…There was a small red studio that my father had built in the cow lot. It stood near one of the silver beech trees (on the lot) and I can so easily visualize him painting by the north window. At an early age, I began to experiment with his paints, canvases and brushes. This must have been a great nuisance for him, but I can't recall of him ever complaining about this misuse of his precious art supplies."[39]

Family get-togethers and holiday gatherings were especially important to the Gruelle clan "when a flock of Gruelle cousins descended upon us on summer weekends…many comforters (were) laid out on the front room floor. All hands were happy and didn't complain about the sleeping arrangements. Often, on the morning after, my Father would put on an apron, shoo Mother out of the kitchen, and produce a great breakfast, including biscuits."[40] The Fourth of July, Justin remembered as "a super noisy day, as there wasn't a ban on fire crackers in those days…At night my Father would always put on a display of pinwheels, Roman candles and skyrockets for the neighborhood small-fry and our numerous cousins."[41]

Music was very meaningful to the sensitive artist. In addition to playing the piano with great gusto[42] and liking to attend as many musical concerts as possible, Gruelle was an inveterate whistler. According to his son: "One of my Father's personal characteristics that I so well remember, was the whistled melody that always accompanied him wherever he happened to be. The years have erased from my mind his whistled 'repertoire' but his melodic sense was a good one and the results were not at all unpleasant to the ear. He was a joyous soul, who loved life, and deeply savored the living of it, and this self-produced melody was an expression of this."[43]

Intrigued by phenomena not readily explainable, Gruelle found himself caught up in the spiritualistic fads sweeping the country at the turn of the century.[44] First introduced to spiritualism during one of his summer visits to Gloucester, the Hoosier artist and his wife became interested in hosting parlor seances in which a medium attempted to contact the spirits of the dead for those present.

After holding a Sunday afternoon seance in which Alice had served as the medium for his good friend James Whitcomb Riley, Gruelle wrote the Hoosier poet: "Mrs. Gruelle wishes me to say to you that the person she saw standing behind you on Sunday afternoon was that of 'Longfellow.' She is always slightly confused when those visions are given her and in that way sometimes fails to go into detail descriptively. He seemed to be holding over you books or manuscripts. I hope you will take the very best of care of your health. Remembering always that you are an instrument dedicated to humanity…

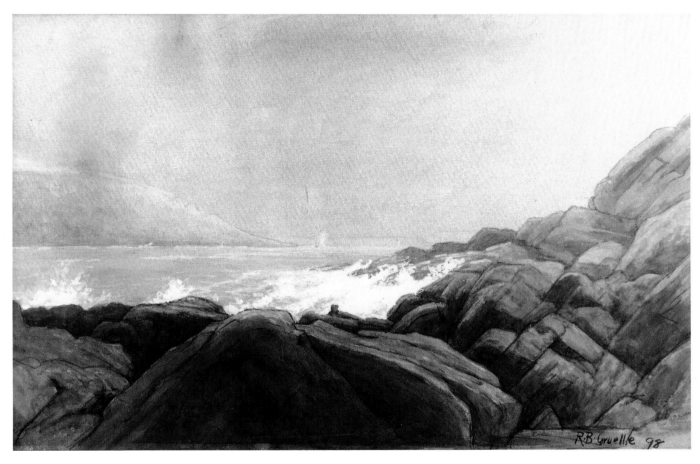

I shall remember with ever-increasing pleasure our little seance of Sunday afternoon for I feel that we were indeed near the borderland and were it not that our spiritual eyes are dimmed we could indeed behold the glory of the yet-to-be."[45]

According to one of the artist's grandchildren, Gruelle's interest in the occult was not limited to his involvement with spiritualism. He also tinkered with numerology, the practice of using a person's name and birth date to tell his character and to see into his past and future, and toyed with automatic writing while in a trance-like state.[46]

In December of 1905, Gruelle decided to close his downtown studio in the Security Trust Building and move his family to New York City where he felt there were greater artistic opportunities. He explained to his disappointed patrons in the capital city: "I have no complaint of my treatment by the people of Indianapolis. They have always given me their kindliest consideration. The press has always received my efforts with a most generous treatment. But the time has come when I feel I must have greater opportunities for improvement. Hence, the change."[47]

With the coming of the new year, the artist rented his Tacoma Avenue bungalow and set off for the East Coast with Alice and their two younger children, Justin and Prudence. His older son John, by 1906, had married and was living in Cleveland, Ohio, where he was a sports and political cartoonist for *The Cleveland Press*.

Justin remembered the family's move from his childhood home: "Looking back, I can only conjecture as to why this move to New York was made. I believe that R.B.G. felt the need of a little artistic rejuvenation and that he realized a visit to Manhattan, with its art galleries and museums would contribute to my aesthetic development. For, by this time, it was quite evident that I was going to follow the family tradition

and become an artist. Prudence had been taking vocal lessons for several years, and no doubt our parents felt that New York would stimulate her future progress in music."[48] The Gruelles' faith in their daughter's musical ability was well-founded since she won a vocal scholarship to study in the city's Grand Conservatory of Music soon after the family's arrival.

Upon reaching New York, the Gruelles leased the top floor of an old building on Twenty-Third Street just west of Sixth Avenue. In the early 1900s, Fourteenth and Twenty-Third Streets were the main crosstown arteries of traffic, and all the city's best shops and many of its art galleries were located close to the family's new lodgings. From their fourth-floor quarters, consisting of a front room, a skylit studio, a kitchen, a bath, and two bedrooms, the Gruelles had a bird's-eye view of the street happenings beneath their windows. Son Justin reminisced: "There were two things that I remember as characteristic of the Manhattan streets of that era, the hansom cabs and the street pianos. The first were two-wheeled, horse drawn vehicles with an open front with the cabby sitting in a rear, top seat. . . The street pianos were very much in evidence, to both the eye and ear. They cranked out their versions of operatic arias and were often accompanied by groups of neighborhood children dancing on the sidewalk."[49]

The congestion and ceaseless commotion of New York City soon began to wear on the Hoosier family who, after considerable soul-searching, resolved to return to Indianapolis. Leaving Prudence in New York to pursue further scholarship work at the Metropolitan Opera School, the Gruelles claimed their Tacoma Avenue home from its tenants in the fall of 1907.

During the next two years, the artist worked in his studio in the Union Trust Building while Justin studied with William Forsyth at the John Herron Art Institute.[50] Corresponding regularly with his East Coast companions, Gruelle soon found that he missed their artistic camaraderie and support. Finally, at the urging of his friend Addison T. Millar, a New York artist who kept a Twenty-Third Street studio,[51] Gruelle agreed that it was time for him to permanently locate in the East. Writing to Prudence and to Justin who had left Indianapolis in February of 1909 to study at the Art Students' League in New York, Gruelle asked that they inspect a piece of land, recommended by Millar, along the Silver Mine River in Connecticut.

After tramping over the proposed sixteen-acre parcel, Prudence, her husband Albert Matzke, and Justin heartily endorsed the Gruelles' purchase of the Connecticut property. In early 1910, Gruelle and Alice left Indianapolis to join the Matzkes and Justin in their new family home. It was located, according to the older artist, "at a point over in Connecticut, just back of Norwalk, near the Sound, and just forty-three miles out of New York."[52] Situated between the historic towns of Norwalk and New Canaan, the Gruelle-Matzke house was not far from a road over which, in Revolutionary times, Washington's troops had passed when they dislodged the British from Norwalk.

By June of that year, Gruelle, his son-in-law Albert, and Justin had outfitted a studio in the three-story furriers' mill across the road from their century-old home. The three artists—Albert was a promising illustrator and watercolorist—wasted little time in filling their sketchbooks with impressions of nearby woodland paths, sparkling streams, and lush meadows.

Soon after Gruelle had settled into the community, he was invited to become a member of the Knockers Club, a group of artists who had chosen to live and work in and around the Silver Mine River district.

Meeting every Sunday, the members, who were portraitists, landscape painters, and illustrators of note, looked forward to their weekly sessions of good-natured joking and candid criticism.[53]

Within months of Gruelle's move to Connecticut, his older son John, who had begun a cartooning career at *The Indianapolis Star* with the creation of the wisecracking weather bird Jim Crow,[54] left *The Cleveland Press* to take a job with *The New York Herald Tribune*. Young Gruelle was hired as a *Tribune* cartoonist after winning the paper's comic strip contest with his entry "Mr. Tweedeedle." The popular Sunday supplement feature was merely a beginning for the talented illustrator who, in 1918, would publish the first of his twenty-seven books for children about the adventures of Raggedy Ann and her friends.[55]

Wishing that his son's New York job might allow him to live closer to the family in Norwalk, Gruelle was pleased when John and his wife Myrtle moved into the upper story of the old furriers' mill. Later, John would build a house on the Gruelle property up the road from the moss-covered stone mill in which he and Myrtle had first lived.

Despite Gruelle's move to Norwalk and his unabashed delight in living amid his out-of-doors subject matter, the landscape artist never lost his interest in Indianapolis. Making periodic visits to the city which had been his home for twenty-eight years, he enjoyed staying with friends and reestablishing valued business relationships. Eager to maintain his ties with the Hoosier capital, the artist continued to hold yearly exhibits of his New England work in a temporary Indianapolis studio or in the galleries of the city's H. Lieber & Company Art Emporium. He also wrote an occasional article about art for *The Indianapolis News*.

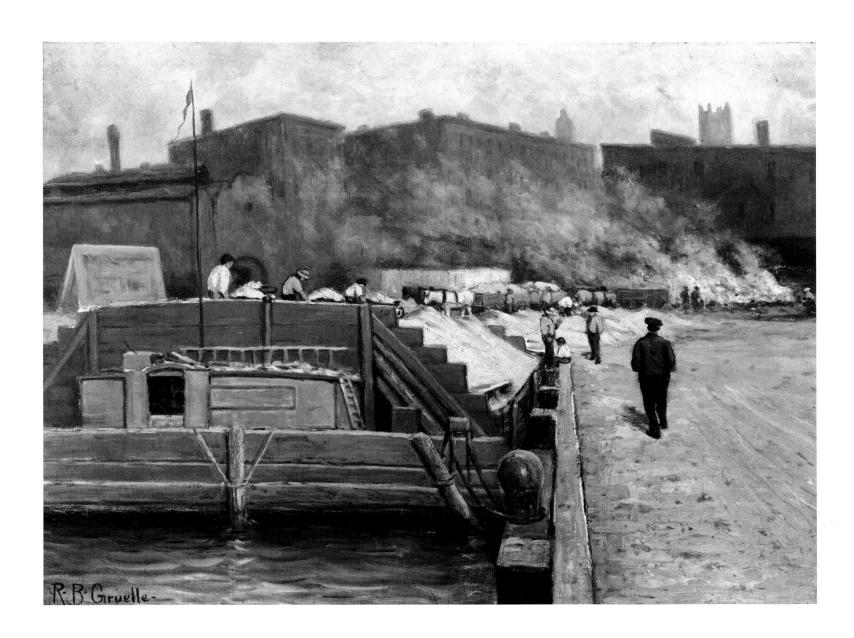

In July of 1912, the sixty-one-year-old painter suffered a paralyzing stroke which rendered the right side of his body partially useless. The mustachioed, white-haired artist later wrote, in halting script, of the frustrations of his condition: "Two years since, I was stricken with Paralysis, and have, as a result, been unable to work since. But, in spite of this setback, I still hope of complete recovery and thus complete the work of life I have undertaken and hope to accomplish. The greater part of my life has been spent in Indianapolis and my time has been devoted to the building up a love of the beautiful and the encouragement of every endeavor in that direction."[56]

The optimistic Gruelle was never able to regain his health or fulfill his artistic dreams. During an autumn visit with Alice's family in Indianapolis, he died on November 8, 1914.

A member of the Art Association of Indianapolis, the New Canaan Society of Artists, the Society of Western Artists, and the Knockers Club, Gruelle was perhaps as well known for his perceptive commentaries in *Notes: Critical & Biographical* as for his pastoral landscapes. An artist who believed in "art for the heart's sake,"[57] Gruelle had only occasionally exhibited in national exhibitions. With the exception of his participation in the Society of Western Artists annuals and the 1904 Louisiana Purchase Exposition at St. Louis, he had chosen instead to focus upon one-man shows and exhibitions in Indianapolis and New Canaan.

Despite his lack of formal art training—an inadequacy arguably compensated for by his exposure to the masterworks in the Walters collection and by diligent study on his part—Gruelle's work was widely appreciated. It was in his paintings at Gloucester that some of his best thoughts and finest sensibilities had found expression. Although his efforts in oil and watercolor showed equal merit, he had devoted more time and interest to exploring the nuances of watercolor.

The impact of Gruelle's death was profoundly felt by his close-knit family and wide circle of friends. Carl Lieber, who had known the affable artist for some twenty years and who had been responsible for starting him on his career of "painting pictures with words,"[58] affectionately remembered: "He was a most lovable character. I never knew anyone who could make friends so easily or hold them so firmly. He was known for extreme loyalty to his friends."[59]

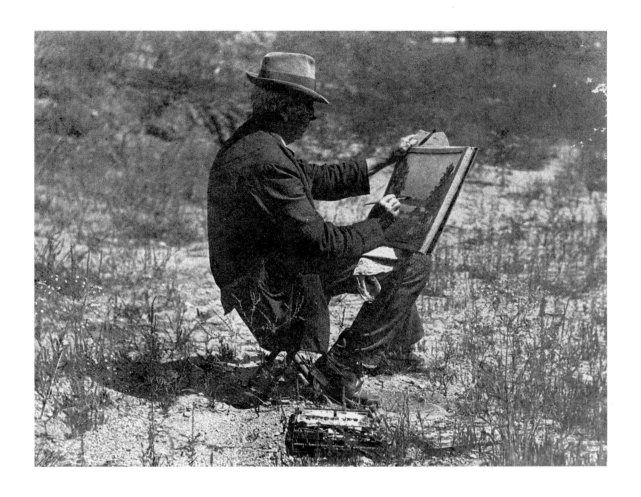

# Chronology

## Otto Stark

**1859**
Otto Stark born in Indianapolis, Indiana, January 29, son of Gustav Godfrey and Leone Joas Stark.

**1875**
Moves to Cincinnati, Ohio, becomes apprentice to lithographer; lives with aunt and uncle.

**1877**
Studies art as night student at the School of Design of the University of Cincinnati; continues work as lithographer.

**1878**
Exhibits in Tenth Annual Exhibition of the School of Design.

**1879**
Enters sculpture work in exhibitions of the School of Design, University of Cincinnati; moves to New York City, works as lithographer, illustrator.

**1882**
Enrolls at the Art Students' League, studies with William Merritt Chase, Carroll Beckwith, Walter Shirlaw, and Thomas Dewing; exhibits at the National Academy of Design Autumn Exhibition and at the American Water Color Society Annual.

**1885**
Sails for France, enrolls in Académie Julian, Paris, becomes student of Gustave Boulanger and Jules Lefebvre; also studies with Fernand Cormon.

**1886**
Exhibits at Paris Salon; marries Marie Nitschelm of Paris, December.

**1887**
Exhibits at Paris Salon; daughter Gretchen Leone is born.

**1888**
Returns to New York City, works as commercial artist; exhibits at National Academy of Design annual; daughter Suzanne Marie is born.

**1889**
Exhibits at Pennsylvania Academy of the Fine Arts and at Indianapolis Art Association annual.

**1890**
Moves to Philadelphia, Pennsylvania, continues working in commercial art; son Paul Gustav is born.

**1891**
Son Edward Otto is born; wife Marie dies at Hahnemann Hospital in New York City on November 11; takes four children to Indianapolis, Indiana, to be tended by father Gustav and sister Augusta.

**1892**
Moves to Cincinnati, Ohio, without children; works as designer.

**1893**
Returns to Indianapolis, Indiana, sets up housekeeping with two sisters and his children.

**1894**
Opens studio in Indianapolis, teaches art classes; exhibits in Exhibit of Summer Work of T.C. Steele, William Forsyth, R.B. Gruelle and Otto Stark in Indianapolis, Indiana; exhibits in Five Hoosier Painters in Chicago, Illinois.

**1895**
Writes "The Evolution of Impressionism" for *Modern Art*.

**1896**
Painting purchased by Art Association of Indianapolis for permanent collection.

**1897**
Joins the Society of Western Artists, exhibits in first annual.

**1898**
Elected honorary member of Art Association of Indianapolis; exhibits at Trans-Mississippi and International Exposition in Omaha, Nebraska.

**1899**
Appointed Supervisor of Art at Manual Training High School, Indianapolis, Indiana; paints in Gloucester, Massachusetts.

**1901**
Elected president of the Portfolio Club of Indianapolis and the Indiana Artists' Club.

**1902**
Teaches summer class at John Herron Art Institute in Indianapolis, Indiana.

**1904**
Exhibits at Louisiana Purchase Exposition in St. Louis, Missouri; joins Roberts Park Methodist Episcopal Church.

**1905**
Appointed instructor of composition and illustration at John Herron Art Institute; moves to Southport, Indiana.

**1906**
Exhibits work done in Southport at Lieber galleries.

**1907**
Elected treasurer of the Society of Western Artists; sells second painting to Art Association of Indianapolis permanent collection; wins honorable mention at Richmond Art Association Annual; moves to Indianapolis, Indiana.

**1908**
Wins Mary T.R. Foulke prize at Richmond Art Association Annual Exhibition.

**1910**
Purchases home at 1722 North Delaware Street in Indianapolis, Indiana, builds studio on grounds; exhibits at International Exhibition at Buenos Aires, Argentina, and Santiago, Chile.

**1912**
Paints at Lake Maxinkuckee, Culver, Indiana for first time.

**1913**
Paints murals at Indianapolis Public School #60; holds exhibition at Palmer House, Lake Maxinkuckee.

**1914**
Completes mural project at Indianapolis City Hospital.

**1915**
Exhibits at Panama-Pacific International Exposition in San Francisco, California; wins $100 J.I. Holcomb award.

**1916**
Designs cover for Centennial Pageant of Indiana University; begins annual fall painting trips with J. Ottis Adams to Leland, Michigan.

**1917**
Devotes time and materials to paint posters for American war effort.

**1918**
Helps paint War Chest signboard on Monument Circle in Indianapolis, Indiana.

**1919**
Resigns teaching positions at Manual Training High School and John Herron Art Institute.

**1920**
Paints in New Smyrna, Florida, with J. Ottis Adams.

**1925**
Honored by former students at Otto Stark reception and exhibition at Manual Training High School.

**1926**
Dies in Indianapolis, Indiana, on April 14.

# Theodore C. Steele

**1847**
Theodore Clement Steele born near Gosport, Indiana, September 11, son of Samuel and Harriett Steele.

**1851**
Moves with family to Waveland, Indiana.

**1859**
Enrolls in Waveland Collegiate Institute.

**1860**
Teaches drawing class at Institute at age thirteen.

**1861**
Wins prize at Russellville Fair with pen and ink drawing.

**1863**
Does portrait work for Professor Tingley, Asbury College, Greencastle, Indiana; wins painting prize at county fair, Terre Haute, Indiana.

**1865**
Listed as instructor of drawing and painting at Waveland Collegiate Institute.

**1868**
Graduates from Waveland Collegiate Institute.

**1870**
Earns living as portrait painter; marries Mary Elizabeth "Libbie" Lakin, February 14, moves to Battle Creek, Michigan; son Rembrandt "Brandt" Theodore is born.

**1872**
Daughter Margaret "Daisy" is born.

**1873**
Moves to Indianapolis, Indiana; opens portrait studio; works with James Whitcomb Riley in sign painting.

**1876**
Relocates studio and family living quarters to Bradshaw Block, Indianapolis, Indiana; Libbie suffers lengthy bout of typhoid fever.

**1877**
Joins John W. Love in organization of Indianapolis Art Association.

**1878**
Son Shirley Lakin is born.

**1880**
Travels to Munich, Germany; enrolls in Royal Academy; studies in drawing school of Gyula Benczur.

**1881**
Moves to Schleissheim, Germany; begins landscape work with J. Frank Currier; accepted into painting school of Ludwig von Loefftz.

**1884**
Awarded silver medal at exhibit of student work at Royal Academy.

**1885**
Sends canvases to Art Exhibit of the Hoosier Colony in München, Indianapolis, Indiana; returns to Indianapolis; leases Tinker Place for family home; opens portrait studio.

**1887**
Accepts commission work in Cavendish, Vermont.

**1888**
Paints near Yountsville, Indiana, and along banks of Sugar Creek.

**1889**
Opens art school in Circle Hall, Indianapolis, Indiana.

**1891**
Joined by William Forsyth as instructor at Indiana School of Art.

**1892**
Works with William Forsyth near Vernon, Indiana.

**1893**
Exhibits at World's Columbian Exposition at Chicago, Illinois.

**1894**
Exhibits at Exhibit of Summer Work of T.C. Steele, William Forsyth, R.B. Gruelle and Otto Stark, Indianapolis, Indiana; exhibits at Five Hoosier Painters, Chicago, Illinois.

**1895**
Leaves teaching post at Indiana School of Art.

**1896**
Joins with William Forsyth and J. Ottis Adams in organization of Society of Western Artists; paints with Adams near Metamora, Indiana.

**1898**
Purchases Hermitage with J. Ottis Adams; elected president of Society of Western Artists.

**1899**
Libbie is diagnosed as having contracted tuberculosis; Libbie dies on November 14.

**1900**
Receives honorable mention at Paris Exposition; awarded honorary Master of Arts degree by Wabash College, Crawfordsville, Indiana.

**1902**
Vacations in Oregon and California with Daisy; opens Hartford Block studio, Indianapolis, Indiana.

**1904**
Exhibits and serves on jury at Louisiana Purchase Exposition, St. Louis, Missouri.

**1906**
Wins Mary T. R. Foulke award at Richmond Art Association annual.

**1907**
Sells ownership interest in Hermitage to Adams; buys land in Brown County, Indiana; begins building studio-home there; marries Selma Neubacher on August 9.

**1909**
Wins $500 Fine Arts Building prize at Society of Western Artists annual.

**1910**
Exhibits at International Exhibition of Fine Arts at Buenos Aires, Argentina and Santiago, Chile.

**1913**
Elected as associate member to National Academy of Design, New York.

**1914**
Does landscape mural for Indianapolis City Hospital.

**1915**
Exhibits and serves on jury at Panama-Pacific Exposition, San Francisco, California.

**1916**
Builds studio barn at House of Singing Winds; receives honorary Doctor of Laws degree from Indiana University, Bloomington, Indiana.

**1922**
Named artist-in-residence at Indiana University.

**1925**
Suffers mild heart attack.

**1926**
Receives $200 Rector Prize at Hoosier Salon, Marshall Field Galleries, Chicago, Illinois; dies on July 24.

# J. Ottis Adams

**1851**
John Ottis Adams born in Amity, Johnson County, Indiana, July 8.

**1871**
Enrolls at Wabash College, Crawfordsville, Indiana.

**1872**
Enrolls in South Kensington School of Art, London, England; finds work in photographic studio to defray expenses.

**1873**
Awarded "Certificate of the Second Grade" from South Kensington School of Art.

**1874**
Returns to Seymour, Indiana; opens portrait studio.

**1875**
Moves to Martinsville, Indiana.

**1876**
Locates in Muncie, Indiana; opens portrait studio; works for local photographer.

**1880**
Sails to Munich, Germany; enrolls in Royal Academy, begins study in life drawing school with Gyula Benczur.

**1882**
Begins work in painting school of Ludwig von Loefftz.

**1885**
Leaves Royal Academy; opens studio in Munich, Germany.

**1887**
Returns to Indiana, settles in Muncie, Indiana; begins teaching art classes in Muncie, Fort Wayne, and Union City.

**1889**
William Forsyth joins him in teaching classes; opens Muncie Art School with Forsyth.

**1891**
Closes Muncie Art School; teaches alone after Forsyth returns to Indianapolis, Indiana.

**1894**
Exhibits in Five Hoosier Painters, Chicago, Illinois.

**1896**
Helps organize Society of Western Artists with William Forsyth and Theodore C. Steele; paints at Metamora, Indiana, with Steele.

# William Forsyth

**1898**
Awarded honorary Master of Arts degree from Wabash College, Crawfordsville, Indiana; buys Hermitage in Brookville, Indiana, with Steele; marries Winifred Brady, October 1.

**1902**
Named principal instructor of drawing and painting at John Herron Art Institute, Indianapolis, Indiana.

**1904**
Wins bronze medal at Louisiana Purchase Exposition at St. Louis, Missouri.

**1905**
Builds family summer cottage in Indiana Woods at Leland, Michigan.

**1906**
Resigns from John Herron Art Institute faculty; moves to Brookville, Indiana, with Winifred and sons John Alban, Edward Wolfe and Robert Brady.

**1907**
Buys Steele's interest in Hermitage; wins $500 Fine Arts Building Prize at Society of Western Artists annual.

**1908**
Elected president of Society of Western Artists.

**1909**
Re-elected president of Society of Western Artists.

**1910**
Receives honorable mention at International Exhibition of Fine Arts at Buenos Aires, Argentina, and Santiago, Chile; teaches summer classes in landscape painting at Hermitage.

**1913**
Rebuilds Hermitage which is nearly destroyed by spring floods.

**1914**
Joins Hoosier artists in mural work at Indianapolis City Hospital.

**1915**
Exhibits at Panama-Pacific International Exposition at San Francisco, California; spends first of several winters painting in St. Petersburg, Florida.

**1916**
Invites Otto Stark for first of annual late summer painting trips to Leland, Michigan.

**1920**
Locates in New Smyrna, Florida, for winter painting season; invites Otto Stark to accompany him to Florida.

**1922**
Builds studio in New Smyrna, Florida.

**1926**
Undergoes surgery for intestinal disorder in Indianapolis, Indiana.

**1927**
Dies in Indianapolis, Indiana, January 28.

**1854**
William J. Forsyth born in California, Ohio, October 15.

**1864**
Moves to Indiana with parents, settles first in Versailles and then in Indianapolis.

**1873**
Drops out of high school, gets job painting houses to augment family finances.

**1877**
Enrolls in Indiana School of Art, established by John W. Love and James F. Gookins.

**1880**
Founds Bohe Club with friends to continue art studies.

**1881**
Travels to Munich, Germany, to enroll in Royal Academy; financial backing provided by Thomas E. Hibben.

**1882**
Resides with Theodore C. Steele family in Schleissheim upon arrival in Germany; moves to Cloister in Mittenheim; accepted into drawing school of Gyula Benczur at Royal Academy in spring; moves to Munich, Germany, in fall.

**1883**
Studies in drawing school of Nikolaus Gysis; accepted into painting school of Ludwig von Loefftz in fall.

**1885**
Wins bronze medal at Royal Academy's exhibition of student work; takes painting trip to Venice, Italy; sends canvases to Indianapolis, Indiana, for Art Exhibit of the Hoosier Colony in München.

**1886**
Leaves Royal Academy; opens studio in Munich, Germany, with J. Ottis Adams.

**1888**
Returns to Indianapolis, Indiana.

**1889**
Helps J. Ottis Adams teach art classes in Fort Wayne and Muncie, Indiana; opens Muncie Art School with Adams in fall.

**1891**
Returns to Indianapolis, Indiana; teaches with Theodore C. Steele at Indiana School of Art; paints in Vernon, Indiana.

**1893**
Exhibits at World's Columbian Exposition at Chicago, Illinois; paints at Logan's Point, near Hanover, Indiana.

**1894**
Exhibits in Exhibit of Summer Work of T.C. Steele, William Forsyth, R.B. Gruelle and Otto Stark in Indianapolis, Indiana; exhibits in Five Hoosier Painters, Chicago, Illinois.

**1896**
Helps organize Society of Western Artists with Theodore C. Steele and J. Ottis Adams; paints in Corydon, Indiana.

**1897**
Begins teaching art classes in Union Trust Building, Indianapolis, Indiana; marries Alice Atkinson, October 14.

**1898**
Exhibits in Trans-Mississippi and International Exposition, Omaha, Nebraska.

**1899**
Daughter Dorothy is born; paints near Brookville, Indiana.

**1901**
Paints outside of Corydon, Indiana.

**1903**
Daughter Constance is born; paints near Shakertown, Kentucky.

**1904**
Wins silver medal for watercolor and bronze medal for oil at Louisiana Purchase Exposition at St. Louis, Missouri; paints outside of Martinsville, Indiana.

**1906**
Daughter Evelyn is born; family moves to Irvington, small community outside of Indianapolis; appointed principal instructor in drawing and painting at John Herron Art Institute, Indianapolis, Indiana; wins honorable mention at Richmond Art Association annual.

**1910**
Wins bronze medal for oil at International Fine Arts Exposition at Buenos Aires, Argentina, and Santiago, Chile; receives $500 Fine Arts Building prize at Chicago annual of Society of Western Artists.

**1911**
Wins honorable mention at Richmond Art Association annual.

# Richard B. Gruelle

1912
Wins Mary T.R. Foulke award at Richmond Art Association annual.

1914
Supervises painting of thirty-three murals at Indianapolis City Hospital.

1915
Wins silver medal for watercolor and bronze medal for oil at Panama-Pacific International Exposition in San Francisco, California.

1922
Paints murals for Indianapolis Public School #57.

1924
Teaches first in series of classes at Art Institute Summer School, Winona Lake, Warsaw, Indiana.

1927
Paints along New England coastline.

1928
Wins $300 Chicago Galleries Association purchase prize; awarded $100 first prize for oil at Indiana Artists' Exhibit at Ball Teachers College, Muncie, Indiana.

1929
Paints near Gloucester, Massachusetts.

1930
Works in California to get new perspective.

1931
Spends two months in Europe.

1933
Retires his teaching position at John Herron Art Institute.

1934
Suffers heart attack.

1935
Dies in Indianapolis, Indiana, March 29.

1851
Richard Buckner Gruelle born in Cynthiana, Kentucky, February 22, son of John Beuchamps and Prudence Moore Gruelle.

1857
Moves to Arcola, Illinois, with family.

1864
Quits school to find work to help meet expenses of large family.

1876
Leaves Cincinnati, Ohio, with wife Alice to return to Arcola, Illinois, to care for mother and aunt.

1880
Son John is born.

1881
Moves to Gainesville, Florida.

1882
Moves to Indianapolis, Indiana, and settles near Lockerbie Street home of James Whitcomb Riley.

1889
Son Justin is born who, with his older sister Prudence and older brother John, completes family.

1891
Illustrates James Whitcomb Riley's "When The Frost Is On The Punkin" and "The Old Swimmin' Hole" from *Neighborly Poems;* paints in environs of Washington, D.C.

1892
Visits art collection of William T. Walters in Baltimore, Maryland; writes article for *Modern Art* magazine.

1893
Spends year working in Baltimore cataloguing Walters collection.

1894
Finishes commentaries on Walters collection; exhibits in Exhibit of Summer Work of T.C. Steele, William Forsyth, R.B. Gruelle and Otto Stark, Indianapolis, Indiana; exhibits in Five Hoosier Painters, Chicago, Illinois.

1895
Publishes *Notes: Critical & Biographical*, poetic description of William T. Walters collection in Baltimore, Maryland.

1896
Adds second story to Gruelle house to accommodate needs of growing family.

1897
Spends first summer season of many painting in Gloucester, Massachusetts, and along the eastern seacoast.

1899
Travels to Boston, Massachusetts, with Otto Stark and Miss Wilhelmina Seegmiller, director of art instruction in Indianapolis public schools.

1900
Becomes involved in parlor seances with such friends as James Whitcomb Riley.

1901
Presents *A Drama of the Elements,* first in series of large marine landscapes, April.

1902
Does commission landscape work on McGowen homestead in Liberty, Missouri; sits for portrait by Theodore C. Steele in Indianapolis, Indiana.

1903
Exhibits *The Song of the Sea,* third painting in series of large marine landscapes, March.

1904
Exhibits at Louisiana Purchase Exposition in St. Louis, Missouri.

1906
Moves to New York City with son Justin, daughter Prudence and wife for extended stay; takes studio on Twenty-Third street.

1907
Returns to Indianapolis, Indiana, with son Justin and wife; works in Union Trust Building studio.

1910
Moves with wife to Norwalk, Connecticut, sharing family house with son Justin, daughter Prudence and son-in-law Albert Matzke.

1912
Suffers stroke which paralyzes right side of body.

1914
Dies November 8 in Indianapolis, Indiana, while visiting wife's family.

# Notes

## Otto Stark

1. *The Indianapolis News*, 30 November 1924.

2. The children born to Gustav and Leone Stark were: Otto, Augusta ("Gussie"), Amalie ("Molly"), Lydia, Robert, Gustav A., and Paul G. Stark. Indianapolis Museum of Art, *Otto Stark: 1859-1926*, exh. cat., text by Leland G. Howard (Indianapolis, 1977), 38.

3. *The Indianapolis Star*, 3 August 1913.

4. *The Indianapolis News*, 30 November 1924.

5. Ibid.

6. Ibid.

7. In 1869, New York artist Thomas S. Noble was named head of the McMicken School of Art and Design in Cincinnati, Ohio, which, in 1873, became the first established department of the University of Cincinnati. Several years after the incorporation of the city's Museum Association, the responsibility for the school was transferred from the University of Cincinnati to the Museum Association. A building for the art school was constructed, and, upon its dedication on November 26, 1887, its name was changed to the Art Academy of Cincinnati.

8. *The Indianapolis Star*, 8 March 1914.

9. Stark to Brown, Librarian, Indiana State Library, 23 April 1914, Indiana State Library Manuscript Collection.

10. *The Indianapolis Times*, 29 November 1922.

11. *Nouveau Dictionnaire de Peinture Moderne*, 5, Académie Julian Papers, Établissement Public du Musée d'Orsay, Paris.

12. Unidentified newspaper clipping, Gustave Boulanger Collection, Musée d'Orsay.

13. *Le Courrier de la Presse*, 6 March 1912.

14. Patricia Jobe Pierce, *Edmund C. Tarbell and the Boston School of Painting: 1889-1980* (Hingham, Massachusetts: Pierce Galleries, Inc., 1980), 22.

15. *The Indianapolis News*, 9 April 1977.

16. Gretchen Stark Notebook, Otto Stark Papers, Archives of American Art, Smithsonian Institution, Washington, D.C.

17. Stark to Brown, 23 April 1914, Indiana State Library.

18. Margaret Stark, granddaughter of Otto Stark, to author, 4 October 1983. Anatole France (1844-1924) was the pen name of Jacques Anatole François Thibault, a noted French poet, novelist, and critic who won the 1921 Nobel prize for literature. William R. Benet, ed., *The Reader's Encyclopedia* (New York: Thomas Y. Crowell, 1965), 363.

19. Margaret Stark to author, 4 October 1983.

20. Gustav and Leone Stark to Otto and Marie Stark, undated, in German, Mary Stark Oakes Papers.

21. Interview, Mary Stark Oakes, granddaughter of Otto Stark.

22. Ibid.

23. Gustav Stark to Otto Stark, 2 September 1891, in German, Oakes Papers.

24. Telegram informing Stark of death of Marie, Oakes Papers.

25. Leone Stark died 8 October 1888.

26. Interview, Mary Stark Oakes.

27. Gustav Stark to Otto Stark, 18 November 1892, in German, Oakes Papers.

28. Gustav Stark to Otto Stark, 19 January 1892, in German, Oakes Papers.

29. Gustav Stark to Otto Stark, 23 March 1892, in German, Oakes Papers.

30. Interview, Mary Stark Oakes.

31. Gretchen Stark Notebook, Archives of American Art.

32. Otto Stark, "The Evolution of Impressionism," *Modern Art*, III no. 2 (Spring 1895), 53-56.

33. Gretchen Stark Notebook, Archives of American Art.

34. Selma N. Steele, Theodore L. Steele, and Wilbur D. Peat, *The House of the Singing Winds* (Indianapolis: Indiana Historical Society, 1966), 185.

35. Lorado Taft to Suzanne Stark Taylor, 15 March 1932, Otto Stark Papers, Archives of American Art.

36. Central Art Association, *Five Hoosier Painters*, text by Lorado Taft, Charles Francis Browne, and Hamlin Garland (Chicago, 1894), 7.

37. Ibid., 10.

38. William Forsyth, *Art in Indiana* (Indianapolis: The H. Lieber Co., 1916), 19.

39. Mary Q. Burnet, *Art and Artists of Indiana* (New York: The Century Co., 1921), 266.

40. Gretchen Stark Notebook, Archives of American Art.

41. Stark to children, 6 August 1899, in German, Oakes Papers.

42. Ibid.

43. *The Indianapolis News*, 9 April 1977.

44. Ibid.

45. Interview, Orpha McLaughlin Pangborn, 1908 graduate of Manual Training High School, Indianapolis, Indiana.

46. Unidentified newspaper clipping, Otto Stark Papers, Archives of American Art.

47. Art Association of Indianapolis, *Art School: Circular for Summer Term, May 1902*, Indiana University-Purdue University at Indianapolis Archives.

48. Art Association of Indianapolis, *Art School: Catalogue of Winter and Evening Schools, 1905-06*, Indiana University-Purdue University at Indianapolis Archives.

49. Interview, Orpha McLaughlin Pangborn.

50. Interview, Mary Stark Oakes.

51. Gretchen Stark Notebook, Archives of American Art.

52. Interview, Evelynne Mess Daily, Indianapolis painter and printmaker.

53. Interview, Beulah Hazelrigg Brown, textile designer and watercolorist. She and her husband artist Francis Folger Brown were students at the John Herron Art Institute in 1915.

54. Unidentified newspaper clipping, 21 October 1913, Stout Art Reference Library, Indianapolis Museum of Art.

55. *The Indianapolis Star*, 17 January 1925.

56. Interview, Mary Stark Oakes.

57. Margaret Stark to author, 4 October 1983.

58. Interview, Mary Stark Oakes.

59. Interview, Evelynne Mess Daily.

60. Steele, *House of the Singing Winds*, 138.

61. Gretchen Stark to Selma Steele, 17 July 1911, Indiana State Library Manuscript Collection.

62. Ibid.

63. Ibid.

64. Stark to Selma Steele, 9 August 1913, Indiana State Library Manuscript Collection.

65. Ibid.

66. Unidentified Indianapolis newspaper clipping, circa 1913, Stout Art Reference Library, Indianapolis Museum of Art.

67. Gretchen Stark Notebook, Archives of American Art.

68. The Indianapolis City Hospital is now named Wishard Memorial Hospital, 1001 West 10th Street, Indianapolis, Indiana. Although many mural sections were lost in the subsequent modernization of the hospital, a number of the paintings remain today. They are hung with great pride in the public areas of the hospital.

# Theodore C. Steele

69. Gretchen Stark Notebook, Archives of American Art.

70. Interview, Rosemary Ball Bracken, niece of J. Ottis Adams.

71. Ibid.

72. Interview, Caroline Brady, great-niece of J. Ottis Adams.

73. *The Traverse City Record-Eagle*, 18 August 1925.

74. Gretchen Stark Notebook, Archives of American Art.

75. Interview, Rosemary Ball Bracken.

76. J. Ottis Adams to Winifred Brady Adams, 9 January 1921, Caroline Brady Papers.

77. Otto Stark to Gretchen Stark, date indistinguishable, Oakes Papers.

78. Margaret Stark to author, 4 October 1983. Ms. Stark is a talented modernist who studied at the Art Students' League under Kuniyoshi and with Hans Hofmann in his studio. She is currently working in New York and in Europe.

79. Ibid.

80. *The Indianapolis Star*, 27 February 1925.

81. Interview, Mary Stark Oakes.

82. Margaret Stark to author, 4 October 1983.

83. *The Indianapolis Star Magazine*, 3 April 1977.

1. Selma N. Steele, Theodore L. Steele, and Wilbur D. Peat, *House of the Singing Winds* (Indianapolis: Indiana Historical Society, 1966), 3.

2. The Waveland Academy, established by the Crawfordsville Presbytery for the training of youth for the ministry, was renamed the Waveland Collegiate Institute in 1859 with the broadening of its curriculum. Ibid., 5.

3. Mabel Sturtevant, "Theodore Clement Steele," *The Hoosier Magazine* 1, no. 2 (February 1930), 20.

4. Steele, *House of the Singing Winds*, 6.

5. *The Indianapolis News*, 20 December 1924.

6. Sturtevant, "Theodore Clement Steele," 20.

7. Ibid.

8. Steele, *House of the Singing Winds*, 176.

9. Theodore C. Steele Papers, Archives of American Art, Smithsonian Institution, Washington, D.C.

10. Art Journal of Theodore C. Steele, 2 February 1871, Archives of American Art.

11. Ibid., 13 November 1870.

12. Interview, Theodore L. Steele, grandson of T. C. Steele.

13. *The Indianapolis News*, 20 December 1924.

14. James Whitcomb Riley briefly wore a mustache. He shaved it off in 1879 and never wore one again. Miss Leslie Payne, Riley's niece, to Margaret "Daisy" Steele Neubacher, 22 October 1937, Archives of American Art.

15. Royal Purcell, "Artists with Words and Brushes," *The Indianapolis Star Magazine*, 3 October 1971, 20-24.

16. John W. Love (1850-1880) was a portrait and landscape painter who studied at the École des Beaux-Arts in Paris from 1872 to 1876. James F. Gookins (1840-1904), also a portrait and landscape painter, studied at the Royal Academy in Munich from 1870 to 1873.

17. William Forsyth, *Art in Indiana*, (Indianapolis: The H. Lieber Company, 1916), 9-10.

18. Carl H. Lieber, "The Art School," *John Herron Art Institute, A Record: 1883-1906* (Indianapolis: Art Association of Indianapolis, 1906), 35, Indiana University-Purdue University at Indianapolis Archives.

19. Brandt Steele, "Meandering Memories" (Paper delivered at Portfolio Club of Indianapolis meeting, undated), unpaginated, Theodore L. Steele Papers.

20. Steele, *House of the Singing Winds*, 15.

21. Ibid. Those who signed the 21 November 1879 document pledging their financial support of Steele in his study were: Herman Lieber, Dr. William B. Fletcher, Stoughton A. Fletcher, Albert E. Fletcher, Ingram Fletcher, Allen M. Fletcher, Laurel L. Fletcher, John T. Brush, Francis M. Churchman, Stoughton J. Fletcher, Emil Martin, Cyrus C. Hines and M. Thompson.

22. Registrar of the Royal Academy in Munich to author, 12 April 1983. The information concerning Steele's enrollment is found in the Royal Academy's Matriculation Book, the only record of the school to have survived the war years. According to the registrar, "The files of the Academy including the personal files of the former students burned during the war."

23. Steele to unidentified financial backer, circa spring, 1881, Steele Papers.

24. Steele to Dr. William B. Fletcher, 13 February 1881, Steele Papers.

25. Steele to unidentified financial backer, circa summer, 1881, Steele Papers.

26. Steele to Dr. William B. Fletcher, 13 February 1881, Steele Papers.

27. Steele to unidentified financial backer, circa spring, 1881, Steele Papers.

28. Steele to second unidentified financial backer, circa spring, 1881, Steele Papers.

29. Mary E. Steele, *Impressions* (Indianapolis: The Portfolio Club, 1893), unpaginated.

30. Ibid.

31. Brandt Steele, "Dreams," (Paper delivered at Portfolio Club of Indianapolis meeting, 26 January 1950), unpaginated, Steele Papers.

32. J. Frank Currier (1843-1909) was one of the leading American painters working in the progressive aesthetics of late nineteenth-century Munich. Born in Boston, Massachusetts, he studied in Antwerp, Paris and Munich, before settling in Munich for twenty-eight years. In 1898, he returned to Boston where he died in 1909.

33. Steele to unidentified financial backer, circa fall, 1881, Steele Papers.

34. Steele, *House of the Singing Winds*, 24.

35. Ibid.

36. Ibid., 25.

37. Built by the Bavarian Franciscans, the Cloister at Mittenheim was opened on 4 October 1718. The nearby church, dismantled in 1804 when the Cloister building was sold, was sanctioned by the religious order on 4 October 1722. Since 11 July 1953, the Cloister building has been the home of the Munich Welfare Society for Catholic Men. Hans Gruber, "Chronik des Guten Mittenheim und seine Fluren."

38. Steele, *Impressions*.

39. Steele, *House of the Singing Winds*, 22-23.

40. *The Indianapolis News*, 18 April 1885.

41. Steele, *House of the Singing Winds*, 22. Those who signed the second document, dated 20 February 1882, to support Steele financially during his study in Munich were: Herman Lieber, Will Richards, Jonathan W. Gordon, John M. Butler, Albert E. Fletcher, Charles E. Coffin, William S. Hubbard, Henry C. Adams, Mrs. Stoughton J. Fletcher and Francis Churchman.

42. Lieber's Art Emporium, *Art Exhibit of the Hoosier Colony in München*, exh. cat., (Indianapolis, 1885), unpaginated.

43. Margaret "Daisy" Steele Neubacher to Professor Alfred Brooks, undated, Archives of American Art. Professor Brooks served as head of the Fine Arts Department at Indiana University from 1896 to 1922 when he left to become the head of the Department of History and Philosophy of Art at Swarthmore College. This letter was written in answer to Professor Brooks's request for research material concerning the life of Theodore C. Steele. He had hoped to gather enough material for a book on the artist; the project, however, was never completed and the material was returned to the Steele family.

44. Brandt Steele, "Meandering Memories or Meandering Again" (Paper delivered at Portfolio Club of Indianapolis meeting, undated), unpaginated, Steele Papers.

45. Neubacher to Professor Brooks, undated, Archives of American Art.

46. Steele, "Meandering Memories."

47. Steele to J. Ottis Adams, 12 September 1887, Caroline Brady Papers.

48. Steele, "Meandering Memories."

49. James Woodress, *Booth Tarkington: Gentleman from Indiana* (Philadelphia and New York: J. B. Lippincott Company, 1954), 50-51.

50. Lieber, "The Art School," 36-38.

51. Central Art Association, *Five Hoosier Painters*, text by Lorado Taft, Charles Francis Browne, and Hamlin Garland (Chicago, 1894), 4.

52. Ibid., 11.

53. Unidentified newspaper clipping, Otto Stark File, Stout Reference Room, Indianapolis Museum of Art.

54. Steele to Richmond Art Association official, 18 June 1906, Indiana State Library Manuscript Collection.

55. Steele, *House of the Singing Winds*, 38.

56. Ibid.

57. During his lifetime, Steele painted the portraits of many of the best-known men and women in the state. Among them were Benjamin Harrison, James Whitcomb Riley, Albert J. Beveridge, Charles W. Fairbanks, Dr. William Wishard, Col. Eli Lilly, John H. Holliday, Catherine Merrill, and May Wright Sewell. In 1916, he completed a commission to paint the portraits of four epochal Indiana governors—William Henry Harrison (1801-1812), Jonathan Jennings (1816-1822), Oliver P. Morton (1861-1865), and Thomas A. Hendricks (1873-1877)—dedicated in the celebration of Indiana's centennial.

58. Art Journal of Theodore C. Steele, 31 July 1870, Archives of American Art.

59. Steele to Memphis, Tennessee, newspaper reporter, 26 November 1894, Indiana Historical Society.

60. Brandt Steele, (Address delivered to Pioneer Club meeting, 25 May 1946), Lewis Neubacher Papers.

61. Neubacher to Professor Brooks, undated, Archives of American Art.

62. Mary E. Steele to Mrs. Brayton, 2 September 1897, Lewis Neubacher Papers.

63. Steele to George S. Cottman, 25 October 1897, Indiana State Library Manuscript Collection.

64. Ibid.

65. Steele to Cottman, 16 November 1897, Indiana State Library Manuscript Collection.

66. A. W. Butler to Steele and Adams, 20 January 1899, Brady Papers.

67. Steele, *House of the Singing Winds*, 46.

68. In 1804, Amos Butler, a Quaker from Pennsylvania, purchased ground along the east fork of the Whitewater River, directly east of what is now Brookville. There he built a grist mill, having the mill iron and millstone shipped from Cincinnati by packhorse. In 1812, he rebuilt the grist mill, adding a saw mill to the structure. Both mills were located directly east of a cabin built in 1812 by Butler to house his family. The cabin, remodeled many times, was later incorporated into the Hermitage. In 1835, the saw mill was replaced with a dry-roll paper mill. Both mills were later abandoned when the milling business floundered. *The Whitewater Valley Explorer*, 10 January 1979.

69. *The Oakland Tribune*, 29 March 1953, Lewis Neubacher Papers.

70. Steele to Mary Steele, August 1889, Steele Papers.

71. Ibid.

72. Steele, "Meandering Memories."

73. Ibid.

74. Steele, "Dreams."

75. Neubacher to Professor Brooks, undated, Archives of American Art.

76. Steele, *House of the Singing Winds*, 41.

77. Interview, Theodore L. Steele.

78. Unpublished notes of Margaret "Daisy" Steele Neubacher on life of Theodore C. Steele, Steele Papers.

79. Interview, Theodore L. Steele.

80. Theodore C. Steele, "In the Far West" (Paper delivered at Portfolio Club of Indianapolis, 1903), unpaginated, Archives of American Art.

81. Ibid.

82. Steele, *House of the Singing Winds*, 51.

83. Ibid., 52

84. T. C. Steele to Brandt Steele, 26 June 1907, Steele Papers.

85. Steele to Garland, 14 August 1916, American Literature Collection, University of Southern California.

86. *The Indianapolis News*, 11 December 1920. Before staying at the House of the Singing Winds with the Steeles, Hamlin Garland (1860-1940) had given a lecture at Indiana University in nearby Bloomington, Indiana. Associated with a movement to make fiction more realistic, Garland wrote in his book of essays, *Crumbling Idols* (1894): "Write of the things of which you know most, and for which you care most. By doing so you will be true to yourself, true to your locality, and true to your time."

87. Steele, *House of the Singing Winds*, 60.

88. Ibid., 100.

89. Ibid., 108.

90. Interview, Theodore L. Steele.

91. *The Indianapolis Star*, 20 December 1919.

92. Steele, *House of the Singing Winds*, 107.

93. Ibid., 126.

94. Ibid., 124.

95. Ibid.

96. *The Indianapolis Star*, 22 April 1923.

97. Brandt F. Steele to Brandt T. Steele, 26 July 1926, Archives of American Art.

98. *The Indianapolis Star*, 26 July 1926.

99. Robert Neubacher, T. C. Steele grandchild, to author, 25 July 1983.

100. Selma Steele to Dr. J. H. Weinstein, 8 July 1926, Indiana Historical Society.

101. Ibid.

102. Unpublished notes of "Daisy" Neubacher on life of T. C. Steele, Steele Papers.

103. *The Indianapolis Star*, 26 July 1926.

104. Theodore C. Steele, "The Value of Beauty" (Paper delivered to Portfolio Club of Indianapolis meeting, undated), unpaginated, Archives of American Art.

## J. Ottis Adams

1. Unidentified newspaper clipping, John Ottis Adams Notebooks, Dearborn Print Study, Indianapolis Museum of Art.

2. Ball State University Art Gallery, *John Ottis and Winifred Brady Adams, Painters*, exh. cat., (Muncie, 1976), unpaginated.

3. Unidentified newspaper clipping, Adams Notebooks.

4. *The Indianapolis News*, 29 January 1927.

5. Ball State University Art Gallery, *Adams, Painters*.

6. *The Indianapolis News*, 28 January 1927.

7. John Ottis Adams Record Book, Caroline Brady Papers.

8. Unidentified newspaper clipping, Adams Notebooks.

9. Mary Q. Burnet, *Art and Artists of Indiana* (New York: The Century Co., 1921), 164.

10. *The Indianapolis Star*, 14 August 1927.

11. John Ottis Adams Record Book; series of Estabrooke American Ferrotypes, Brady Papers.

12. John Ottis Adams Record Book, Brady Papers.

13. Royal College of Art, "History and Purpose of the College," *The Royal College of Art Calendar* (London, 1957), 16-17. In 1896, Queen Victoria consented to the taking of the title of Royal College of Art by the South Kensington School of Art.

14. United Kingdom. Parliament. *Schools of Art and Art Union Laws: 1864-97*, Vol. 6, Royal College of Art Reference Room, London.

15. John Rothenstein, *An Introduction to English Painting* (New York: W. W. Norton & Co., Inc., 1965), 92-93.

16. South Kensington School of Art Proficiency Certificate, 1 July 1873, Brady Papers.

17. Christopher Wood, *The Dictionary of Victorian Painters* (Suffolk, England: Antique Collectors' Club, 1971), 119. While serving as an instructor for John Ottis Adams, John Parker was also associated with St. Martin's School of Art in London, England; he was headmaster of the school in 1884. The stationery upon which Parker Letter of Introduction for Adams was written used St. Martin's School of Art as the return address. It may be assumed, therefore, that Adams was either a private pupil of Parker or enrolled as a St. Martin's student after the completion of his course work at South Kensington School of Art. The research librarian at St. Martin's School of Art indicates: "The history of the school is lost in the mists of time I'm afraid because the school has moved a number of times and a fire at the beginning of the century destroyed all the early academic records that we had. As far as we know the school is not directly a branch of South Kensington though we were a part of the general movement at that period to set up art schools in London and the provinces." Katherine Baird, research librarian at St. Martin's School of Art, London, to author, 17 February 1984.

18. Adams Notebooks, Indianapolis Museum of Art.

19. Wilbur D. Peat, *Pioneer Painters of Indiana* (Indianapolis: Art Association of Indianapolis, 1954), 106.

20. Ibid., 107.

21. Ronald G. Pisano, *A Leading Spirit in American Art, William Merritt Chase: 1849-1916* (Seattle: Henry Gallery Association, 1983), 185.

22. Chase to Adams, 31 May 1880, Brady Papers.

23. *The Indianapolis Star*, 16 October 1927.

24. According to artist Beulah Hazelrigg Brown of Muncie, Indiana, she and her husband Francis Folger Brown restored the reproduction of *The Lion Hunt* by Adams. She explained: "The face was torn so we had to patch that and repair it; you can't tell where it's been repaired." The painting is currently owned by the Muncie Public Library, Muncie, Indiana.

25. John Alban Adams to the Indiana School for the Blind, Indianapolis, Indiana, 6 December 1955, Adams Notebooks.

26. Diary of John Ottis Adams, 24 July 1880 through 29 July 1880, Adams Notebooks.

27. Adams Diary, 30 July 1880, Adams Notebooks.

28. June DeBois, *W. R. Leigh* (Kansas City: The Lowell Press, 1977), 21. The Königlishe Akademie der Bildenden Künste is now located at Akademiestrasse 2, 8000 München 40, Deutschland.

29. Registrar of the Royal Academy in Munich to author, 12 April 1983. The information concerning Adams's enrollment is found in the Royal Academy's Matriculation Book, the only record of the school to have survived the war years. According to the registrar: "The files of the Academy including the personal files of the former students burned during the war."

30. Pisano, *William Merritt Chase*, 27.

31. *The Indianapolis News*, 28 January 1927.

32. Selma N. Steele, Theodore L. Steele, and Wilbur D. Peat, *The House of the Singing Winds* (Indianapolis: Indiana Historical Society, 1966), 25.

33. Adams to Forsyth, 17 July 1885, Constance Forsyth and Evelyn Forsyth Selby Papers.

34. Nelson C. White, *The Life and Art of J. Frank Currier* (Cambridge: Riverside Press, 1936), 30.

35. Burnet, *Art and Artists*, 164.

36. Steele to Adams, 12 September 1887, Brady Papers.

37. L. Harry Meakin in Cincinnati, Ohio, to Adams, 6 April 1887 through 9 November 1887, Brady Papers.

38. Adams to Forsyth, 20 April 1888, Forsyth and Selby Papers.

39. Forsyth to Adams, 4 June 1888, Brady Papers.

40. Adams to Forsyth, 6 August 1889, Forsyth and Selby Papers.

41. Circular, *Muncie Art School: 1889-90*, Forsyth and Selby Papers.

42. *The Muncie Star*, 25 March 1923.

43. Central Art Association, *Five Hoosier Painters*, text by Lorado Taft, Charles Francis Browne, and Hamlin Garland (Chicago, 1894), 5.

44. Charter members of the Society of Western Artists were: L. H. Meakin, Frank Duveneck, and H. F. Farny from Cincinnati; William Forsyth, T. C. Steele, and J. Ottis Adams from Indianapolis; George L. Schreiber, H. W. Methven, and F. C. Peyraud from Chicago; Holmes Smith, Robert Bringhurst, and C. F. Von Saltza from St. Louis; George C. Bradley, W. J. Edmondson, and Charles H. Ault from Cleveland; Percy Ives, F. P. Paulus, and J. W. Gies from Detroit.

45. Bulletin, Fifth Annual Exhibition of the Society of Western Artists, Cincinnati, Ohio, 23 November 1900.

46. Adams to Forsyth, 7 February 1898, Forsyth and Selby Papers.

47. *The Muncie Weekly News*, 9 December 1896.

48. Steele to Cottman, 25 October 1897, Indiana State Library Manuscript Collection.

49. Ibid.

50. Steele to Cottman, 16 November 1897, Indiana State Library Manuscript Collection.

51. *The Indianapolis Times*, 14 March 1956.

52. A. W. Butler to Steele and Adams, 20 January 1899, Brady Papers.

53. *The Whitewater Valley Explorer*, supplement to *The Brookville American* and *The Brookville Democrat*, 10 January 1979.

54. Interview, Rosemary Ball Bracken, niece of John Ottis and Winifred Brady Adams.

55. Marion Adams Stockwell, one of the Adams daughters-in-law, to author, 18 July 1983.

56. *The Muncie Weekly News*, 21 January 1899.

57. Nancy L. Comiskey, "Crossroads of Culture," *Indianapolis Monthly* (November 1982), 29.

58. Series of catalogues and circulars of the John Herron Art Institute from the school years of 1902-03, 1903-04, 1904-05, 1905-06, and 1906-07. When Adams left in 1906, he was replaced by William Forsyth as the principal instructor in drawing and painting. Indiana University-Purdue University at Indianapolis Archives.

59. *The Indianapolis Star*, 6 February 1927.

60. Adams Notebooks, Indianapolis Museum of Art.

61. Gruelle to Adams, 14 December 1907, Adams Notebooks.

62. *The Richmond Daily Palladium*, 17 June 1904.

63. Circular, *Summer Class in Landscape Painting: 1912*, Stout Art Reference Library, Indianapolis Museum of Art.

64. Interview, Beulah Hazelrigg Brown, textile designer and watercolorist from Muncie, Indiana.

65. Interview, Rosemary Ball Bracken.

66. Stark to Adams, 27 July 1908 through 24 August 1908, John Ottis Adams Papers, Archives of American Art, Smithsonian Institution, Washington, D.C.

67. Interview, Rosemary Ball Bracken.

68. Adams to Winifred Adams, 27 March 1913, Brady Papers.

69. Stark to Selma Steele, 9 August 1913, Indiana State Library Manuscript Collection.

70. Unidentified St. Petersburg, Florida newspaper clipping, Adams Notebooks, Indianapolis Museum of Art.

71. Adams to Winifred Adams, 21 February 1916, Brady Papers.

72. Adams to Winifred Adams, 27 March 1916, Brady Papers.

73. Adams to Winifred Adams, 21 January 1917, Brady Papers.

74. Adams to Winifred Adams, 15 January 1917, Brady Papers.

75. *The Indianapolis Star*, 21 August 1927.

76. Adams to Winifred Adams, 20 September 1919, Brady Papers.

77. Adams to Winifred Adams, 11 October 1919, Brady Papers.

78. Adams to Winifred Adams, 27 September 1920, Brady Papers.

79. Adams to Winifred Adams, 9 January 1921, Brady Papers.

80. Warranty Deed, 10 April 1923, Brady Papers.

81. Warranty Deed, 19 April 1924, Brady Papers.

82. Adams to Winifred Adams, 25 September 1926, Brady Papers.

83. Adams Notebooks, Indianapolis Museum of Art.

84. *The Indianapolis News*, 6 October 1927.

85. Art Association of Indianapolis, *Memorial Exhibition of the Paintings of John Ottis Adams*, foreword by William Forsyth (Indianapolis, 1927).

# William Forsyth

1. William Forsyth, "Confidences" (Paper delivered at Literary Club of Indianapolis meeting, 9 January 1922), unpaginated, Constance Forsyth and Evelyn Forsyth Selby Papers.

2. Interview, Constance Forsyth, Evelyn Forsyth Selby, and Robert Selby.

3. The birth of William J. Forsyth to Elijah and Mary Forsyth was followed by the births of another son John and two daughters, Elizabeth and Alice.

4. Interview, Constance Forsyth, Evelyn Forsyth Selby, and Robert Selby.

5. Forsyth, "Confidences."

6. Interview, Constance Forsyth.

7. Forsyth, "Confidences."

8. Ibid.

9. Ibid.

10. Ibid.

11. Ibid.

12. Barton S. Hays (1826-1914) was a portrait, animal, and still life painter who worked in Indianapolis from 1858 to 1870.

13. Interview, Constance Forsyth, Evelyn Forsyth Selby, and Robert Selby.

14. John Washington Love (1850-1880) was a portrait and landscape painter who studied with Gérôme at the Ecole des Beaux-Arts in Paris from 1872 to 1876. Returning to Indianapolis in 1876, he and James F. Gookins founded the first Indiana School of Art.

15. Paul R. Martin, "William Forsyth: Indiana's Artist—His Triumph in Fight for Fame," *The Indianapolis Star*, undated newspaper clipping, Stout Reference Room, Indianapolis Museum of Art.

16. Interview, Evelyn Forsyth Selby.

17. Forsyth, "Confidences."

18. Ibid.

19. James Farrington Gookins (1840-1904) was a portrait and landscape painter who studied at the Royal Academy at Munich from 1870 to 1873. He returned to Indianapolis in 1873 to found the Indiana School of Art with John W. Love in 1877. Leaving the school in 1878, Gookins worked in Terre Haute, Indiana; Chicago, Illinois, and again in Indianapolis before his death in New York in 1904.

20. William Forsyth, *Art in Indiana* (Indianapolis: The H. Lieber Co., 1916), 11.

21. Love to Forsyth, 2 September 1879, Forsyth and Selby Papers.

22. Love to Forsyth, 6 September 1879, Forsyth and Selby Papers.

23. Love to Forsyth, 22 September 1879, Forsyth and Selby Papers.

24. Carl H. Lieber, "The Art School," *John Herron Art Institute, A Record: 1883-1906* (Indianapolis: Art Association of Indianapolis, 1906), 36.

25. Forsyth, *Art in Indiana*, 12.

26. *The Indianapolis Star*, 24 May 1931.

27. Forsyth to Thomas Hibben, 12 January 1882, Forsyth and Selby Papers.

28. Forsyth, *Art in Indiana*, 13.

29. Thomas E. Hibben was unable to seriously pursue a career in art because of the need to assume managerial responsibilities in the family dry-goods wholesale business of Hibben, Hollweg & Co. in Indianapolis, Indiana. Hibben promised financial aid for Forsyth's study in Munich in return for one-half of the work produced by the artist during his stay. Constance Forsyth to author, 21 April 1984.

30. Steele to Forsyth, 3 November 1881, Forsyth and Selby Papers.

31. Forsyth to Hibben, 12 January 1882, Forsyth and Selby Papers.

32. Brandt Steele, "Meandering Memories" (Paper delivered at Portfolio Club of Indianapolis meeting, undated), unpaginated, Theodore L. Steele Papers.

33. Forsyth to Hibben, 12 January 1882, Forsyth and Selby Papers.

34. Forsyth to Hibben, 20 February 1882, Forsyth and Selby Papers.

35. Ibid.

36. Forsyth to Hibben, June 1882, Forsyth and Selby Papers.

37. Forsyth to Hibben, 20 February 1882, Forsyth and Selby Papers.

38. Registrar of the Royal Academy in Munich to author, 12 April 1983. The information concerning Forsyth's enrollment is found in the Royal Academy's Matriculation Book, the only record of the school to have survived the war years. According to the registrar, "The files of the Academy including the personal files of the former students burned during the war."

39. Forsyth to Hibben, June 1882, Forsyth and Selby Papers.

40. Forsyth to Hibben, 13 May 1882, Forsyth and Selby Papers.

41. Forsyth to Hibben, 23 October 1882, Forsyth and Selby Papers.

42. Forsyth to Hibben, 26 December 1882, Forsyth and Selby Papers.

43. Forsyth to Hibben, 28 September 1882, Forsyth and Selby Papers.

44. Forsyth to Hibben, 23 October 1882, Forsyth and Selby Papers.

45. Forsyth to Hibben, 29 November 1882, Forsyth and Selby Papers.

46. Ibid.

47. Forsyth to Hibben, 24 July 1882, Forsyth and Selby Papers.

48. Forsyth to Hibben, 6 July 1883, Forsyth and Selby Papers.

49. Forsyth to Hibben, 26 July 1883, Forsyth and Selby Papers.

50. Forsyth to Hibben, 30 October 1883, Forsyth and Selby Papers.

51. Ibid.

52. Forsyth to Hibben, 26 November 1883, Forsyth and Selby Papers.

53. Forsyth to Hibben, 28 August 1882, Forsyth and Selby Papers.

54. Forsyth to Hibben, 13 May 1882, Forsyth and Selby Papers.

55. Ibid.

56. Forsyth to Hibben, 26 December 1882, Forsyth and Selby Papers.

57. *The Indianapolis News*, 18 April 1885.

58. Interview, Constance Forsyth, Evelyn Forsyth Selby, and Robert Selby.

59. Forsyth to Hibben, 29 November 1882, Forsyth and Selby Papers.

60. Ibid.

61. Forsyth to Hibben, June 1882, Forsyth and Selby Papers.

62. Forsyth to Hibben, 30 October 1883, Forsyth and Selby Papers.

63. Forsyth to Hibben, 28 September 1882, Forsyth and Selby Papers.

64. J. Ottis Adams to Forsyth, 20 April 1888, Forsyth and Selby Papers.

65. Forsyth to Adams, 4 June 1888, Caroline Brady Papers.

66. Adams to Forsyth, 24 August 1889, Forsyth and Selby Papers.

67. Adams to Forsyth, 20 October 1889, Forsyth and Selby Papers.

68. Adams to Forsyth, 26 October 1889, Forsyth and Selby Papers.

69. Circular, *Muncie Art School: 1889-90*, Forsyth and Selby Papers.

70. Letterhead of the Indiana School of Art stationery, 23 November 1891, Indiana State Library Manuscript Collection.

71. Lieber, *John Herron Art Institute*, 36-38.

72. Central Art Association, *Five Hoosier Painters*, text by Lorado Taft, Charles Francis Browne, and Hamlin Garland (Chicago, 1894), 10.

73. Ibid., 6.

74. Ibid., 4.

75. Forsyth, *Art in Indiana*, 16-17.

76. Ibid., 16.

77. "Historical Notes," *Constitution of the Society of Western Artists: 1909-10*, Brady Papers.

78. Constance Forsyth to author, 16 April 1984.

79. Interview, Constance Forsyth, Evelyn Forsyth Selby, and Robert Selby.

80. Evelyn Forsyth Selby, "Cedar Farm" (Paper delivered at Portfolio Club of Indianapolis meeting, undated), unpaginated, Forsyth and Selby Papers.

81. Ibid.

82. Constance Forsyth to author, 16 April 1984.

83. Marian College, *Exhibit of the Works of William Forsyth*, exh. cat. (Indianapolis, 1966), 10.

84. Interview, Isabelle Layman Troyer, a childhood playmate and close friend of Constance Forsyth and Evelyn Forsyth Selby.

85. Interview, Dorothy Canfield Blue, a childhood playmate and close friend of Constance Forsyth and Evelyn Forsyth Selby.

86. Ibid.

87. Interview, Jean Brown Wagoner, a childhood playmate and close friend of Dorothy Forsyth, Constance Forsyth, and Evelyn Forsyth Selby.

88. Forsyth, *Art in Indiana*, 21.

89. Interview, Beulah Hazelrigg Brown, textile designer and watercolorist. She and her husband, artist Francis Folger Brown, were students at the John Herron Art Institute in 1915.

90. Ibid.

91. Interview, Evelynne Mess Daily, Indianapolis painter and printmaker.

92. Ibid.

93. *The Indianapolis Star*, 12 May 1940.

94. *The Indianapolis Star*, 10 November 1913.

# Richard B. Gruelle

95. Interview, Evelyn Forsyth Selby.

96. The artists involved in the Indianapolis City Hospital murals were: William Forsyth, T. C. Steele, J. Ottis Adams, Otto Stark, Clifton Wheeler, Carl Graf, Wayman Adams, Dorothy Morlan, Emma B. King, William Scott, Walter Hixon Isnogle, Francis Folger Brown, Simon Baus, Jay Connaway, and Martinus Anderson.

97. Constance Forsyth to author, 10 March 1984.

98. Interview, Jean Brown Wagoner.

99. Interview, Mildred Stilz Haskens, a childhood friend of the Forsyth daughters.

100. Interview, Evelyn Forsyth Selby.

101. Constance Forsyth to author, 10 March 1984.

102. *The Indianapolis Star*, 31 March 1935.

103. Interview, Constance Forsyth, Evelyn Forsyth Selby, and Robert Selby.

104. Ibid.

105. Ibid.

106. Ibid.

107. Art Association of Indianapolis, *Art School: Catalogue of the Winter, Evening and Summer Schools, 1924-25* (Indianapolis, 1924), 13.

108. Interview, Evelynne Mess Daily.

109. *The Indianapolis Star*, 5 October 1931.

110. The eight teachers whose faculty positions were terminated by Mattison were: William Forsyth, Clifton Wheeler, Ethelwynn Miller, Paul Hadley, Burling Boaz, Edward H. Mayo, Constance Forsyth, and Dorothy Eisenbach. The students protested Mattison's unpopular decision by hanging him in effigy from a tree on the Art Institute grounds, *The Indianapolis Star*, 24 May 1933.

111. Interview, Constance Forsyth.

112. Interview, Evelyn Forsyth Selby.

113. Interview, Constance Forsyth.

114. Forsyth, "Confidences."

1. Gruelle Family Scrapbook, compiled by Justin C. Gruelle, Jane Comerford Papers.

2. Gruelle to Indiana State Library, circa 1914, Indiana State Library Manuscript Collection. Gruelle's shifting point of view as he wrote this autobiographical letter for the library's Indiana artists' file might have been due, in part, to his ill health. Mrs. Gruelle added the following postscript to her husband's letter: "Mr. Gruelle does not improve as fast as we wish, still unable to work."

3. Ibid.

4. Ibid.

5. Ibid.

6. Ibid.

7. Ibid.

8. Ibid.

9. Ibid.

10. Mary Q. Burnet, *Art and Artists of Indiana* (New York: The Century Co., 1921), 185.

11. Gruelle to Indiana State Library, Manuscript Collection.

12. Ibid.

13. Gruelle Family Scrapbook, Comerford Papers.

14. Ibid.

15. Gruelle to Indiana State Library, Manuscript Collection.

16. Ibid.

17. Ibid.

18. Richard B. Gruelle, *Notes: Critical & Biographical* (Indianapolis: J. M. Bowles, 1895), unpaginated introduction.

19. *Modern Art*, one of the nation's foremost art publications of its time, was published in Indianapolis during 1893 and 1894 by J. M. Bowles. The magazine was taken to Boston by L. Prang & Co. which continued to publish the magazine for two more years with Bowles as editor. Jacob Piatt Dunn, *Greater Indianapolis: The History, The Industries, The Institutions and The People of a City of Homes* (Chicago: The Lewis Publishing Company, 1910), 486.

20. Gruelle, *Notes*, unpaginated introduction.

21. Gruelle to Indiana State Library, Manuscript Collection.

22. Ibid.

23. Gruelle, *Notes*, unpaginated introduction.

24. Ibid.

25. Ibid., 5-6.

26. Selma N. Steele, Theodore L. Steele, and Wilbur D. Peat, *The House of the Singing Winds* (Indianapolis: Indiana Historical Society, 1966), 185.

27. Central Art Association, *Five Hoosier Painters*, text by Lorado Taft, Charles Francis Browne, and Hamlin Garland, (Chicago, 1894), 6.

28. Ibid., 6-7.

29. William Forsyth, *Art in Indiana* (Indianapolis: The H. Lieber Co., 1916), 18.

30. *The Indianapolis Star*, 3 December 1905.

31. *The South Bend New Era Weekly*, 6 April 1912.

32. Gruelle to Indiana State Library, Manuscript Collection.

33. *The Indianapolis Sentinel*, 14 November 1904.

34. *The Indianapolis News*, 10 October 1898.

35. Gruelle Family Scrapbook, Comerford Papers.

36. Interview, Worth Gruelle, grandson of Richard B. Gruelle.

37. The Indianapolis streets were renumbered around the turn of the century and by 1900, the house number had been changed to 517 Tacoma Ave. According to Gruelle family correspondence in 1907, the house number had again been changed to 537 Tacoma Avenue.

38. Gruelle Family Scrapbook, Comerford Papers.

39. Ibid.

40. Ibid.

41. Ibid.

42. Peg Slone, granddaughter of Richard B. Gruelle, to author, 30 January 1984.

43. Gruelle Family Scrapbook, Comerford Papers.

44. In the late 1880s, American psychologist William James studied the case of a Boston homemaker who felt she was experiencing hypnotic trances. During her trance-like state, she claimed that the spirits of composer Johann Sebastian Bach and poet Henry Wadsworth Longfellow were competing for control of her mind.

45. Gruelle to Riley, 13 March 1900, Riley Manuscripts, Manuscript Department, Lilly Library, Indiana University, Bloomington, Indiana.

46. Interview, Worth Gruelle.

47. *The Indianapolis Star*, 3 December 1905.

48. Gruelle Family Scrapbook, Comerford Papers. Upon the completion of her study in New York City, Prudence worked as a singing cartoonist in vaudeville for several seasons under the name of Prudence Grue, *The Indianapolis News*, 28 April 1915. Later, she became an authoress, publishing *The Meadow Folks Story Hour* in 1921 and writing a syndicated newspaper column of children's stories, Peg Slone Papers.

49. Gruelle Family Scrapbook, Comerford Papers.

50. In the Gruelle Family Scrapbook, Justin wrote: "My most interesting activity in Indianapolis during the next year was the months spent in William Forsyth's life class at the John Herron Art Institute. Forsyth, while primarily a landscape painter, was a fine instructor in drawing from life, and it was a valuable experience. Among his students at that time was Wayman Adams and Simon Baus, and these two were to remain our friends for many years." Several years after the death of Gruelle, Wayman Adams painted his famed portrait of the Hoosier Group. According to Justin, "Wayman always expressed his regret to me that R.B.G. was not included," Gruelle Family Scrapbook, Comerford Papers. Justin Gruelle entered Forsyth's day class at John Herron on October 25, 1907 and worked through the school year under the demanding professor. He failed to enroll in the fall of 1908, but entered Forsyth's day life class on January 23, 1909, only to abruptly leave in February of 1909, *The Roll Book: 1906-09*, John Herron Art Institute, handwritten, unpaginated, Indiana University-Purdue University at Indianapolis Archives.

51. Marjorie Knight Macrae, "Johnny Gruelle and His Raggedy Ann," *Landmarks of New Canaan* (New Canaan, Connecticut: The New Canaan Historical Society, 1951), 322.

52. Gruelle to Indiana State Library, Manuscript Collection.

53. Macrae, *Landmarks of New Canaan*, 324.

54. *The Indianapolis Star*, 8 October 1940. The name of the cartoon was changed to "Joe Crow" during the 1960s.

55. Ibid.

56. Gruelle to Indiana State Library, Manuscript Collection.

57. Burnet, *Art and Artists*, 195.

58. Gruelle to Indiana State Library, Manuscript Collection.

59. *The Indianapolis Star*, 9 November 1914.

# Selected Bibliography

Adams, J. Ottis. *Muncie Art School: 1889-90.* Muncie, Indiana, 1889.

Adams, J. Ottis. *Summer Class in Landscape Painting.* Brookville, Indiana, 1912.

Adams Notebooks. Dearborn Print Study, Indianapolis Museum of Art, Indianapolis, Indiana. Includes sketchbooks of John Ottis Adams as well as family papers and newspaper articles.

Adams Papers. Archives of American Art, Smithsonian Institution, Washington, D.C. Includes correspondence and newspaper articles pertaining to John Ottis Adams.

Ansell, Florence Jean, and Fraprie, Frank Roy. *The Art of the Munich Galleries.* Boston: L.C. Page & Co., 1910.

Art Association of Indianapolis. *Art School: Catalogue of Winter and Evening Schools, 1905-06.* Indianapolis, 1905.

Art Association of Indianapolis. *Art School: Circular for Summer Term, May 1902.* Indianapolis, 1902.

Art Association of Indianapolis. *Art School: Catalogue of the Winter, Evening & Summer Schools, 1924-25.* Indianapolis, 1924.

Art Association of Indianapolis. *Memorial Exhibition of the Paintings of John Ottis Adams.* Indianapolis, 1927.

Art Association of Indianapolis. *The Work of Theodore Clement Steele.* Indianapolis, 1926.

Arts Center, Inc. *Impressionistic Trends in Hoosier Painting.* exh. cat., 1979.

Ball State University Art Gallery. *John Ottis and Winifred Brady Adams, Painters.* Muncie, Indiana, 1976.

Bellony-Rewald, Alice. *The Lost World of the Impressionists.* Boston: New York Graphic Society, 1976.

Benet, William R., ed. *The Reader's Encyclopedia.* New York: Thomas Y. Crowell, 1965.

Brady Papers. New York. Includes correspondence, family documents and photographs of John Ottis Adams and his friends.

Burnet, Mary Q. *Art and Artists of Indiana.* New York: The Century Co., 1921.

Caldwell, Howard C. *Butler College Years, 1911-1915.* Indianapolis: Irvington Historical Society, 1965.

Carpenter, Allan. *Indiana: The New Enchantment of America.* Chicago: Childrens Press, 1966.

Cathcart, Charlotte. *Indianapolis From Our Old Corner.* Indianapolis: Indianapolis Historical Society, 1965.

Central Art Association. *Five Hoosier Painters.* Chicago, 1895.

Comerford Papers. Includes family scrapbook of Richard B. Gruelle, compiled by Justin C. Gruelle.

Comiskey, Nancy L. "Crossroads of Culture." *Indianapolis Monthly* (November, 1982).

Courthion, Pierre. *Montmartre.* Editions d'Art, Albert Skira, 1956.

DeBois, June. *W.R. Leigh.* Kansas City: The Lowell Press, 1977.

De la Sizeranne, Robert. *The National Gallery, London: The Early British School.* London: George Newnes, Ltd.

Division of Historic Preservation. *T.C. Steele: Indiana State Memorial.* Indianapolis: Indiana Department of Natural Resources.

Dunn, Jacob Piatt. *Greater Indianapolis: The History, The Industries, The Institutions and The People of a City of Homes.* Chicago: The Lewis Publishing Co., 1910.

Escholier, Raymond. *Matisse: A Portrait of the Artist and the Man.* New York: Frederick A. Praeger, 1960.

Finke, Ulrich. *German Painting from Romanticism to Expressionism.* Boulder, Colorado: Westview Press, 1975.

Forsyth, William. *Art in Indiana.* Indianapolis: The H. Lieber Co., 1916.

Forsyth, William. "Confidences." Paper presented to the Literary Club of Indianapolis, January, 1922.

Forsyth Papers. Austin, Texas. Includes correspondence, family documents and photographs of William Forsyth.

Funk, Arville L. *A Sketchbook of Indiana History.* Rochester, Indiana: Christian Book Press, 1969.

Gerdts, William H. *American Impressionism.* Seattle: The Henry Art Gallery, 1980.

Gruelle, Richard B. *Notes: Critical & Biographical.* Indianapolis: J.M. Bowles, 1895.

Hall, Ann L. *The Irvington Artists.* Indianapolis: Irvington Historical Society, 1965.

Hendy, Philip. *The National Gallery, London.* New York: Harry N. Abrams, Inc., 1960.

"Historical Notes." *Constitution of the Society of Western Artists: 1909-10.*

Hoover, Dwight W. *A Pictorial History of Indiana.* Bloomington, Indiana: Indiana University Press, 1980.

Indianapolis Museum of Art. *Otto Stark: 1859-1926.* Indianapolis, 1977.

Kingsbury, Layman. *Early Irvington.* Indianapolis: Irvington Historical Society, 1965.

Leary, Edward A. *Indianapolis: The Story of A City.* Indianapolis and New York: Bobbs-Merrill Co. Inc., 1971.

Leary, Edward A. *The Nineteenth State: Indiana.* Indianapolis: Ed Leary & Associates, 1966.

Lieber's Art Emporium. *Art Exhibit of the Hoosier Colony in München.* Indianapolis, 1885.

Lieber, Carl H. "The Art School." *John Herron Art Institute, A Record: 1883-1906.* Indianapolis: Art Association of Indianapolis, 1906.

Macrae, Marjorie Knight. "Johnny Gruelle and His Raggedy Ann." *Landmarks of New Canaan.* New Canaan, Connecticut: The New Canaan Historical Society, 1951.

Marian College. *Exhibit of the Works of William Forsyth.* Indianapolis, 1966.

Martin, John Bartlow. *Indiana: An Interpretation.* New York: Alfred A. Knopf, Inc., 1947.

Montreal Museum of Fine Arts. *William Bouguereau: 1825-1905.* Paris: Nouvelle Imprimerie Moderne du Lion, 1984.

Neubacher Papers. Berkeley, California. Includes newspaper clippings, photographs, and correspondence pertaining to T.C. Steele and his family.

Nolan, Jeannette C. *States of the Nation: Indiana.* New York: Coward-McCann, Inc., 1969.

Oakes Papers. Sarasota, Florida. Includes correspondence and photographs of Otto Stark and his family.

Peat, Wilbur D. *Pioneer Painters of Indiana*. Indianapolis: Art Association of Indianapolis, 1954.

Peckham, Howard H. *Indiana: A Bicentennial History*. New York: W.W. Norton & Co., 1978.

Pierce, Patricia Jobe. *Edmund C. Tarbell and the Boston School of Painting: 1889-1980*. Hingham, Massachusetts: Pierce Galleries, Inc., 1980.

Pisano, Ronald G. *A Leading Spirit in American Art: William Merritt Chase, 1849-1916*. Seattle: Henry Art Gallery, 1983.

Purcell, Royal. "Artists with Words and Brushes." *The Indianapolis Star Magazine* (October 1971).

Rose, Ernestine Bradford. *The Circle: The Center of Indianapolis*. Indianapolis: Crippin Printing Corp., 1971.

Rothenstein, John. *An Introduction to English Painting*. New York: W.W. Norton & Co., Inc., 1965.

Royal College of Art. "History and Purpose of the College." *The Royal College of Art Calendar*. London, 1957.

Selby, Evelyn Forsyth. "Cedar Farm." Paper presented to the Portfolio Club of Indianapolis, undated.

Sérullaz, Maurice. *The Impressionist Painters*. New York: Universe Books, Inc., 1960.

Slone Papers. Miami, Florida. Includes newspaper articles concerning Richard B. Gruelle and his family.

Stark, Otto. "The Evolution of Impressionism." *Modern Art* No. 2 (Spring 1895).

Stark Papers. Archives of American Art, Smithsonian Institution, Washington, D.C. Includes correspondence and newspaper articles pertaining to Otto Stark.

Steele, Brandt T. "Dreams." Paper presented to the Portfolio Club of Indianapolis, January, 1950.

Steele, Brandt T. "Meandering Memories." Paper presented to the Portfolio Club of Indianapolis, undated.

Steele, Brandt T. "Meandering Memories or Meandering Again." Paper presented to the Portfolio Club of Indianapolis, undated.

Steele, Mary E. *Impressions*. Indianapolis: The Portfolio Club, 1893.

Steele Papers. Archives of American Art, Smithsonian Institution, Washington, D.C. Includes correspondence and family journals.

Steele Papers. Indianapolis, Indiana. Includes sketchbooks, correspondence, family photographs, and documents.

Steele, Theodore, C. "The Trend of Modern Art." Paper presented to the Literary Club of Indianapolis, May 1896.

Steele, Theodore C. "The Value of Beauty." Paper presented to the Portfolio Club of Indianapolis, undated.

Steele, Theodore C. "In the Far West." Paper presented to the Portfolio Club of Indianapolis, 1903.

Steele, Selma N., Steele, Theodore L., and Peat, Wilbur D. *House of the Singing Winds*. Indianapolis: Indiana Historical Society, 1966.

Sturtevant, Mabel. "Theodore Clement Steele." *The Hoosier Magazine* No. 2 (February, 1930).

Thornton, J.F. and Reade, Anna R. *Indiana: The Story of a Progressive Commonwealth*. Chicago, New York and Dallas: Mentzer, Bush & Company, 1926.

United Kingdom. Parliament. *Schools of Art and Art Union Laws: 1864-1897*, Vol. 6.

University of Notre Dame. *Mirages of Memory: 200 Years of Indiana Art, Volume I*. South Bend, Indiana, 1977.

Waitley, Douglas. *Portrait of the Midwest: From the Ice Age to the Industrial Era*. London, New York and Toronto: Abelard-Schuman, 1963.

Watt, Alexander. *Art Centers of the World: Paris*. Cleveland and New York: World Publishing Co., 1967.

White, Nelson C., *The Life and Art of J. Frank Currier*. Cambridge: Riverside Press, 1936.

Wilson, William E. *Indiana: A History*. Bloomington and London: Indiana University Press, 1966.

Wood, Christopher. *The Dictionary of Victorian Painters*. Suffolk, England: Antique Collectors' Club, 1971.

Woodress, James. *Booth Tarkington: Gentleman From Indiana*. Philadelphia and New York: J.B. Lippincott Company, 1954.

# Index

Italic numeral indicates illustration.

**Photograph Credits**

Unless otherwise noted, the paintings have been photographed by Ken Armour.

Art Association of Richmond, 46; Ruth Chin, 97; Marilyn Glander, Indiana State Museum, 25, 60, 109; Neu-Foto Products, Pacific Palisades, California, 60; Robert Wallace, Indianapolis Museum of Art, 14, 15, 17, 30, 62, 68, 70, 71.